Material Culture and the Study of American Life

D0075322

Material Culture
and the Study
of American Life

EDITED BY

Ian M. G. Quimby

CALVIN T. RYAN LIBRARY
KEARNEY STATE COLLEGE
KEARNEY, NEBRASKA

PUBLISHED FOR
The Henry Francis du Pont Winterthur Museum
WINTERTHUR, DELAWARE

W · W · Norton & Company · Inc ·
NEW YORK

Copyright © 1978 by The Henry Francis du Pont Winterthur Museum.
Published simultaneously in Canada by George J. McLeod Limited,
Toronto. Printed in the United States of America.

ALL RIGHTS RESERVED

FIRST EDITION

Library of Congress Cataloging in Publication Data
Main entry under title:

Material culture and the study of American life.
 1. United States—Antiquities—Collection and preser-
vation—Congresses. 2. Museum conservation methods—
Congresses. 3. Indians of North America—Southwest,
New—Antiquities—Collection and preservation—Congresses.
I. Quimby, Ian M. G.
E159.M37 1978 973 77–10894
ISBN 0–393–05661–9
ISBN 0–393–05665–1 pbk.

1 2 3 4 5 6 7 8 9 0

Contents

List of Illustrations

Preface

Eleven noted experts were invited to present their views on the role of historical artifacts in understanding the American past. The collection, preservation, and interpretation of our material heritage has generally been accomplished by a variety of amateurs and specialists rather than by professional historians. The latter group has traditionally ignored material culture in favor of documentary research. The study of American history proceeded largely without reference to the three-dimensional remains of the American past, while the preservation, restoration, and interpretation of artifacts too often proceeded on the basis of outmoded historical theories or for nonhistorical reasons at all. These two parallel lines of development have shown signs of converging in recent years as some historians have become involved with material culture and as some curators and preservationists have come to recognize the need for accurate historical information necessary for more sophisticated interpretation. Several historians, at least three of whom are now professionally associated with museums, along with an archaeologist, an ethnologist, and a museum curator address the problem in this group of papers. Collectively the papers reveal a variety of ways of dealing with the American past, each one valid in its own right. More importantly, this volume suggests a coming of age in which specialists with vastly different training and backgrounds realize the value of interdisciplinary or multidisciplinary studies in order to achieve a far richer, broader picture of the American past.

These papers were originally presented at the 1975 Winterthur Conference, John A. H. Sweeney, chairman. The conference was funded in part by a grant from Mr. and Mrs. John Mayer.

Ian M. G. Quimby
Editor

xi

Material Culture and the
Study of American Life

Introduction
John A. H. Sweeney

Material culture does not exist as a separate academic discipline. It is an umbrella under which many disciplines coexist for the common purpose of identifying and interpreting man-made objects. The study of material culture may be undertaken by the historian, the art historian, the anthropologist, the archaeologist, any or all of whom may use the research techniques of the social sciences. Museums contribute to the study of material culture by collecting, preserving, exhibiting, and interpreting materials deemed worthy of the effort. These are the practitioners of material culture.

In an effort to explore a subject of significance to the nation's bicentennial celebration, the planners of the 1975 Winterthur Conference chose to focus on the relationship between the study of material culture and the study of American life. Experts from various fields were chosen to address the question: How has our study of artifacts altered our perception of American history? The conference topic reflects and reinforces the Winterthur Museum's continuing preoccupation with the analysis of American decorative arts in terms of cultural history. Since 1952 the Winterthur Program in Early American Culture, a graduate program conducted jointly by the museum and the University of Delaware, has been a focal point of this concern. Three of the speakers are graduates of that program.

The decorative arts are not only decorative; they are often functional. Historical examples represent choices, and, as such, they reflect not only aesthetic preferences but also economic and social factors. Furniture and silver, significant if only for their beauty, are

1

documents to be read by the informed student of material culture. After decades of study of the material culture of the American past—whether architecture or decorative arts, artifacts of prehistoric or historic cultures, above ground or below—the conference provided a forum to analyze the meaning of these varied efforts.

With the provocative title "How Much Is a Piece of the True Cross Worth?" Brooke Hindle describes the visual and psychological impact of historical objects upon society. Three-dimensional survivals provide a means of direct contact with the past. They benefit the historian whose interpretations of the past are presented through the abstract medium of language. If history is the collective memory of a culture, then there should be a partnership of objects and language.

Ivor Noël Hume discusses the growth of the field of historical archaeology. He also demonstrates the relevance of objects discovered in excavations to the specific societies in which they were used. The archaeological process is suggested in his title, "Material Culture with the Dirt on It: A Virginia Perspective."

"Doing History with Material Culture" by Cary Carson offers the point of view of the New History in which the social sciences and the application of quantification techniques are integrated with the study of history. Mr. Carson states that artifacts have rarely been the source of ideas for historians. Speaking as a social historian and illustrating his statements with the results of studies made at St. Mary's City, Maryland, he shows that the interests of some historians are for the first time converging with those of the "thing" people. It is merely necessary to ask the right questions.

James V. Kavanaugh describes the importance of material culture in college teaching in "The Artifact in American Culture: The Development of an Undergraduate Program in American Studies." Accepting a variety of cultural phenomena as artifacts, he outlines their use as the integrating factor in an interdisciplinary course dealing with a multiplicity of perspectives.

Bernard L. Fontana, in "Artifacts of the Indians of the Southwest," deals with the impact of the white man on Indian artifacts. Such changes by Europeans as the introduction of the horse have become so much a part of Indian life that their external origins are often forgotten. With Indians now making Indian artifacts for non-

Indians—and vice versa—the question of what constitutes an Indian artifact is complex in the extreme.

Nathaniel W. Alcock's study of English farmhouses, "Vernacular Architecture: Historical Evidence and Historical Problems," is based on a survey of sixteenth- and seventeenth-century houses in the south and west of England. He suggests that architectural plans depend as much upon economic, geographic, and social factors as upon functional requirements.

Noting the relevance of architectural monuments to the study of material culture, Charles B. Hosmer, Jr., examines the history of preservation in the United States in "The Broadening View of the Historical Preservation Movement." He traces the development from the original concept of a historic building as a shrine or a moral example to the present reliance on professional techniques of restoration so that restored buildings can be used in a more accurate and useful interpretation of the past. Significant in this development have been the architectural research initiated at Colonial Williamsburg and the training of technical experts by the National Park Service.

Neil Harris draws on his knowledge of the American museum movement to describe the museum as a social phenomenon in "Museums, Merchandising, and Popular Taste: The Struggle for Influence." For one hundred years museums, world's fairs, and department stores shaped the taste of Americans by offering examples of material culture to which a materialistic society might aspire. With the disappearance of world's fairs and the decline of the great department stores, museums, in the last quarter of the twentieth century, play a more important role than ever as arbiters of taste.

"Interpreting Material Culture: A View from the Other Side of the Glass," by Harold K. Skramstad, Jr., stresses the importance of the museum exhibit as a medium for communicating to the expert and the general public. The development of an exhibit is an intellectual experience, and the result is a unique cultural phenomenon; there is a consequent responsibility on the part of the historians and curators who conceive it and the designers who bring it to fruition. Citing recent exhibitions which have entailed vast amounts of labor and large sums of money, Mr. Skramstad sug-

gests models in which material culture intersects with history and other disciplines through verbal and visual communication.

In "Clio's Dilemma: To Be a Muse or to Be Amusing," James C. Curtis reports the results of a survey of historical films. Museums and other institutions trying to produce educational films have lacked a sophisticated approach to media interpretations and adequate control over their production. Noting that films affect a wider audience than either museums or history books, Mr. Curtis calls for more attention to historical authenticity and for more precise interpretation. The effective use of slide techniques was demonstrated at the conference by two slide-and-sound presentations produced under his direction, one on the architecture of Frank Lloyd Wright and one on the material culture of the American Shakers.

Arlene M. Palmer, in "Through the Glass Case: The Curator and the Object," identifies the research activities involved in the acquisition, identification, and interpretation of museum artifacts. Using recent accessions at the Winterthur Museum as illustrations, Miss Palmer explains the steps used by curators to determine the properties of artifacts and indicates that attributions are often based on the relationship of one object to others of its kind. While the primary purpose of the curator is to care for and develop information about specific objects, the process is also the foundation for interpretation through exhibits, lectures, and publications.

Scholarly meetings often raise as many questions as they answer, and the 1975 Winterthur Conference was no exception. By bringing together representatives of various disciplines, a variety of attitudes was expressed, including several suggestions that historians, curators, and exhibit designers learn from and possibly collaborate with each other. While disagreements over methodology or direction remain, the interchange of ideas initiated at the conference and perpetuated by the publication of the papers should stimulate closer cooperation between all those engaged in the study of American material culture. If that happens, then perhaps we shall see more valid generalizations about the American past.

How Much Is a Piece
of the True Cross Worth?
Brooke Hindle

To ask the question "How much is a piece of the true cross worth?" may be to wave a red flag before enthusiasts of material culture. It seems to project into the center of concern association objects of limited importance to anthropological archaeologists and to emphasize the doctrine of implicit importance which is anathema to "the new historians." It seems to deny the social-science approach to history with its problem-solving emphasis upon the general rather than the particular.

Yet, even if some may regard association objects as representing the nether end of the spectrum of legitimate concern with artifacts and objects of the past, there may be reason to indulge this question. There may be a very important, if not transcendent, folk wisdom implicit in the popular value accorded relics of the past. Medieval reliquaries are something more than embodiments of a past age of superstition. They answered a deep human need to reach beyond abstraction and myth to reality. The scientific revolution, the Age of Enlightenment, and the revolutions of our own time have not eliminated the need. Indeed, modern man is separated more firmly from the realities of his own world than was man in earlier periods of history. Man's need to touch the past has increased rather than decreased.

The medieval peasant may have known of saints and kings only through the distortions of verbal accounts, but he lived securely

within a three-dimensional world he could touch and feel. Today, electronic media, computers, and punch cards bar us from direct access to most of the people who control the primary aspects of our existence. More than ever it is important to see and to know "the real thing." You may recall that George Orwell's "Newspeak" was a language barrier epitomizing the distortions which separated his protagonists from the real world.[1] Where did they look for the opportunity to reach through distortion to touch the dimly remembered past? The oasis of reality the searchers thought they found was an antique shop. The author's insight was significant.

Americans must not dismiss the endless viewing of Lenin's refrigerated body and the preservation of the bones of saints as alien superstitions. These, like Dolley Madison's gown, Benjamin Franklin's printing press, and George Washington's uniform, are more than curiosities. They provide direct, three-dimensional evidence of individuals who otherwise exist only as abstractions in words, paintings, or monuments.

Novelist Sheila Ballantyne attacked a museum director who failed to distinguish between fakes and genuine articles. "One tends to look longer, and more lovingly, at the real thing than at a fake. In life we are left to make this distinction for ourselves—all the time, in fact. That's precisely why we expect it to be provided for us in places like museums."[2] It does matter whether or not the crown jewels are fakes.

The need to touch reality is real and permanent. The "historical souvenir museum" has an abiding mission, and it is a great mistake to dismiss this mission as an unworthy attribute of elitism.[3] The past has been perceived primarily in terms of the movers and shakers, because our understanding of the past has been expressed primarily in terms of those people. The need, however, is to reach a three-dimensional embodiment of whatever history we accept. The desk at which Thomas Jefferson wrote the Declaration of Independence, Eli Whitney's cotton gin, and Charles Lindbergh's

[1] George Orwell, *1984* (New York: Harcourt, Brace, 1949).

[2] Sheila Ballantyne, *Norma Jean, the Termite Queen* (New York: Doubleday, 1975), p. 116.

[3] Albert Eide Parr, "History and the Historical Museum," *Curator* 15, 1 (March, 1972), 53–61.

Spirit of St. Louis—each connects us with the reality of the histori-
cal abstractions we have learned. Even the more or less anony-
mous period rooms also convey the three-dimensional world of the
eighteenth or the nineteenth century. The hermit's hut preserved at
the Adirondack Museum, though a nonelitist association item,[4]
provides the reality toward which we reach through half-believed
tales of hermits.

At the same time, the fact that three-dimensional objects serve
as reinforcing monuments has questionable aspects. Inevitably,
objects buttress myths. Factually, they neither confirm nor deny
them but, by providing a three-dimensional reality for George
Washington or Martin Luther King, they tend to confirm whatever
the conventional history of the moment says. Thus, these objects
play an important social role in a society whose cohesion depends
upon widely shared conceptual systems.

The professional historian, however, is more sensitive to doubts
about our shared historical concepts than he is to confirmations of
them. His mission is to search for the truths which improve our
vision of the past. How material culture can improve historical
vision is a complex question. Before it can be asked, history itself
must be defined.

History is the collective memory. Like the individual memory, it
is the essential basis for all activity. Like the individual, society
recalls from history whatever information it needs to function in a
given direction at a given moment, and the needs of both individ-
uals and society change. Neither individual memory nor history is
an unordered data bank. Data is recorded with differing intensities
and retained in differing complexes and interconnections. Healthy
memory provides more protection from the erosion of time for
positive events and complexes. It remembers both pains and plea-
sures, but pain and failure tend to be recalled less easily than
pleasure and success.

History as the collective memory calls up interpretations of past
events when they are needed to understand current problems. His-
tory thus provides the dimension of time for all of our thoughts
about the present and the future. This is the reason that each
generation has to rewrite history.

[4] Cold River "Camp" of Noah John Rondeau, Adirondack Museum, Blue
Mountain Lake, N.Y.

In the early years of the United States, a sense of national identity was very much needed. Historians looked for and found details of patriotic achievement, personal sacrifice, and valor. Not long ago the need arose to face America's failure to include blacks fairly and equally in our society. As soon as the need was recognized, historians found much previously unused information about the black past and developed new interpretations.

The interpretations themselves are history and should not be confused with the data bank of past events from which they are drawn. Interpretations are similar to the individual memory which orders the remembered experiences of the past, often without applying a conscious logic, and interprets remembered data to reach overall conclusions which form the base for action and reaction. Individual pieces of data are not themselves significant. They gain significance by their relationships to each other. The individual searches his memory for the meaning of his experiences as they relate to a particular need; the historian searches his sources for the meaning of all the bits of data he can find related to a specific object of inquiry. He seeks meaning, not a parade of presumed facts.

A historian acts as an artist in seeking to abstract meaning from the myriad retained data. With words he constructs abstract conceptual models; he seeks generalization. It is not true that the historian seeks only the unique, only the differences to be found in the past, while the sociologist seeks the similarities. The historian interprets the past, usually in the way an artist interprets character in a portrait.

The fact that the historian nearly always presents his generalization in words is not the important characteristic of history. The important characteristic is that it is an abstraction which is one and often several steps removed from real people and events.

Historians rely upon what may be the greatest of all human inventions, language. Language is a tool of unbelievable power. It exceeds belief to imagine that a few grunts or scratches could convey the structure of a building, or the tactics of a battlefield, or the facets of a human personality. Yet language does just that, not precisely as "it really was" but as the author perceives its meaning. In this sense, language is similar to mathematics, which is also a **tool for using and communicating information but is fundamen-**

tally a tool for ordering and making sense of human experience through abstraction. Mathematical models used by the physicist have the same objective as the models constructed in words by the historian. The abstractness of modern mathematical models, however, is so great that the model makers often find it impossible to visualize their insights in three-dimensional terms.[5]

What is the relationship of linguistic models to the nonverbal, three-dimensional world? Of course, it is a representation or a shorthand. It does not produce a replicated image. What it communicates depends wholly upon the experience and memory bank of the receiver. Thus, the spoken or written word conveys different meanings depending upon the sensitivities of those who receive it. It is often wholly impossible to know what was intended by the writer or the speaker, and often he himself did not know. Great and flexible as the tool of language is, it has enormous deficiencies of which the historian probing the past for meaning is now more than ever conscious.

I had an imaginative third-grade teacher who told her pupils to put their heads on their desks, close their eyes, and picture a field of goldenrod. This seemed a great opportunity because I had heard of goldenrod, which my father thought the source of his allergy and had pointed out from the car. However, it had always been so far off that it was only a distant yellow blur; therefore, the exercise in imagination seemed a chance truly to see goldenrod. The trial failed; there still was nothing more to be seen but a yellow blur.

Actually, much of language relates to nonverbal images. Language floats on top of the material world. It is often inaccurate and imprecise in expressing nonverbal images, and is just as often imprecise in representing the three-dimensional world. But this is not, as some seem to suggest, because writers represent a conspiracy against the three-dimensional world, but simply, that language is not sufficient to deal adequately with the world of material culture.

It is not a new insight that language separates us by at least one step from the real, material world. Especially because the present

[5] Even three-dimensional restoration villages and period rooms represent models separated by abstraction and conjecture from the real world of the past. Darwin Kelsey, "Historical Farms as Models of the Past," *Proceedings of the Annual Meeting, June 16–18, 1974, The Association for Living Historical Farms and Agricultural Museums* (Washington, 1975), pp. 33–38.

world of complex institutions removes the individual from face-to-face transactions which have been a part of most of history, direct contact with the three-dimensional survivals of the past is of utmost importance. The less that contact with three-dimensional past is available, the less direct and usable is the history to which we appeal. Some of America's greatest historians have been very sensitive to the essential need for this three-dimensional experience. Francis Parkman gained something in writing his great histories from walking the battlefields on which France and England contested for empire. Samuel Eliot Morison made the famous *Capitania* cruise in order to experience the seas, the skies, the crossing under sail, and the landfall as Columbus might have known them.[6]

Many of the three-dimensional fragments of past history are preserved through photographs and descriptions. Much of recent history is known through movies and sound tracks. The Colosseum and Roman water pumps may be known before they are seen. The same can be said of the White Tower and beheading blocks, of Faneuil Hall and Samuel Morse's telegraph. What, then, does one gain from actually seeing them?

Probably no one ever saw these things without gaining impressions and understanding very different from what he formerly had. Many have remarked upon this experience but none of the explanations of it are very satisfying. An improved sense of scale is usually mentioned, and, truly, scale does appear quite different from what it may seem in photographs, especially in the case of large objects. Is it colors, smells, surroundings, quality of lighting, texture, or patina? Is it specific dimensions which could have been measured? Specific materials which could have been described in terms of known examples? Is it purely a mystical experience? A sense of communion? Somehow many objects belong to the viewer and are firmly a part of his understanding of history in a way that would have been totally impossible had he never seen them. This is the important and valid insight which folk culture expresses in placing high value upon not only the true cross and the true sword of George Washington but upon the sharecropper's cabin and the manacles of a slave.

Marshall McLuhan has shown that language is linear, progres-

[6] Samuel Eliot Morison, *Admiral of the Ocean Sea* (Boston: Little, Brown, 1942), pp. xvi–xviii.

sive, and logical, while life is complex, multidimensional, instantaneous, and often illogical.[7] The logic of language is imposed by the man who uses it as well as by its own structure. In fact, language is one of man's great tools for reducing illogic and irrationality. But the order and rationality achieved are useful only if the abstractions of language are penetrated by direct knowledge of life's complex multidimensional and instantaneous character. Abstractions are useful only when related to whatever can be found of "the real thing."

Material culture is insufficiently served by language, but language serves broader reaches than objects alone. Knowledge of the cultures of the past is gained, for most people, primarily through language. Interpretations of material culture are stated in terms of language. Yet, verbal records are concerned not only with material culture. They also abstract and interpret many other aspects of the human past. They convey the personalities of men and women, their actions, feelings, and assertions; they convey love, anger, panic, perseverance, and qualities of mind and character but little hinted at in most preserved evidences of material culture. Man's material world has been his environment and his achievement, but it is only one aspect of his history and probably not the most important one.

New patterns of abstraction are emerging in current historical interpretation. Two of these, the New History and "modernization," have a particular relevance to material culture and should be studied in conjunction with material culture history to develop their insights. The New History, which highlights a complex of needs felt by the present generation, and the modernization concept, which has been brought over from the social sciences, both require that new questions be put to history and both need the hard realities of material culture as touchstones.

The New History is a product of need and of newly available techniques and capabilities. A certain segment of historians have long wanted to know better the pervasive characteristics of a culture, its social, economic, and intellectual forces, knowledge of which was previously conveyed largely through words and actions of the great historical figures. The complicated social problems

[7] For example, Marshall McLuhan, *The Gutenberg Galaxy: The Making of Typographic Man* (Toronto: University of Toronto Press, 1962).

inundating the present world lend a sense of urgency to the task of understanding these forces. The collective memory, history, is asked to provide information about common experiences to help modern man to understand the enormous problems of the moment so that he can respond as creatively as possible.

Fortunately, the compelling need is paralleled by new capability, by new tools for organizing and making sense out of enormous bodies of data. Although inspired by the so-called Annales School in France, the New History has been developed primarily by a group of British and American scholars. They have borrowed from the social sciences quantification techniques and applied them to history. They have focused upon localities or, in prosopography, upon groups. The ultimate tool, in ordering enormous banks of data, is the computer, even though not all historians working in this context make serious use of it.

Using social-science quantification and the computer, the new historians have concerned themselves primarily with the elements of culture in an anthropological sense. They tabulate and measure the structure of economic and social life, as well as "collective mentalities" and conceptual frameworks. They find their sources in archival records, in lists of births and deaths, in census returns, in estate inventories, in records of deeds and exchange, and in city directories.

The New History clearly intersects the study of material culture at several important points. Sometimes archaeological data which seem fragmentary can be combined with the data quantitatively mobilized in the New History. Thus Cary Carson's insights about the social organization of St. Mary's City are derived from archaeological evidence of the form of dwellings and other buildings. Ivor Noël Hume has long urged that bottle seals, potsherds, and similar fragmentary combings of archaeology, which themselves convey limited information, may, in combination with archival studies, provide new knowledge about the quality and way of life of groups in specific places at specific times.[8] These intersections hold large promise.

[8] A Report to the National Endowment for the Humanities from the St. Mary's City Commission: The Making of Plantation Society in Maryland: A Research Partnership between History and Historical Archaeology, Sept. 1, 1974; for example, Noël Hume, *All the Best Rubbish* (New York: Harper and Row, 1974).

Material culture, however, has a still larger meaning for the New History, and some of its more sensitive practitioners, such as Jack Greene, have begun to seek it out.[9] The greatest deficiency of the social-science approach to history, and the reason it has been resisted so long by the so-called "anecdotal" historians, is precisely its quality of abstraction. By calculating average family size, intervals between children, and sex ratios and by examining this data in terms of current understanding of child development and psychology, much can be inferred. Still, the conclusions remain abstractions which retain a certain ethereal quality.

This sort of history more than any other requires the direct contact with the "things" of the past which material culture provides. One may interpret the distance between births in a family as postulating a certain kind of family life and even a personality set, but this is an abstraction removed from direct experiential reality. If it can be combined with and found to harmonize with utensils, furniture, furnishings, costumes, and buildings, it may be possible to nail it down and accept it. Otherwise, it may be too abstract to fly very far.

A related interpretive abstraction, now gaining recognition among historians, is the concept of modernization. This is a term introduced from economics, political science, and sociology, in each of which fields it is understood somewhat differently. It remains a bit foggy in its historical applications, but it embraces the processes and characteristics of change associated with the transition from a traditional society to a modern one. More specifically, it is associated with the dominant social structure of western Europe and America between the sixteenth and nineteenth centuries and present-day social structure which began to emerge generally in the nineteenth century. It is particularly useful to focus upon the parallel processes of specialization and integration which mark a modern society and which are always accompanied by tension, conflict, and change. One definition of a modern society is that it is based upon continuing change.[10]

9 Jack P. Greene, "The 'New History': From Top to Bottom," *New York Times*, Jan. 8, 1975.
10 Richard D. Brown, "Modernization and the Modern Personality in Early America, 1600–1865: A Sketch of a Synthesis," *Journal of Interdisciplinary History* 2, 3 (Winter, 1972), 201–228; George D. Rappaport to Brooke Hindle, Oct. 9, 1975.

The concept of modernization has not yet penetrated deeply into historical studies, but it cries out for a material-culture component. The basis of modernization is change related to material culture. The concept will flourish much more fruitfully if it is combined with studies in material culture.

When George Kubler talked about intersections at a Winterthur Conference some time ago, he dealt with the intersections between the history of art and other disciplines.[11] Creative insights are frequent at such intersections or interfaces. The intersection of material culture with the history of art has caused that well-developed minor discipline to move into the broader stream of cultural history. Historians of art emphasize individual creativity with eponymic overtones. However, they have always remained close to the products of art and, as a consequence, are familiar with things through the whole spectrum of art. They can move easily into study of the broad culture.

Other studies related to material culture have been less successful in placing their interpretations within the broad context of cultural history. The history of technology, for example, began even more firmly mired in an eponymic view of history which perceived change in terms of individual inventors. Some disciplines have contributed at intersections to the enrichment of the history of technology, but too few intersections have been explored. The type of insight to be derived was demonstrated when Otto Mayr completed his catalog of feedback mechanisms and thought about them in terms of the larger cultural context, especially economic theory.[12] The concept of Adam Smith's system as a feedback device was, once he stated it, obvious. All sorts of intersections remain to be explored for the insights they may hold.

Despite the great need to place material culture within a larger understanding of history, another need may have equal priority. This requirement is the study of the internal processes of material culture. Process, like social history, has long commanded attention from historians. Again, however, needs of the present demand an

[11] George Kubler, "Time's Perfection and Colonial Art," 1968 *Winterthur Conference Report: Spanish, French, and English Traditions in the Colonial Silver of North America* (Winterthur: Henry Francis du Pont Winterthur Museum, 1969), p. 9.

[12] Otto Mayr, "Adam Smith and the Concept of the Feedback System," *Technology and Culture* 12, 1 (Jan., 1971), 1–22.

increased understanding of process in history. This is nowhere more centrally important than in the realm of material culture. It is not enough just to catalog and to relate our studies to other fields of study and knowledge. It is essential to reach into the internal character and workings of material culture.

Material culture is fundamentally the story of man's physical environment and his manipulation of it. How do the elements of a material culture grow and develop? What are its social and personal origins, and what is its social and personal impact? Viewed in these terms, material culture embraces a large portion of human history, but it is a different portion from that with which we are most familiar.

The processes involved in the unfolding of a material culture may be very different from those that have been most investigated. It seems probable that much of this process is illogical and certainly much of it has been unscientific. It seems probable that the artist who paints or sculpts, the cooper who makes barrels, and the potter who makes ceramics use processes that differ in kind from those of historians or scientists. The former have to see pictures in their minds and perhaps in their material. They must think three-dimensionally, rearrange the elements of a cabinet or a machine in their minds without having to think their way along a linear, linguistic path. The apprentice to a craft is instructed primarily in terms of demonstration, models, and trial. The verbal explanation is often peripheral. Indeed, when a wheelwright or a carpenter describes his craft, a process of translation into words has clearly been involved.[13]

Eugene S. Ferguson has introduced critical examples of "thinking with pictures." He explains that the mental working of the artisan is an intellectual process that has been almost universally denigrated because it is nonverbal. He calls our attention to a particularly prescient passage from a forthcoming book by Anthony F. C. Wallace, who writes, "It has become conventional to assume that the thought itself is merely a kind of internal speech and to disregard almost completely those kinds of cognitive processes which are conducted without language, as though they were

[13] For example, George Sturt, *The Wheelwright's Shop* (Cambridge: Cambridge University Press, 1923); Walter Rose, *The Village Carpenter* (New York: Macmillan, 1937).

somehow more primitive and less worthy of intellectual attention. Those who have thought about machinery have tended to undervalue their own accomplishments, or to deny that it is intellectual at all, and to belittle 'intellectuals' in turn."[14]

These internal processes of mental activity and creativity in material culture require study before their larger meaning will emerge. The large picture probably will show an evolution or process of gradual development with some of the characteristics of biological evolution, including movement toward greater complexity and specialization of both units and components. A few years ago Bruce Mazlish wrote a paper which has not proved to be the stimulant expected. In "The Fourth Discontinuity," he suggested a continuum which includes biological man with all of the material extensions by which he has manipulated his environment.[15] The point he makes is that there is not a sharp line between man in his biological state and his repairs such as gold teeth, plastic blood vessels, or pacemakers. It is then just another short step to include in the continuum costume, shelter, transportation, and man's endless variety of tools. The question is not whether man and his material extensions actually constitute a continuum but why no one is even speculating about man and the evolution of his material culture.

What about the eponymic elements of the history of art and the history of technology when confronted by the anonymity and abstraction of the New History? Indeed, many in the field of material culture, whether unavoidably or intentionally, work with the anonymous rather than with well-known individuals. It is, nevertheless, important to know individuals and individual contributions and not to work only with averages or anonymous potsherds. Detailed studies of individuals need not be eponymic even though they pertain to association pieces with some of the characteristics of the true cross.

Current studies of Eli Whitney provide an example. Written accounts and verbal reports of his assembling muskets from a

[14] Eugene S. Ferguson, "The Mind's Eye: Nonverbal Thought in Technology," *Science*, in press; Anthony F. C. Wallace, *Rockdale: The Growth of an American Village in the Early Industrial Revolution, 1825–1865* (New York: Knopf, forthcoming).

[15] Bruce Mazlish, "The Fourth Discontinuity," *Technology and Culture* 8, 1 (Jan., 1967), 1–15.

great number of interchangeable elements once seemed to identify him as the inventor of interchangeable parts. The written record may have yielded most of what it can say on this point. Archaeology may have more to report, although the New Haven digs of 1974 and 1975 offer nothing directly related to the question of interchangeable parts.[16] Indeed, they offer little that is new beyond information about the layout of the factory buildings and confirmation of some of the written reports.

The most important investigation so far is Edwin A. Battison's analytical study of a Whitney musket. It remains a model that could serve in most realms of material culture. It demonstrated the type of machinery used. It showed the use of a hollow mill. It also revealed the filing and fitting required to make parts fit and the fact that parts were fitted to only one musket; they were not interchangeable. Interchangeable manufacturing was not achieved instantaneously but grew slowly. Merritt Roe Smith documents the actual achievement of interchangeability at Harper's Ferry. The important result is not the reduction of Whitney's role, but an improved understanding of process in the entire arms culture.[17]

Because objects are a source material, an additional word must be said about their documentary role in material culture. As source material, the objects of material culture as well as all available information found about them must be preserved. They have to be regarded in the same light as archives or manuscript sources and must be accorded a degree of sanctity to preserve them against assault. After information is extracted from them they cannot be simply discarded.

Just as in the case of manuscripts, future generations will have to return to these material sources to ask of them questions that cannot now be predicted. The questions will depend upon the needs of future societies. In addition, future techniques and tools for extracting information may well be superior to those of today.

[16] See T. Allan Comp, "New Evidence on the American System in Eli Whitney Armory Site," *Historic American Engineering Record* C7–2, Jan., 1975; Michael Knight, "Industrial Archaeology: A 'Dig' for Eli Whitney," *New York Times*, July 28, 1975.
[17] Edwin A. Battison, "Eli Whitney and the Milling Machine," *Smithsonian Journal of History* 1, 2 (Summer, 1966), 9–34; Merritt Roe Smith, *Harper's Ferry Armory and the New Technology* (Ithaca: Cornell University Press, 1977).

Consequently, the absolute need to keep and preserve material sources, and to study and catalog them for continuing interpretation must be agreed upon.

The more difficult question is how to decide what should be preserved. Obviously everything cannot be. Indeed, more material objects are being produced today, and destroyed, than ever before in history. What should be saved? One suggestion, not really a counsel of despair, is to make an absolutely random collection, assuming that there is no means of knowing what to preserve and what to discard.[18] This approach is wholly uncongenial not only with collectors' impulses but the impulses of all scholars working in the field of material culture. The only recourse is to use the best possible present judgment as to what to preserve and what to discard.

The degree to which objects have been reduced to order is very limited. Even those now preserved in well-ordered museums are, for the most part, not well cataloged or readily accessible to study. For instance, the National Museum of History and Technology has only now attained the capability of accessioning and cataloging the objects currently received. The magnitude of the task of assimilating the millions of objects already at hand, and not satisfactorily recorded, has no obvious solution. The problem should be seen from the viewpoint of the twenty-first century. Thus, the first priority is to preserve what should be kept for the future in the best possible order. After that, and with a lower priority, come the various studies of material culture which have been discussed here.

Some progress is being made in preservation, internal study of material culture, interdisciplinary studies, and synthesis of overall meaning. But the profession should be "honest and modest" about what has been accomplished. Directions for further study are about all we have.[19]

Perhaps some of this modesty should be expressed about current exhibit aspirations, all of which build upon the corpus of material culture. There seems to be near universal agreement that museums should teach and that exhibits ought to interpret not only the

[18] Cyril S. Smith to Brooke Hindle, Nov. 19, 1974.

[19] Phrase from Bruce Sinclair, Norman R. Ball, and James O. Peterson (eds.), *Let Us Be Honest and Modest* (Toronto: Oxford University Press, 1974).

whole realm of material culture but the course of history to their visitors. What should be taught and what interpretations should be offered is much less clear. Indeed, some advocates seem not to care in the least about the message; they tout only the medium.

The profession must be careful about teaching and interpreting without something to teach. Systematic or taxonomic exhibits can be put together in traditional fashion following the natural history or evolutionary approach. Another level of exhibits, fortunately, is also possible. This is the presentation of the period room, or of the environment in which objects were used including the so-called living museum. Such exhibits are readily developed and can be placed successfully upon foundations already at hand. They contain limited interpretation.

This, however, is not what is meant by teaching and interpretation by those who urge the need for museum teaching. Here, one must tread warily. Very few satisfactory exhibits of this type have been developed, and the danger is that the demand for teaching may lead us to use objects as mere illustrations of interpretations unrelated to material culture. The need is for interpretative exhibits growing out of the study and understanding of material culture. They may well show intersections of material culture with politics or economics, or they may show the internal processes of material culture.

Indeed, the objects of material culture must be used to illustrate and illuminate the conventional interpretations of our history. This, after all, is the valid lesson to be drawn from the folk value placed upon pieces of the true cross. There is a great and growing need to offer a wide audience opportunities to see and to know the things of history—both prime association objects and anonymous tearings from lost worlds of the past. The importance of being able to reach the past through material culture can never be overemphasized.

In the present state of our understanding of material culture, however, such opportunities ought to be offered with very spare interpretation. They ought not be associated with ranges of peripheral objects swept up in the hope of using the exhibit medium to illustrate historic syntheses derived from the written record alone. This would be to demean the value of collections of objects and to reduce them to the level of illustrative material.

Such exhibits would be akin to books written by historians whose sense of the three-dimensional is entirely abstract and who have engaged others to garnish their texts with appropriate illustrations. Exhibits should grow out of and present the best insights of material culture. They should not be viewed as simply a different medium for teaching the same lessons already available in books, plays, and movies.

This view, of course, asserts that those who study material culture have a more fundamental mission than marshaling objects or producing exhibits. The mission, to integrate the three-dimensional remnants of our past into new historical syntheses, if fulfilled, will provide the historical understanding we lack today. They will then have the capability to produce the interpretive exhibits that we all seek and that their teaching mandate requires.

The mission is a great one. Even the beginnings so far registered are exciting. They point to the fulfillment of the deep-running need of this generation and those to come for a better history of their past which is both true and useful. It will be truer and more useful than the present histories precisely because its abstractions will be tied by an intricate web to the real world of material culture.

Material Culture
with the Dirt on It:
A Virginia Perspective
Ivor Noël Hume

Academic terminology has a way of grabbing the past by the scruff of the neck and squeezing the life out of it. Of course, I fully recognize the need for, and the value of, the term *material culture* —after all, if we are to be taken seriously, we must use terms that are sufficiently abstract and scholarly to be accepted by traditional historians. About eighteen years ago a member of the history department at the University of Delaware scornfully dismissed the work of the social historian as "pots-and-pans history"; today we would call it material culture. As a so-called "archaeologist" working with the material remains of the post-medieval or, in America, the historical centuries, I am not offended by the term "pots-and-pans history." Pots and pans evoke the idea of cooking, of smoke grasped by breezes and carried away over the trees and rooftops, creating aromatic smells to titillate the palate. And pots and pans have sounds of their own: a wooden spoon beating against the side, the clatter of crockery in the hands of a scullery maid. These and a dozen other lively images are instantly brought to mind— and *lively* is the key word, for these pots and pans are echoes from the life of the past.

Traditionally trained museum scholars may not agree with nor even understand what I am talking about. If one has never had the

opportunity to set foot in the past, and to see one's museum objects as their contemporary owners left them, it is hard to visualize "things" as anything but themselves or, at best, as theatrical properties on a painter's canvas. We measure our accessions, analyze and identify the materials from which they are made, photograph them from every conceivable angle, even examine their innermost secrets by X-ray; and yet at the end of it all we find ourselves with an object—and a catalog card. The card goes into a file, while we congratulate ourselves on the number of cards we have managed to complete in a day or a week. The object may be assigned to a storeroom shelf to languish for another eternity, or it may be placed in a case, beautifully lighted and designed, where the public will admire it—if only because it must be worthy of praise; otherwise we would not have gone to such trouble. Then again, the item may be placed in a period setting in juxtaposition to other objects that it has never met before in its life, but which together comprise a curator's view of "the way it was" at this or that moment in time.

The word *authenticity* is vastly overplayed; it has been dirtied by hucksters and by fools. And yet we all recognize that when we really have it, we have something beyond price. The archaeologist has more opportunities to grasp it than any other group for whom the past is a profession. He sees things as they were. When, for example, Auguste Mariette entered the Serapium at Saqqara, Egypt, in 1852, he found the footprints of the retreating burial party clearly visible in the sand on the tomb floor. Time had been arrested. The chamber looked precisely as it had when the light from the last flickering bitumen-tipped torch receded, leaving the tomb in darkness for nearly three thousand years. For those footprints in the sand, there was nothing to indicate that the figure holding aloft a similar torch in 1852 was not a member of the burial party returning after a lapse, not of millennia, but of as many seconds.

I confess that the point is not always as graphically made—if it were, I might not be citing an 1852 example—yet it does occur whenever the archaeologist turns the pages of the earth. Whether or not he is able to make good use of these revelations depends on his competence to read the words recorded on those pages. It was for this reason that I rather hesitantly referred earlier to the "so-

called archaeologist. It was also why I chose an Egyptian tomb as an excursionist's destination aboard the archaeological time machine. Egypt is the ultimate and ever-persistent archaeological cliché. In the popular mind, and certainly in that of the cartoonist, archaeology and Egyptology are synonymous.

Government agencies in this country and elsewhere have been known to confuse seniority with competence; an archaeologist who has managed to keep his trowel clean (possibly by not using it) for an impressive number of years, may be assumed to be capable of directing a major project, regardless of whether or not his knowledge and experience have been acquired in that field. Thus a specialist in American Indian cultures in the Southwest may be invited to direct the excavation of a seventeenth- or eighteenth-century town site in the erstwhile British colonial East. One might suppose that anyone with anything but sand in his head would recognize the fallacy of such an arrangement. Unfortunately, many sensible people do not, and archaeologists have been among them. Furniture specialists, for example, would not have much respect for allegedly authoritative opinions on the merits of Philadelphia highboys voiced by a curator of ceramics specializing in English phrenology busts. It is imperative, therefore, if we are to accept the thesis that an archaeologist has something important to contribute to the study of material culture, that we first have confidence in his knowledge and in his judgment.

When archaeological excavations began in Williamsburg in the late 1920s, it was recognized that a professional archaeologist was needed. Employing what was then unimpeachable logic, the chosen individual was about to be associated with a well-known American university's archaeological program in Egypt. In attempting to reconstruct the history of Williamsburg's archaeological program, I needed to know whether this man was, in fact, an archaeologically trained Egyptologist. It happens that Egyptologists come in three varieties, two of which need have nothing to do with archaeology in the digging sense—namely, art historians and epigraphists. To solve my Williamsburg problem, I first talked with an Egyptologist who turned out to be an art historian. He assured me that my man was not an Egyptologist at all, but simply a draftsman.

This "draftsman" was actually in charge of the university's fieldwork in Egypt in 1930 and 1931, which did not make a great

deal of sense if he was not an Egyptologist. A letter of inquiry to the university brought confirmation that the man was indeed a draftsman rather than an Egyptologist. Nevertheless, that same institution had published his two-volume report on one of Egypt's most important Old Kingdom tombs. Why, one wondered, was so important a task put in the hands of a mere draftsman? An Egyptologist of the archaeological persuasion explained it this way: The report on the tomb provided first-rate drawings and plans; it included impeccable architectural descriptions, but it offered no interpretation. It is, she said, the ability to interpret as well as to record that distinguishes the Egyptologist from the draftsman. It is, in fact, a distinction that identifies good and bad archaeologists in any period, and it does so far more effectively than a consideration of whether he is paid for what he does (and is thus a professional) or whether he does it for the love of it—in which case he stands the danger of being branded an amateur.

It turned out that our man in Egypt was employed not in digging on ancient sites for new information, but in measuring and drawing already exposed monuments, a task for which an architectural draftsman was likely to be better equipped than an epigraphist or a straightforward digging archaeologist. Nevertheless, in this country, in 1930, that man was considered to be an Egyptologist, and therefore an archaeologist.

Williamsburg's early restoration architects were only able to judge the competence of an archaeologist by the quality of his architectural drawing, which had nothing to do with his ability to interpret the archaeological remains of the American past. In those days, of course, the only archaeological remains that mattered were architectural: building foundations, window glass, hinges, nails, wall plaster. Fragments of pottery, glassware, clothing accessories, cutlery, food remains—none of those spoke to the archaeologist; or, to be more precise, the archaeologists could not hear them. These men were looking at the seventeenth and eighteenth centuries A.D. much as antiquaries looked at Egyptian inscriptions of the seventeenth and eighteenth centuries B.C., before Champollion le Jeune opened their eyes.

It is inevitable that what we do not understand we cannot fully appreciate. Consequently, the retention of artifacts from early excavations on American colonial sites was capriciously selective.

Objects that were well preserved, interesting in appearance, pretty, and easily recognizable, were more likely to be retained than were things broken into very small pieces or obscured by corrosion. It is equally important to recall that those artifacts that were retained were considered to be self-explanatory. Their relationships to each other and to the layers of the ground in which they had lain were rarely, if ever, recorded. And without that information an excavated artifact is little more than a collector's item, barely better than an anonymous antique purchased from a dealer who declines to reveal where he got it.

It is important to understand that archaeological reasoning develops around one's ability to establish a chronology of events—not a chronology of stylistic evolutions. Once we know, for example, when a house was built and when destroyed, we can begin to interpret the life that existed there between those termini. There is nothing very profound about that. As in any other discipline, one must first isolate and define the problem before attempting to solve it.

Here is an example of archaeological reasoning: Three joining fragments of a Rhenish stoneware chamber pot are found on a site, but they have been recovered from different locations and at different levels (Fig. 1). The sherds are, in fact, three out of thousands, all of which must be sorted and cross-mended once the excavation is finished. First, however, each fragment is marked with a number identifying its archaeological placement on the site. Thus, the cross-mending serves not only to reconstruct shattered objects, but also, and much more importantly, to establish associations between numbers. Of the three Rhenish stoneware sherds, one was found beneath the original foundation of a house and must, therefore, have been deposited before the house was built. The second comes from the upper filling of a well, which indicates that the shaft had ceased to perform its intended function before the potsherd was thrown into it. The third piece was found in the silting of a shallow ditch. On the evidence of this juxtaposition one can deduce that the well was out of use by the time the house was built; therefore, if we are reconstructing or restoring the building we should not do the same for the well. On the other hand, the ditch might be contemporaneous with the construction date of the house, but the sherd's placement high in the silt indicates that the ditch did not

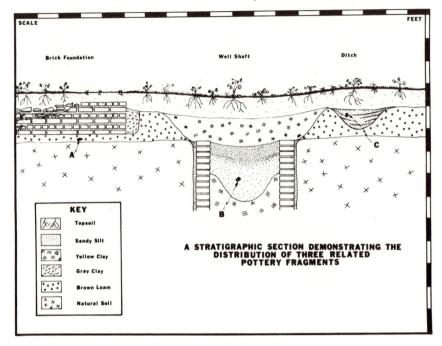

Figure 1. A stratigraphic section demonstrating the distribution of three related pottery fragments. (Drawing, Leonard Winter.)

long remain in service. Consequently, if the house is to be furnished to reflect the occupancy of one of its later owners, the ditch should not be visible.

It is true that one can conceive of circumstances that would cause the redistribution of the three sherds after the pot's original breakage, and thus invalidate the house-well-ditch relationship. Consequently, the more cross-mends one can establish, the more defensible one's conclusions become.

To arrive at *any* archaeological conclusions, it is necessary to be able to establish a chronology based on the dates *when*—when this cellar hole was dug, when that ravine was filled in, when this maidservant dropped the delft bowl. Unlike the prehistorian, the historical archaeologist digs as often and as deeply amid history's documentary detritus as he does in the earth. Historical archaeologists must, and do, use written sources, employing them to rebut or

modify previous archaeological conclusions, or to be themselves confirmed or enriched by artifactual evidence. Indeed, I prefer to call those who follow this calling archaeological historians. They provide documentary social history with a new dimension. There are many times, however, when the documentary sources let us down; in fact, when one is studying colonial and even much later daily life, precise answers to specific archaeological questions are all too rarely found in written sources.

My wife dug a vegetable garden to the east of our house a decade ago, and thus created an archaeological feature. But trees grew up on our neighbor's property and cut off the light to the beds. Consequently, my wife abandoned the garden after six seasons, and, because good topsoil is rare and valuable in our area, she shifted it from the old beds to the new location. The old garden then became a large depression that was left to grow back into woods. All this was a major undertaking; it had a visual effect on the property, first as a cultivated area and then as a location whose contours had been changed. If, in fifty years time, anyone should try to reconstruct the life or the environment of this household, there will be not one documentary reference to help identify or date that landscaping change. The shifting of the soil from one place to another will have to be deduced on the evidence of matching fragments of domestic trash found in the new bed and fortuitously left behind in the old. Accurate dating will depend on the archaeologist's ability to correctly date a plastic cup or the neck of a Gordon's gin bottle. Of course, such an exercise seems mildly ludicrous, and the assumption that the future will care about us smacks embarrassingly of arrogance. But wouldn't they all have said that?

Having spent a considerable amount of time, effort, and money on the excavation this past summer of a Williamsburg well, filled between 1928 and 1931, and having found how difficult it is to find documentary dating for even the artifacts of our childhood, the need for material culturalists to record the life of our own time seems perfectly reasonable.

One has only to read the daily papers to be reminded that the printed word cannot be assumed to be as holy writs inscribed on stone, ten at a time. Words are designed both to inform and to deceive. More often, however, the deception is the result of omis-

sion, and the blame, if any, rests with the historian who fails to recognize that only part of the documentary story survives. Thus, for example, the documentary history of the James Anderson House in Williamsburg indicated that before being occupied by Anderson it was operated as a tavern by Christiana Campbell from 1760 until 1769, and that in 1771 Anderson leased it to another tavern keeper with the splendidly allegorical name of William Drinkard.[1] In a tape-recorded summary of the house history, I have been guilty of telling thousands of Williamsburg visitors that the Anderson house, which survived until 1842, was the same house previously used as a tavern. Archaeological evidence has demonstrated that this was not true. A single fragment of English creamware found under a brick drain leading into the cellar, and almost certainly contemporaneous with the building's construction, told us that it could not have been built before creamware arrived in the colony. So far, the earliest recorded examples of creamware in the colonies occurs in 1769.[2] It follows, therefore, that if Mrs. Campbell occupied the house for nine years beginning in 1760, and we have archaeologically arrived at an original construction date for the now reconstructed building of circa 1769 or later, the Campbell and Anderson houses are not the same. Subsequent digging revealed debris of a dismantled domestic structure in the shape of beds of whitewashed wall plaster and deposits of brick rubble (some of it burned), all pointing to the destruction of a building on the site after about 1770, and before the commencement of James Anderson's blacksmith's shop which we know was active on the property during the American Revolution. Consequently, a void in the historical record between the residency of William Drinkard in 1771 and Anderson's documentarily established presence on the site during the Revolution leaves a gap of more than four years wherein the old house could have burned or been pulled down to be replaced by the building that we know

[1] Mary A. Stephenson, "James Anderson House, Block 10," research report (Colonial Williamsburg Foundation, 1961).

[2] For details of an order of Martha Jacquelin of Yorktown dated Aug. 14, 1769, see Frances Norton Mason (ed.), *John Norton & Sons, Merchants of London and Virginia* (1937; reprint ed., New York: Kelley, 1968), p. 103, as quoted in Noël Hume, "Creamware to Pearlware: A Williamsburg Perspective," in Ian M. G. Quimby (ed.), *Ceramics in America*, Winterthur Conference Report 1972 (Charlottesville: University Press of Virginia, 1972), p. 227.

Anderson occupied until his death in 1798. Without the archaeological evidence, there would have been no reason to assume that Mrs. Campbell and James Anderson were not occupants of the same building. It is, one might add, a cardinal rule of archaeological, historical, and particularly architectural reconstruction that while one may cautiously *assume* the obvious or the commonplace, anything else requires solid proof.

It is obvious enough that ground built up in a series of layers represents events having a built-in chronology, the stratum at the bottom (sealed by those above) must have been deposited first, while the layer at the top came last. But first and last relate only to each other; they are not anchored in historical time. To fix the site in time, the levels must contain artifacts, and we must be able to determine accurately their dates of manufacture. The fragment of creamware under the brick drain at the James Anderson House would have told us nothing had we not been able to identify it as creamware and to have done enough documentary research to know approximately when it arrived in colonial Virginia.

Here we find the classic chicken-or-egg situation. Artifacts create archaeological chronologies, but archaeology establishes artifactual chronologies. They are interlocking, they breed, they grow out of each other. In my view, archaeology is a means to an end; it should never be an end unto itself. One digs to answer questions, not to find questions to ask. Admittedly, exceptions occur when a site is destined to be destroyed; then the recovery of raw and incomplete data is better than losing it altogether. But under normal circumstances, the archaeologist, with the help of appropriate specialists, is employed to provide needed information, just as fingerprint experts are brought to the scene of a crime to help identify criminals, not merely to add to the police department's print collection. Having indicated, however briefly, the way in which the past's archaeological prints are collected, let me now move on to consider those who use them.

First and, from the public's point of view, foremost, the restorers, furnishers, and interpreters of historical places benefit directly from the work of the historical archaeologist. They put the past to work in a practical sense. They are interested in the big picture and all its components. Without these mission-oriented sponsors, historical archaeology would still be mewling in its

swaddling clothes. At the same time, however, the history of restorational archaeology has been one of solving specific problems with all reasonable dispatch, allowing far too little time for the extraction and interpretation of everything that a site may be capable of revealing.

Next come the institutions where archaeology is undertaken for its own sake, the work blissfully unfettered by the needs of architects or museum personnel eager to start feeding large numbers of visitors in and out of a building not yet reconstructed or restored. Archaeologists who enjoy the luxury of pleasing no one but themselves are prone to describe their contributions as pure research. But because research for its own sake can be never-ending, there is a danger that a lack of deadlines or any necessity that a problem be solved removes the incentive to arrive at a recognizable end product.

A third group, barely worthy of consideration were it not for the damage it does, uses the products of archaeology for personal gain. This group consists of the collectors and dealers who enrich themselves through the looting of sites, particularly those of shipwrecks which, in the proper hands, can offer contributions to material culture unparalleled on land.

Fourth, although not in order of importance, come students of "things," museum curators and collectors whose primary concern is the analysis of historic objects and their presentation to their peers and to the public. Although the first group tends to refer to its venue as the *living* museum, it is doubtful whether the "thing" people would want to define themselves as the scholars of *dead* museums. But no matter how we define them, historical archaeology offers new sources of knowledge and new lines of research for both the "thing" people and the "people" people.

The discipline of historical archaeology developed in a rather undisciplined way. Through trial and many an error, architects and curators began to extract information from the ground in ways that gave them what they knew they needed. But because their goals were limited, their techniques were equally modest and the loss of historical data immense. It was inevitable that eventually, the only people trained to examine the American past archaeologically, the prehistorically oriented anthropologists, would enter the field and bring their archaeological expertise to bear on the colonial period

and later centuries. Commenting on the abilities and goals of these scholars as he saw them in 1955, J. C. Harrington (who many rightly consider the father of historical archaeology in America) had this to say:

> Some were just in need of employment; some saw these projects as contributing to American Indian studies. Few had any real familiarity with the cultures involved or with the intricacies of historical research.

Harrington went on to call for the training of specialists, but he doubted that such a solution was practical at the time:

> Even if they could be trained . . . we cannot expect a single individual to be qualified to excavate and interpret cultural remains so varied and so complex as those represented in this country any more than we would consider an Egyptologist qualified to excavate in the Roman Forum. Yet we send out an archaeologist to investigate a seventeenth-century English plantation site, a Civil War fort site, or a Hudson's Bay post, naively assuming he can do the job because he has successfully excavated prehistoric Indian sites.[3]

That was still the way it was in 1956 when I first came to Williamsburg, and it remained so for several years thereafter. I knew that Harrington was right, and that he was equally correct when he asked "What have these excavations at historic sites contributed to American history?" and answered "Their contributions to *historical data* are considerable; to *history* relatively little."[4] Twenty years later it is the anthropologists who are asking this question, and they direct it primarily at me as an ogre who through the 1960s persistently urged that they learn to use historical records and to read the evidence of the artifacts before they disturbed historical sites. This is not a forum in which to debate the relative values of so-called historical and anthropological approaches to an understanding of the past. Nevertheless, some attention to the unnecessarily opposing views is relevant for two reasons: (1) because they are allowed to be unproductively divisive, and so reduce the volume of the archaeological contributions

[3] J. C. Harrington, "Archaeology as an Auxiliary Science to American History," *American Anthropologist* 57, 6, pt. 1 (Dec., 1955), 1121–1130.
[4] *Ibid.*, p. 1124.

to material culture; and (2) because it is necessary to demonstrate the kinds of reasoning used in extracting archaeological information.

Anthropologist John Cotter has frequently condemned the work that my colleagues and I have been doing in Williamsburg on the grounds that I do not "comprehend the anthropologist's objective of discovering patterns of associations between peoples of one site and those of other related sites." Lyle Stone, anthropologist at Fort Michilimackinac, puts it even more strongly (although he cautiously attributes his charge to Cotter): "Noël Hume's failure to comprehend anthropological objectives deprives his work of relevance to the interpretation of anthropological problems." While preparing this contribution, I wrote to John Cotter and asked him to define how anthropological problems can be separated from those of the historian. He agrees that they cannot, but he insists that it is the quantitative approach of the anthropologist that makes his thinking and his conclusions different from those of the

> traditionally trained historians who simply record the dicta and opinions of the historical past and of their peer historians and "interpret" history with reference to their own interests at the present time.[5]

Because, in my own publications, I have not demonstrably made use of quantitative data, Cotter and his colleagues assume that I deny its usefulness. Nothing could be further from the truth, as those on the Williamsburg staff well know; they spend weeks, often months, examining every fragment from a site to arrive at a total number of objects represented in each and every deposit, and to attempt to perceive trends and relationships suggested by the products of one site in relation to another. When each half-acre lot can be expected to yield close to 200,000 artifacts, this is no mean undertaking. But quantitative data should never be used blindly; and it is certainly no substitute for basic historical knowledge. Furthermore, its intelligent use requires that it be preceded by

[5] John Cotter, review of *Historical Archaeology*, in *American Anthropologist* 71, 6 (Dec., 1969), 1216; Lyle Stone, *Fort Michilimackinac 1715–1781, An Archaeological Perspective on the Revolutionary Frontier* (East Lansing: Michigan State University Museum, 1974), p. 3; Cotter to author, Aug. 6, 1975.

sufficient, unimpeachable statistics to establish the norm, and that the sampling be large enough to overwhelm unrecognized anomalies. (Elimination of the anomaly may not be an altogether desirable goal; it has Orwellian implications that I find disconcerting. If, in our quest for the group norm, we lose sight of the individual and the anomalies that make him so, we are in danger of rejecting archaeology's greatest potential, to wit: the opportunity to reach out to the individuals who made the American colonial experience.)

Returning to current Williamsburg excavations, for an example, the James Anderson site was supposed to have been occupied throughout most of the 1760s by tavern keeper Christiana Campbell. Excavations to the west of the property show that during her presumed occupancy the ground fell away sharply and that the slope was slowly built up by deposits of domestic trash. There was much pottery, predominantly delftware, and large quantities of faunal material, but so far, the identifiable remains of only thirty-three wine bottles. This figure is considerably below what one would expect of a tavern. Indeed, many a private dwelling site has produced vastly more. A cellar under the present United States Post Office contained 1,138 wine bottles; the John Custis well gave us 95; a ditch behind the Chiswell house held 104; and Wetherburn's tavern produced 47 deliberately buried in the maturing of cherry brandy or brandied cherries—excluding those that were broken and scattered about the lot. The Anderson site has given us 15 drinking glasses from the Christiana Campbell period, as opposed to 124 from Wetherburn's tavern in approximately the same period. In short, therefore, the presently available archaeological evidence points more toward eating than drinking. The as yet unanswered question is "Why?" But the evidence asks it loud enough to merit a careful investigation of Mrs. Campbell's activities in Williamsburg in the 1760s. Are we right in calling her a tavern keeper throughout that period if we cannot *prove* that she had a tavern license? Could she have simply been a lodging-house keeper? That would certainly explain the many bones and the relatively small number of bottles and glasses. Was she really on the Anderson lot throughout the years embraced by the extant records? This recent example simply demonstrates the kinds of research that can be generated by a quantitative approach coupled

with a basic knowledge of what to expect. It is essential, of course, that the statistician first be able to recognize the glass and bottle types that relate to the Christiana Campbell occupancy.

The same is true of the archaeologist who must be able to read the artifactual evidence as it is uncovered in the ground. This brings us full circle. Before we can interpret the "big picture" we must first become thoroughly familiar with its components. My own published work has been largely directed toward compiling the dictionary that others may use in putting together what will ultimately prove to be more impressive and more valuable propositions and conclusions. Harrington can legitimately look at our efforts in Williamsburg twenty years after he read his landmark paper to the American Anthropological Association and say that our contributions to historical data have been considerable but to history relatively small. In other words our contributions to knowledge of materials has been greater than our contributions to material culture. But aren't we simply playing with semantics? Can we really draw a line between a corpus of data and a paragraph of history? Can we really say that refining a typology of English drinking glasses is any less valid a contribution to material culture than is, say, an analysis of the Irish glass trade in the late eighteenth century? The answer is "yes" if, having drawn all our wine glasses, we then pack them away and promptly turn our attention to the evolution of Welsh love spoons. If, however, we go on to use our wine-glass chronology to better define and analyze what the overly cute might term the wine ceremony, we *are* contributing to material culture. If not, we are back to "pure research," something for which very few mission-oriented archaeologists have the time.

Suppose, for example, the superintendent of Fort Fussocks National Park contracts to obtain information about the placement of a palisade ditch. The project is estimated to take X amount of time and Y amount of money. In the course of the digging, however, the excavators come upon fragments of a ceramic type in a tightly dated context that may revolutionize previous thinking regarding the production and import dates for that ware. But one occurrence is not enough. Before he can disseminate this potentially important information, the archaeologist must find other instances that previous excavators have failed to publish or perhaps even to recognize. This takes time, time to travel, time to

pursue the clues wherever they lead him. But he is not paid to do that. He is there to provide a ditch plan. The ceramic information will not affect the placement of the reconstruction, so it is pushed onto the back burner in the hope that some day, somewhere, under some other aegis, the opportunity to continue the research will present itself. In the meantime, other excavators, whose thinking and conclusions might well be influenced by the availability of that piece of half-digested knowledge, go on without it and go on making mistakes.

There is, alas, no easy solution to that problem. Restoration projects are still the primary sponsors of sustained programs in historical archaeology and, very properly, their material needs must be served first. Providing our record keeping is sufficiently accurate and our retrieval systems efficient, the information is there for those who have time and the need to answer broader questions. That, of course, is at best a face-saving rationale. In truth, any restoration project claiming to show the public what it was like to live at some other moment in time is delinquent if it fails to assemble every available scrap of evidence and pursue every research avenue—if only to *prove* that they lead nowhere. The need is less obvious, if it exists at all, when a building is restored for adaptive use; then the commitment to salvage all available information is more a moral than a practical necessity.

A visiting architectural historian recently told a colleague that he was not in the least interested in archaeological evidence, only in standing buildings. A myopic archaeologist might claim the reverse. Both would be unconsciously declining to contribute to the study of material culture, for in my view, failure to consider every aspect of life is a rejection of the goal of recreating life as it was lived. The collector or curator who specializes in porcelain without caring about the people who made, sold, and used it is in love with objects, not with life. Samuel Johnson is credited with coining the well-known eulogy to the artifact: "I am not yet so lost in lexicography as to forget that words are the daughters of earth, and things are the sons of heaven."[6] It is a questionable thesis, although it is certainly one that most museum curators prior to World War II would have endorsed. The architectural historian

[6] Samuel Johnson, *Dictionary of the English Language*, 2 vols., 3d ed. (London: A. Miller, T. Longman, J. Dodsley, et al., 1765), preface.

who admits to being interested only in standing buildings is contributing to the deification of things for their own sake as is the archaeologist who is interested only in mechanically recording the interrelations between artifacts and stratigraphy and considers his task done when he has established the date when this or that was thrown away. Both are equally guilty of missing the point.

At Colonial Williamsburg, we are all, from our differing points of view, concerned with the accurate interpretation of the quality of life. Thus, for example, through a careful comparative examination of the material remains of life as it was lived at the Governor's Palace, at Wetherburn Tavern, and at the foundry site of metalworker James Geddy, we detect similarities suggesting that many of the ceramics and glasswares used in all these establishments were strikingly similar. Why?

Why not? The Governor's Palace was home to many people beside the governor, people of differing taste and economic status, which means that the potsherds found in the garden may just as well have come from the quarters of housekeeper Anne Ayscough as from the dining room of Governor Fauquier. Although Governor Dunmore owned his own armorial Chinese porcelain (the evidence for which was provided by archaeology and not by documentary sources), the field of eighteenth-century ceramics did not offer a range of wares catering to each stratum of society. It is true that a man of wealth would possess silver or silver gilt for formal occasions, but there was no reason for him not to be content with plain creamware at others. Indeed, in colonial Virginia, the choices were limited, and London taste less readily translated than in colonial centers less dependent on a crop-bound, plantation economy. Eighteenth-century Williamsburg was never a cultural center on a par with Boston, New York, Philadelphia, or Charleston. Those who assume that it was have been misled by an almost irrelevant factor—the accident of survival. Just as the discovery of the tomb of an unimportant boy king in the Biban El-Malouk in 1922 made the name Tutankhamen synonymous with everything Egyptian, so the survival of much of eighteenth-century Williamsburg into the twentieth century attracted the attention of John D. Rockefeller, Jr., and made its restoration the layman's epitome of colonial America.

Several years ago, when the archaeological excavations at Mich-

igan's Fort Michilimackinac were in an early stage, an excited historian wrote to us saying that something totally unexpected was happening; archaeologists were unearthing a "Williamsburg on the frontier," a claim based on the fact that the ceramics, glassware, and other artifacts unearthed there were comparable to those previously found in Williamsburg. Had Fort Michilimackinac been explored in the 1920s, the reverse might have been claimed. Williamsburg was being proved on the basis of its excavated artifacts, to have been no more affluent or sophisticated than a frontier fort in northern Michigan. The second proposition is no more, and no less, preposterous than the first. In truth, British ceramics, glassware, cutlery, and most other household possessions were mass produced and skillfully merchandised. Consequently, they are found on colonial sites around the world, from Australia and West Africa to Brazil and Nova Scotia. Indeed, I have even found English white saltglazed stoneware and creamware on the alleged site of Columbus's first New World settlement at La Navidad in northern Haiti! So successful was the British ceramic trade in the late eighteenth century that a French planter in Haiti, a Levantine merchant at the Sublime Porte, or a British officer assigned to a Michigan fort, who wished to be in vogue, could be expected to dine off comparable products from the factories of Josiah Wedgwood and his competitors. At strictly British colonial outposts, there was very little choice. The market was supplied by British merchants shipping British goods in British bottoms. Ironically, however, the chances for the swift arrival of the latest London fashions could be greater at Fort Michilimackinac than in Williamsburg. A British officer newly posted to the fort might well have come almost directly from London, bringing in his baggage items freshly purchased and of his own choice; whereas in Williamsburg, plantation owners dependent on the sale of tobacco crops, and relying on London agents as suppliers of goods drawn on estimated profits, could expect a much longer wait, indeed an indefinite delay, if the ship carrying both crop and order went down rather than across.

Deductions such as these are the product of both documentary and artifactual knowledge and analysis. They cannot be arrived at with any confidence without the use of *both* historical sources. There may be a few anthropologists who still feel that conclusions

based on archaeologically arrived at quantitative analysis can be reached without a catholic knowledge of documentary sources and how to use them. Similarly, at the other end of the spectrum, there will be historians who will continue to argue that while words may be daughters of the earth, things are certainly *not* the sons of heaven. But in the middle, sheltered from the ice blasts from the poles of extremism, there is an ever-growing number of scholars who recognize that regardless of whether the record is written or manufactured, it is all part of the history of American culture and thus worthy of open-minded consideration. This is not to suggest that archaeological evidence is, or ever will be, any better than the skills of excavators and interpreters permit it to be; and even when they do the data justice, there will be times when their hard-won and often costly findings will be worthless—just as the skilled translator or transcriber can rarely make a laundry list anything but a list of dirty clothes. My point is only that we do the past a disservice if we fail to make use of any and every scrap of evidence that it has left us.

I spoke earlier of the unique advantage that the archaeologist has in being allowed to see the past in a way that is denied the document-tied social historian or the gift- and purchase-bound museum curator. The archaeological historian sees a side of life that rarely finds its way onto paper and is rarely manifested in objects of museum quality. He becomes the custodian of the commonplace, the treasurer of trivia, but from it can emerge the features of the hitherto faceless masses, without whom there could be no social history, nor any material culture.

Traditionally, museums have tried to preserve the best of the best, and curators have admitted to feeling personally defiled if they should be forced to pay lip service to objects that do not aesthetically deserve it.[7] The archaeologist has no such qualms; he takes the past as he finds it. The museum curator who, for example, mounts a display of wine bottles invariably exhibits those that bear named or dated seals thus leading the public to suppose that

[7] Victoria and Albert Museum's Advisory Council, "Report of the Sub-Committee upon the Principal Deficiencies in the Collections" (1913), as quoted in Frank Hermann (comp.), *The English as Collectors: A Documentary Chrestomathy* (London: Chatto & Windus, 1972), p. 47.

sealed bottles were the norm. The archaeologist can prove that this was not so. The curator shows examples of English earthenwares, most of them inscribed and many of them dated. The public assumes that the majority of English pottery was so marked. The archaeologist knows that it was not. The museum displays the work of the cabinetmaker but rarely that of the joiner. It reconstructs table settings for a rich man's home, but it has no way of recalling the ferry-house keeper who had no cutlery and served unscaled fish in a communal wooden bowl.[8] The archaeologist may find the remains of both and along with them the knowledge that the man owned delftware mugs of types that now fetch large sums in the sales room. Learning that his humble wares were the object of such appreciation would have reduced that ferry-house keeper to gales of vulgar and derisive laughter.

But just as the testimony of objects should not always be believed, the written word is equally worthy of suspicion. Those who wish to gain support and justification for their love affair with objects may turn to Samuel Johnson and his marvelously appropriate epigram about words being the earth's daughters and things the sons of heaven. They are unlikely to admit, however, that Johnson was only playing their game. His was an exercise in self-justification—for compiling a dictionary from whose preface the lines are drawn. He had in fact borrowed them from Samuel Madden's *Boulter's Monument* which he, Johnson, had been paid by the publisher to revise. Madden's version read: "Words are men's daughters, but God's sons are things."[9] To give the Great Cham his due, the Madden lines may have been the product of his revision. But even so, that would not necessarily demonstrate a Johnsonian reverence for objects. Indeed, his true thoughts on that subject may have been revealed three years earlier, when he wrote: "Life is surely given to us for higher purposes than to gather what our ancestors have wisely thrown away, and to learn what is of no

[8] For the reference to the ferry house at Havre de Grace on the Susquehanna River, see Carl Bridenbaugh (ed.), *Gentleman's Progress: The Itinerarium of Dr. Alexander Hamilton, 1744* (Chapel Hill: University of North Carolina Press for the Institute of Early American History, 1948), p. 8.

[9] Samuel Madden, *Boulter's Monument*, in E. L. McAdam and George Milne (eds.), *Johnson's Dictionary, A Modern Selection* (New York: Pantheon, 1963), p. 7.

value, but because it has been forgotten."[10] Unless we are able to put our ancestors' disinterred trash to work to better understand how those people lived, and unless we use that understanding for the purpose of enriching a broad spectrum of present and future American society (not just to stimulate and entertain ourselves), then Johnson's statement has no counter that we would like to hear.

[10] Samuel Johnson, *The Rambler*, 4 vols., 9th ed. (London: W. Strahan, J. Rivington & Sons, et al., 1779), 3, no. 121 (May 14, 1751), 100.

Doing History
with Material Culture
Cary Carson

The title of this collection of papers, *Material Culture and the Study of American Life*, sounds too impartial to quarrel with. Yet those of us who were invited to participate in the Winterthur conference at which these essays were first read soon found that the organizers had stacked the deck. Their letter of invitation phrased the conference question in a way that *was* open to debate. "Tell us," they asked, "how the study of artifacts has altered our perception of American history."

There are two assumptions embedded in that question that I want to pry out and test for purity. First of all, I doubt that the many different ways different scholars become involved with the past are accurately portrayed in that all-in-the-family phrase "our perception of American history." Noël Hume's essay illustrates an archaeologist's point of view. In the other papers, we hear from a classroom teacher, an ethnologist, a preservationist, a curator, a museum teacher, and a film critic. Each turns to the past for different purposes, asks different questions, and finds different answers. Before anyone can really get down to consider how the study of artifacts may have contributed to people's knowledge or experience of American history, he must be prepared to recognize several, quite different perspectives on the past, all legitimate, but each having its own distinguishing rationale.

41

My perspective is that of the social historian. That is not to say that my raw materials don't sometimes come from archaeologists', that my interests don't overlap with anthropologists', or that I don't borrow research techniques from social scientists. I confess to all three. Yet my point of view remains steadfastly a historian's as long as my subject is the history of people, not things, and my object is to explain the changing patterns of their behavior.

Let me, then, rephrase the question my way: How has the study of artifacts altered the historian's perception of American history? Putting it like that, we run headlong into the second of the two dubious assumptions I want to take issue with. The conference question clearly implies that the material record has been instrumental in helping historians understand their subject, just as written records have. By asking "how," it leaves us authors nothing to do but count the ways. I wish I could comply. To do so, though, would result either in a very short paper or else one prolonged by sleight of pen. No matter what standard measure objective scholars use they can hardly avoid the conclusion that the study of artifacts has contributed to developing the *main themes* of American history almost not at all. Yes, of course, historians use artifacts all the time to *teach* history, in films, in classrooms, and in history museums. Yes again, artifacts often come in handy to set historical scenes, to put us in a believing frame of mind. From time to time they also put historians on the scent of something they have not already sniffed out in recorded sources. Occasionally they even dot i's and cross t's that could not have been dotted and crossed any other way. But the monumental fact remains unbudged that *things* have seldom been a source of *ideas* for historians. The substance of their major interpretations almost always comes from someplace else. Indeed, much more could be said if the question were turned around and I were asked to tell how the study of American history has altered our perception of material culture.

In fact, that is not a bad place to start. It lets bygones be bygones, and it looks ahead to a more hopeful, productive future. Now by sounding optimistic I am aware that I risk my credibility. Year after year, starry-eyed scholars attend conferences in this field only to be told that the Brave New Synthesis has been postponed another twelve months. While, alas, it is still too early to look for the millennium around the next corner, skeptics will be

encouraged to learn that this brighter future I speak of is already ten years old.

About a decade ago American and British historians began writing a new kind of history. They learned it initially from social historians in France, who published their work in the *Annales d'histoire économique et sociale*, thereby earning their nickname, the *Annales* school. It is a history that starts with new assumptions about what ought to be studied in the past and goes on from there to pose new questions, search out new or neglected sources of information, invent new methodologies, and use new tools to find the answers it seeks. Computers are *not* what makes it different from other kinds of history. *Ideas* make it different. That is the reason why students of material culture should see in these developments such tremendously exciting opportunities for themselves. For the first time they have an intellectual stake in one of history's mainstreams. The New Historians are raising questions that bring the man-made world inside the circle of ideas that interest them most. For the first time real, live, degree-holding, card-carrying academic historians are interested in things not as mere illustrations, not just as props for teachers, and not, I would answer in response to the remarks on this point in Brooke Hindle's essay, not simply as reminders of a reality that historians lose sight of in their abstractions. All these still leave artifacts on the sidelines. What I find encouraging are signs that at last some historians are beginning to look at artifacts as *sources of ideas* about a whole range of topics that are just now coming into prominence. So far, these scholars are still mostly nibbling round the edges, but they need not stop there. These small beginnings may be part of something larger, a subject that may ultimately prove to be as full of insights as the new fields of demographic history and the history of the family have turned out to be. Certainly it is a subject no less neglected than they were only ten years ago.

First, though, a word of explanation. Scholars are always quick to proclaim their latest brainstorm as the "new this" or the "new that." Like cawing blackbirds, it is their way of staking out territory. Obviously I believe that the New History offers us something we have not had before. But no one should suppose that the practice of history has changed entirely. Two things about it remain the same as ever: the nature of historical evidence and the nature of

historians. Students of material culture must understand both if they expect to play starring roles in future social history scholarship.

When artifacts sell at auction for six figures and when documents are displayed behind bullet-proof glass, it is hard to remember that no historical record is inherently significant to scholars. A number of years ago, when Rudolf Wittkower toured the Winterthur Museum for the first of many times, a colleague asked him afterward what he thought of it. "An unmatched collection," he replied, then added slyly, ". . . of anthropological curiosities." His answer, of course, was partly high art's high priest playing high jinks with lowboys and Lowestoft. But there was more than a little truth in his implication that museums are warehouses of largely unassimilated pieces of the past, just as archives curate written records by the shelfload against the day when scholars will put a few of them to use. In a working lifetime a historian encounters many records whose moment has not come yet and may never. There is a trunk in the hall on the way to the men's room in the Plympton Massachusetts Public Library that contains 123 diaries kept by a farmer who made only one entry each day: "Monday: cloudy; Tuesday: rainy," and so on for forty-seven years. That material still awaits discovery by meteorological historians. The poor and the inarticulate were not the only ones who left behind bits and pieces of information that, so far, everyone has done happily without. The foreign state papers of Queen Elizabeth I contain hundreds of receipts for her messengers' post horses, which, as far as I know, are no more useful than a collection of turnpike tollbooth receipts. The Public Record Office also owns a very handsome and, so far, entirely useless list of identifying marks by which royal swans on the Thames could be told apart from the commonality of swandom. It is not that these documents are beneath historical notice; but until historians find something to do with them, they languish in a mass of unenfranchised facts. Facts do not become historical evidence until someone thinks up something for them to prove or disprove.

Artifacts are like that too. Moreover, in the hard world of "pure research" they must compete for usefulness with any other sources of information that may bear on a problem a historian is trying to solve. I can demonstrate what I mean by turning the tables on an

illustration from Noël Hume's essay. The small number of wine bottles and drinking glasses he found on the James Anderson site in Williamsburg casts doubt on the tradition that Christiana Campbell kept a tavern there. As long as the documentary sources yield nothing, this negative archaeological evidence is of considerable value to the museum that has to know how this site was used in the 1760s. But suppose the written records *did* contain conclusive proof that Mrs. Campbell operated only a rooming house (or perhaps a very genteel tavern called "The Social Drinker"), then the merely suggestive artifacts would amount to nothing more than corroborating footnotes *for the purpose of answering that specific question.* For some other purpose, such as making the reality of an eighteenth-century flophouse come alive for museum visitors, the broken bottles and glasses might still be invaluable.

Because research is so time-consuming, historians observe a principle I call the Rule of Least and Best; they achieve a necessary efficiency in their work by gathering the least amount of best information needed to solve their problem. What may be true for the props managers of history museums—that they do the past a disservice if they fail to make use of every scrap of evidence—is just plain not true for historians. That is a fact that archaeologists and curators who have designs on social history will have to accept. Only a fraction of the many beautiful or curious things in their collections have met the least-best test so far. A somewhat larger fraction, but a fraction nonetheless, will be serviceable to the New Historians.

How can historians, new or old, afford to be so choosy when the record of the past is fragmentary anyway? Why should they even want to? That question was posed to a panel of historians several years ago by an anthropologist who could not understand what all the fuss was about. Didn't every little bit we found out about the past help to give us a more complete picture? Noël Hume says "failure to consider every aspect of life is a rejection of the goal of recreating life as it was lived."[1] The historian answers both the same way: those are not his goals, not exactly. He tries to explain only certain aspects of past human behavior, aspects that he and the historical fraternity have chosen over and above others. His-

[1] See elsewhere in this report, Ivor Noël Hume, "Material Culture with the Dirt on It: A Virginia Perspective," p. 35.

torians are famous for slicing up the past and putting it in tidy pigeonholes: *The Fall of the Roman Empire, The Defeat of the Spanish Armada, A Thousand Days* in the Kennedy administration. Even the apostles of "total history" write on certain subjects primal to the scheme of things as *they* see it and ignore others they hold to be secondary or peripheral. If you think about it, so do anthropologists, ethnographers, folklorists, and students of American studies. They talk about culture as comprehensive, integrated, and seamless, or, to use their current vogue word, holistic. And indeed it is. But from "the complex whole" they too pick out those organizing ideas that best arrange their understanding of past cultures into a logic that explains how they were structured, how they worked, and (borrowing the historian's traditional question) how they changed. Only antiquaries try to recreate life as it was lived in all its aspects, antiquaries and antiquarian museums. For them history *is* equivalent to the total data bank. Every little bit *does* count. By contrast, history for historians is equivalent only to the interpretations they concoct from the data they withdraw from the bank. I draw this distinction not to disparage the antiquary. His is yet another legitimate and useful perspective on the past. It is just that he and his repository, which Brooke Hindle aptly names "the historical souvenir museum," must not be confused with historians and history museums when we have set out to assess the latter's special contribution to understanding the material culture of American history.

Making choices is ingrained in a historian's nature. So is a quality we might call serviceableness. Both Noël Hume and I have already used the term *pure research* to describe what academic historians supposedly do inside ivory towers. But how pure is pure research really? My brother is a professor of marine geology. Every summer he cruises to the Chukchi Sea north of Siberia where twice a day he lowers a little tin can on a string to the ocean floor. On the bottom the can fills up with mud and the skeletons of millions of microscopic bugs that died there eons ago. He takes these back to his university, counts them, writes scientific papers about them, and gets grant money to go back for more the next summer. No doubt his information has practical uses to somebody, somebody like the Department of Defense or the Exxon Corporation with something up its sleeve. But for my brother and his

fellow geologists it's the bugs that count, the bugs and what they tell them about the adolescence of our planet. Surely research can't get much purer than that.

Historians seldom, if ever, achieve such detachment. Many go about their business as scientifically as they can, describing, measuring, and explaining past cultures even with an ultimate view to discovering laws that may have governed their operation. Nevertheless, historians are and always will be humanists ultimately. Hindle explains the reason why. Historians are the keepers of society's collective memory. When changing times bring new and unfamiliar problems, historians supply the wisdom of experience to those who have learned to free their choices by coming, through the study of history, to understand the forces working on them. These words should not be taken too literally, of course. Historians are seldom beckoned and called. Compared with economists, sociologists, planners, pollsters, and pundits, they are infrequent guests on talk shows and rarely testify at congressional hearings. In one sense a scholar's choice of topics is entirely his own, and yet in a more funadmental sense it is not. Ultimately what *he* considers important more than likely will reflect the concerns of those around him. Therein lies his serviceableness: he provides his own honest answers to society's practical questions.

So much for the ground rules. Let me rephrase the question I had to invert to answer at all: How have recent trends in the study of American history changed our view of material culture? Although the New History really is still new, its proponents have made good progress, so much so that already we can begin to see how their reordered priorities will require the use of artifactual evidence that has been lying around unused for a long time.

The New History starts by rejecting the traditional notion that the most important subjects for study are political leaders and ruling groups, the public events they participated in, or the earth-shaking political, economic, cultural, and scientific transformations that have altered the course of Western history. By refocusing their investigations of the past in ways that bring the lowborn into equal prominence with kings and presidents, the New Historians have been mistaken for levelers, social radicals who would rewrite history "from the bottom up," as the slogan goes. While no one can deny that women, children, slaves, Indians, sailors, foot sol-

diers, even homosexuals and unwed mothers are swarming onto history's center stage in numbers never seen before, the reason is not fundamentally because their patron historians are dedicated egalitarians. Recognition for history's neglected majority follows inevitably from the new emphasis historians are giving to society as a working organism, a community of individuals and groups who are mutually dependent on one another—top to bottom or bottom to top, it doesn't matter. This integrated, all-aboard view of society *is* fundamental to the New History perspective, as are the questions that flow from it: How were historic societies structured? How did their parts work together? What underlying forces eventually altered both structure and function?

An analogy may help to clarify each of these questions by simplifying the social organism under review. A hive of honeybees is a neatly self-contained society familiar to almost everyone, at least from a safe distance. Its social order is a model hierarchy whose perfection has inspired social commentators wherever men believed, as many did in the seventeenth century, that a people's general welfare was assured only if society provided a fixed place for everyone and everyone was fixed in place. The insect commonwealth is, of course, ruled by a single individual, a queen, attended by her ladies-in-waiting. Next in rank come the drones, who, like the courtiers they literally are, exist solely to serve their monarch. For this they expect and receive full support from the mass of ordinary bees, the workers' proletariat.

All this is as familiar to most people as sociology has been for a long time to social historians. So then, what's new? Well, if you are just another ordinary bug-swatter, chances are you have never stopped to ask about bees as historians are just now learning to ask about people, what function their social structure serves, how it works, how its values are passed on from one generation to another. These are questions that lead in one direction to wide-angled studies of economic organization. As an industrial corporation organized for the production of honey, the queen bee's matriarchy is an efficiency expert's dream. By building some cells that are larger than normal, big enough for growing drones, the worker bees ensure that their queen will have enough suitors to guarantee her fertility. She mates with one, and thereafter can lay as many as 1,500,000 eggs, which grow up to be more worker

bees, who gather the pollen, which makes the honey, which feeds the hive, and so round again.

Similarly, when historians make the functional relationships of a human economic system the object of their attention, they are sure to give each participant exactly the credit he deserves. In a tobacco economy, for example, slaves and indentured servants are every bit as important as the planters, factors, merchants, and ultimately the pipe-smoking consumers. When historians ask the *right* question— not "What was it like to be a planter?" or "How did merchants make a living?" but "How did their economy work?"—they have to take into account everyone who provided labor, capital, know-how, transportation, sales, or markets. Some object that this reduces man to a single, blinkered, economic dimension. That is true to the extent that, when a historian writes economic history, economic man is his subject. But it is not true that economic historians ignore those things that make people people: their joys, their aspirations, their idiosyncrasies, even that mysterious notion men persist in, that, cogs though they be, somehow they are still ends in themselves. Complexities that do not complicate the life of a bee profoundly affect producers and consumers in ways historians are too smart to discount.

It is precisely here, in man's sense of self, that artifacts impinge on questions of economic organization. Bees make honey, but men work to produce goods and services that go far beyond mere sustenance. What they do not put into food and taxes, or turn back into increased production, they are likely to spend on liquor, women, or things. The production of consumer goods is one of the principal ends of capitalism. Why and when it became so, how the wealth of artifacts has been unevenly distributed, how that, by differently affecting the ways people lived, caused further changes in society—*these* are the central questions for students of material culture. These are the *historical questions* that most need to be answered using the evidence of the artifacts themselves as well as documents about their manufacture, distribution, and use.

I will return to these ideas again. Before laying aside the question about the functions of society, I must point out that the New Historians' macroscopic perspective on world-wide economic systems is matched by a microscopic interest in the components of society. Scholars are scrutinizing families, households, and other

social institutions more closely now than anyone thought possible before computers unlocked the treasuries of information stored away in parish records, censuses, inventories, and the like. They reveal that social order began at home and that regional and inter-regional economies usually had a basis in household economy. Historians are looking at the family life cycle, for example. Its various stages from birth and childhood to old age and death bear directly on such important matters as a family's budget, the independence or dependence of its children, the role and authority of the parents, and the socialization of younger generations. Again a bee colony aptly illustrates the connections historians are looking for, if I may reuse that metaphor this time as an analogy for the family. It takes a queen bee's eggs three days to grow into larvae and eighteen more to become young bees. The newborn then spend three more adolescent weeks doing house chores round the hive. Only after a total of forty-two days are they finally ready to leave the nest and join the main labor force of foragers. Among social insects the rites of passage are timed by biochemical instinct to ensure that a colony is mature and vigorous when food supplies are most plentiful. No less must the rhythms of human life conform to the necessities of making a living, sometimes contrary to custom, as with child laborers, sometimes seemingly contrary to biology itself. For instance, historians have recently discovered a startling, even repugnant fact about marriage in seventeenth-century Maryland and Virginia. Because women were outnumbered three to one by men, the pressure on them to marry and bear children was intense. The mean age of marriage for native-born women was as low as sixteen in some places, and not infrequently they were scarcely twelve![2]

Life cycles call to mind family roles and work routines. All families assign tasks to their members, usually according to age and sex. Historians are interested in learning how and why these assignments are made and under what conditions traditional household responsibilities change. They also see families as society's prime educators, its social conditioners. Mothers and fathers and masters have found many different ways to instruct the young

[2] Lois G. Carr and Lorena S. Walsh, "The Planter's Wife: The Experience of White Women in Seventeenth-Century Maryland," *William and Mary Quarterly* (1977), in press.

—religion, apprenticeship, love, fear, jellybeans. The New History looks at education as a process of socialization.

There is new interest also in diet and health, especially health, because it leads directly into a subject that is so basic to understanding all peoples that it has become a highly specialized field of its own, historical demography, the study of population. Beekeepers know that there is a critical number below which a colony of bees cannot fall and still perform the tasks necessary to stay alive. So, too, American historians are finding that the ability of colonial settlements to reproduce a native population vitally affected most other aspects of life: the demand for labor, the character of immigration, the growth of opportunity, the accumulation of wealth (central to the very existence of material culture), the formation of cohesive social groups, the creation of stable political institutions, and the continuity of family life.[3]

By investigating the smallest, most intimate groups in society, historians are making a place in their ideas for the serious study of material culture. Most artifacts, after all, were used in homes or where people gathered in small groups. Families, households, and neighborhoods are the natural settings for much architecture, many tools and utensils, domestic furnishings, and articles of clothing. If we are to apply our Rule of Least and Best as rigorously to this body of evidence as historians apply it to other sources, then it is surely here, in further understanding family matters and the affairs of communities, that artifacts must finally show their stuff or concede defeat. The moment is auspicious. Historians are interested; their questions are on target; the evidence is ample; the right analytical tools are at hand. Will students of material culture rise to the occasion?

Only time will tell that. All that historians can foresee yet are the broad lines of inquiry that successful studies are most likely to follow. Voyages of discovery have only points of departure; where they will end nobody knows. Call this a preview then.

Several years ago a group of us working for the St. Mary's City

[3] Lois G. Carr and Russell R. Menard, "Immigration and Opportunity: Servants and Freedmen in Early Colonial Maryland," in Thad W. Tate and David Ammerman (eds.), *The Chesapeake in the Seventeenth Century: Essays on Its Euramerican Society and Politics* (Chapel Hill: University of North Carolina Press, forthcoming).

Commission received two grants for a study of the society and economy of the Old Tobacco South. It was indicative of everyone's uncertainty as to just where the New History belonged that the granting agencies were the National Endowment for the Humanities and the National Science Foundation and, furthermore, that NEH supported our archaeologists and NSF our historians.[4] The illustrations I have chosen to show what artifacts can teach us about human relationships are taken from the tentative conclusions these two groups of scholars have reached in concert. It must be added that, like all good marriages, this one left both partners in no doubt as to the other's limitations.

Case Study Number One: Americans learn the technology of segregation. Far and away the greatest number of English immigrants to the Chesapeake colonies in the seventeenth century came as servants. We know their number, their names, their ages, their sex, where they came from, how they were employed here, what their rights were, and how their opportunities diminished as time went by.[5] We know they were ubiquitous, fixtures of many, many planters' households, not as slaves, of course, not as members of the family either, perhaps not even as "familiars" in the same sense day laborers from the next village were in England. Because their terms of service lasted only four or five years, they were temporary in their masters' eyes; they would be moving on.

What is harder to know is how their peculiar status affected their relations with their masters and their masters' families. One possible answer has recently come from an unexpected source. For some time we had puzzled over the fact that some of the earliest house foundations archaeologists have excavated in Maryland and Virginia are straightforward examples of English house-types with a central chimney serving a hall on one side and a parlor on the other.[6] A house of 1638, recently excavated at St. Mary's City, is

[4] National Endowment for the Humanities Grant RO–6228–72–468 (renewed and extended in RO–10585–74–267); National Science Foundation Grant GS–32272.

[5] Russell R. Menard, "From Servant to Freeholder: Status Mobility and Property Accumulation in Seventeenth-Century Maryland," *William and Mary Quarterly*, 3rd ser., 30, 1 (Jan., 1973), 37–64.

[6] For example, two houses on Mathews Manor, Warwick County, Virginia, one built in the decade before 1650, the other shortly afterward (preliminarily reported on by Ivor Noël Hume, "Mathews Manor," *Antiques*, 90, 6 [Dec., 1966], 832–836); also, in Virginia a structure on Maycock Plantation (ca.

Figure 1. St. John's, St. Mary's City, Maryland. Built in 1638, and shown as it might have appeared in 1678 when used as a tavern, following extensive renovations. These included underpinning "the great House," rebuilding its central chimney and adjoining staircase, covering the roof with pantiles, building "a new porch and Chamber over it" (modified as shown), repairing "the Room called the Nursery" and shoring up its post-supported sills with brick, rehabilitating "the little House near the Gate for a Quarter," and building a brick-based kitchen chimney with a "daub and lath" stack. There are earlier references to the hall and parlor, a chamber, a loft, and a dairy off the rear (serving the hall when it was still used for cooking). Archaeologists and soil analysts have confirmed the plans and dimensions of the buildings, doorway locations, window-pane shapes, fence lines, trash tips, and latrine sites. (Drawing, Cary Carson: photo, Colonial Williamsburg.)

a good example (Fig. 1). Its plan was very familiar in the lowland counties of England.[7] That part did not surprise us, for we knew that 60 percent of our immigrant population came from the Lowlands.[8] But why, then, did they not perpetuate that tradition, as New Englanders were doing? Why did they soon come to prefer a different kind of house altogether, one whose antecedents were rarely built in the counties around London, but were commonplace in the West Country from which only one in five colonists had emigrated?[9]

Two years ago we found the answer to that question in England and, by the by, may have found an answer to our other question about the treatment of servants. We found that the predominant West Country plan, from which Southern buildings evolved, was often easily divided along its traditional cross passage into living and especially sleeping quarters for the farmer's family separated from work rooms and dormitories for the servants (Fig. 2). On the other hand, the undivided plans, more numerous in the lowlands, were difficult to partition and still retain the efficiency of a staircase located in the lobby entrance.[10] We concluded—tentatively, of course, for the evidence is slight—that Chesapeake planters came to favor a less familiar building type, because it gave them greater privacy from the indentured servants temporarily attached to their households. Architecture became the instrument of segregation, first of Europeans, only afterward of black Africans. For both groups the arrangement of architectural space gave pattern to their relationships.

Case Study Number Two: The quality of life in a demographic disaster area. Indentured servants were not the main reason for

1630–1640), Prince George County, and the John Hallowes house (ca. 1650), Westmoreland County (William T. Buchanan, Jr., and Edward F. Heite, "The Hallowes Site: A Seventeenth-Century Yeoman's Cottage in Virginia," *Historical Archaeology*, 5 [1971], 38–48).

[7] Garry W. Stone, "St. John's: Archaeological Questions and Answers," *Maryland Historical Magazine*, 69, 2 (Summer, 1974), 155.

[8] Carr and Menard, "Immigration and Opportunity," msp. 3.

[9] Cary Carson, "The 'Virginia House' in Maryland," *Maryland Historical Magazine*, 69, 2 (Summer, 1974), 185–196; "English Vernacular Architecture Gone Native," conference paper summarized in *Journal of the Society of Architectural Historians*, 34, 4 (Dec., 1975), 298–299.

[10] Cary Carson, "Segregation in Vernacular Buildings," *Vernacular Architecture*, 7 (1976), 24–29.

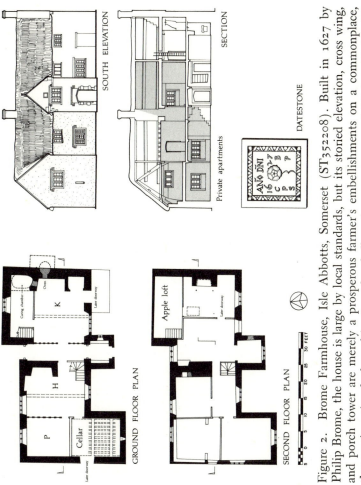

Figure 2. Brome Farmhouse, Isle Abbotts, Somerset (ST352208). Built in 1627 by Philip Brome, the house is large by local standards, but its storied elevation, cross wing, and porch tower are merely a prosperous farmer's embellishments on a commonplace, three-unit regional plan of inner parlor, hall, and cross passage and kitchen. Originally the house was divided into two entirely separate parts. The kitchen-users (presumably servants) had their own stairs to the apple loft and kitchen chamber and from there up a ladder to a floored but unlit loft. (Drawing, Cary Carson: photo, Allen Photo Service.)

Maryland's social instability in the seventeenth century. Disease was. Since the project began, the Commission's historians have been carefully exploring the demographic history of the colony.[11] We now know that it was not a healthy place to live. Statistics alone tell a stark story. For most of the century any young man who had reached his twentieth birthday was already middle-aged; he would probably die in his forties. If he married and had a family, chance as not his children would be orphaned. Two of every three children lost one parent before coming of age; one out of three lost both. Widows remarried; estates were broken up; guardians dispoiled their wards' inheritances. Until the early years of the eighteenth century, few families knew the feeling of permanence that comes when sons can build on the accumulated achievements of fathers and grandfathers. The Chesapeake was a perpetual frontier; frequently each succeeding generation had to start from scratch.

Written records give us the life-and-death statistics, and often too we can follow the rise and sudden fall of families in economic terms. But historians are at a loss when they try to speculate how such grim uncertainties weighed on people's minds, how they lived from day to day when someone in their family was likely to die soon. Oddly enough, their anxiety (if such it was) has left traces in the archaeological record. Only a handful of seventeenth-century houses survive in Maryland and Virginia: less than ten probably, compared with more than 200 in Massachusetts alone. The climate obviously was not the culprit. Although there are good reasons to suspect termites, the architectural detective who follows that lead must explain why they ate up nearly all the wooden houses of the seventeenth century and left standing hundreds more built just a few decades later. In fact, that is the clue. Seventeenth- and eighteenth-century buildings were not alike. Many of the earlier structures were not only *not* built to last, they *were* built in ways that termites could not resist. In the last few years archaeologists in Maryland and Virginia have brought to light the remains of

[11] Lorena S. Walsh and Russell R. Menard, "Death in the Chesapeake: Two Life Tables for Men in Early Colonial Maryland," *Maryland Historical Magazine*, 69, 2 (Summer, 1974), 211–227; Darrett B. Rutman and Anita H. Rutman, "Of Agues and Fevers: Malaria in the Early Chesapeake," *William and Mary Quarterly*, 3rd ser., 33, 1 (Jan., 1976), 31–60.

dozens of impermanent buildings erected on posts standing directly on the ground, set into postholes, or driven into the ground palisade-style.[12] They appear to have been intentionally temporary, put up quickly and cheaply until an immigrant or a freed bondsman could clear land, grow tobacco, and after a few years, if he were lucky, establish himself. Timber-frame houses with hole-set posts and studs were built in New England too. The difference was that New Englanders stayed alive, prospered, and replaced the settlers' dwellings with ones more permanent. Chesapeake planters died sooner, their assets were dispersed, the old houses fell down, and the orphaned sons or grandsons had to start all over again by building more temporary dwellings. It can hardly be mere coincidence that a building boom in permanent structures followed less than a generation after the native-born populations of Maryland and Virginia began growing larger and more balanced, thereby offsetting the worst social effects of disease. Well-built and well-furnished houses satisfy more than creature comforts; they are also a source of pride, security, and a sense of belonging. The posthole houses tell us that these intangible, but no less real qualities of healthy community life were often absent on the perennial Chesapeake frontier.

I have no illusions about these two case studies. They are small potatoes. I use them where I would prefer the better examples that are still forthcoming because they do demonstrate two points worth understanding: first, that artifacts *can sometimes* measure up to the Rule of Least and Best and still inform larger historical issues; and, second, that material culture is most likely to alter our perceptions of American history where it most commonly altered the patterns of American life—within the home circle and in the community immediately outside. Most artifacts in use before our own technological times governed somebody's personal relationship with somebody else, be they family, friends, neighbors, or business associates. If artifacts cannot contribute to the study of history here, then by all means let us make them a permanent loan to the art historians and museum curators and be done with them.

By now, anyone has the right to ask: Is that really all there is to

[12] Norman Barka et al., "Impermanent Architecture in the Southern American Colonies: The 'Great Rebuilding' Deferred," submitted to *Post-Medieval Archaeology*.

it? Will material culture never be anything more than history's little helper? At best can it only open sidelong dimensions on issues that other sorts of evidence have shaped up beforehand? Maybe so. Then again, maybe not. Things I have read and conversations I have had with other historians in the last three or four years have begun to congeal in my mind into one of those hunches that scholars get every now and then. So far it is the kind of thing that is easier to illustrate than it is to describe. So let me try that way first by taking us on a quick perambulation of two colonial capitals. They say there is nothing like traveling to open your eyes.

St. Mary's City was the seventeenth-century capital of Lord Baltimore's colony in Maryland. Located on a tributary of the Potomac, the site was chosen partly in hopes that its natural harbor would foster the growth of a great port city. It did not, and sixty years after its founding, the town probably still looked like an overgrown English hamlet (Fig. 3). After the seat of government was transferred to more centrally located Annapolis in the 1690s, St. Mary's City withered away and disappeared.[13]

Our walking tour starts near one of the first and best houses in the settlement, St. John's (1). John Lewgar, the provincial secretary, built a timber-frame hall-and-parlor house in 1638 to use as a dwelling, an office, and a sometimes meeting place for the General Assembly. Although located within the boundaries of the town, it was really a farm. Paddock fences ran up within a few yards of the kitchen. Yet, despite its modest size and rude appearance, it not only suited Lewgar, but afterward a wealthy merchant and, after him, even a governor, Charles Calvert, later the third Lord Baltimore. Now, in the 1690s, it is leased as a tavern.

Hastening on to the village center, we cross Mill Creek, so-named for the corn mill here on the right (2). Just beyond, but still on the outskirts of town, we pass by two or three cottages. Notice across the fields to your left the Catholic church (3) and, behind that, the brick-built "Great House" belonging to Chancellor Philip Calvert, the proprietor's half-uncle (4). He built that only ten or twelve years ago.

[13] Lois G. Carr, " 'The Metropolis of Maryland': A Comment on Town Development Along the Tobacco Coast," *Maryland Historical Magazine*, 69, 2 (Summer, 1974), 124–145.

Figure 3. St. Mary's City, Maryland, ca. 1690. This conjectural view incorporates archaeological and historical information available in 1972. Numbered sites are identified in the text. (Drawing, Cary Carson: photo, St. Mary's City Commission.)

Finally we get to the village center, nothing more than a built-up crossroads really. Pausing to look down Middle Street, you see on one side two more ordinaries (5, 6) and on the other a clapboard-covered building that the colony built in 1666 as its first official State House (7). Before that, the courts and the Assembly met in a private dwelling (8), which has become yet another tavern. How many does that make? Four so far, and that's not counting the one (9) you can just catch glimpses of between the lawyers' lodgings (10) as we walk down Aldermanbury Street. Farther along, the town thins out quickly until we get to the new State House down near the point (11). It was the only building that made the town look like a capital before the Chancellor built his house. Rounding

the corner on to North Street, the town peters out. A printing shop (12) and a jail (13) ahead there, and, alongside the landing, Chesoldyne's and Slye's warehouse (14). It's almost empty now. There has not been a ship in for several weeks, and the planters in the neighborhood usually buy out a ship's stock as soon as it comes in. Otherwise, there's almost no commerce. There was talk once about a market place and a yearly fair, but nothing came of either.

St. Mary's City had its counterpart in Virginia at Jamestown, whose official functions also moved in the 1690s to a new site, Williamsburg. That is our next destination (Fig. 4).

Here again the tour starts at the Governor's residence (1), a small mansion by English standards, but light years beyond Charles Calvert's gubernatorial farmhouse at St. Mary's City. A long, open green south of the Palace is fronted with houses whose façades reflect the images of their owners as faithfully as looking glasses: George Wythe—lawyer, burgess, attorney-general (2); Thomas Everard—clerk and mayor (3). Turning the corner on the Duke of Gloucester Street, we are not only reminded that there are artisans here, but that, like the silversmith James Geddy whose house this is on the corner (4), the successful ones are accorded social standing in the "middling" class.

Walking east, we pass a *real* market square (5) and then the first of more than a half-dozen hostelries between this one, the Market Square Tavern (6), and Burdett's Ordinary (7) near the Capitol. In this respect, the two seats of government are alike. But look closely at the lots *between* the taverns. The pig sties, orchards, and open fields of St. Mary's City are replaced in Williamsburg by craft shops and stores. In 1775 the town supported three shoemaking shops, six tailors, six milliners, seven cabinetmakers, the same number of jewelers and silversmiths, and eight coachmakers and wheelwrights.[14] You begin to see what I'm driving at. Look in the windows here. Even ordinary rooms are clut-

[14] James H. Soltow, *The Economic Role of Williamsburg* (Williamsburg: Colonial Williamsburg, 1965), p. 7. The number of craftsmen employed in these and other trades was even larger. "During the twenty-five years between 1750 and 1775 there were 223 identifiable craftsmen working at forty-four occupations in the town" (Harold B. Gill, Jr., "Craftsmen in Colonial Virginia" [typescript report, Research Department, Colonial Williamsburg Foundation], p. 7.)

Figure 4. A plan of Williamsburg, Virginia, showing the uses of buildings along Palace Green, Market Square, and Duke of Gloucester Street during the mid 1770s to 1782. Numbered sites are identified in the text. Based on "The Frenchman's Map" of 1781–82 and on house histories compiled by the Research Department of the Colonial Williamsburg Foundation (collated by Lou Powers). (Drawing, Cary Carson: photo, Allen Photo Service.)

tered with artifacts that have specialized uses. Look at the people. Their stylish dress proclaims that ordinary tradesmen have become consumers in a modern sense.

The difference between St. Mary's City and Williamsburg cannot be explained simply as the difference between a remote provincial capital and a bustling center of trade. Williamsburg was not a metropolis in the same way that other American cities dominated centralized regional economies. Nor were the two different because Virginia was supposedly "aristocratic" and Maryland "middle class." Jamestown was hardly more commercial than St. Mary's City, and Annapolis hardly less so than Williamsburg.

The real difference was the difference between 1690 and 1750. Something happened in that half century to change the course of social and economic history throughout the English-speaking world and beyond. It rebuilt the medieval city of Bath into a playground for middle-class consumers. Its enticements beckoned from shop windows in every market town in England. It changed people's standards and styles of living from Wellington to Surinam. When historians start to investigate this "consumer revolution," I have a feeling they may find that it originated in bedrock alterations in English and European society beginning as far back as the fifteenth century perhaps. Certainly it could not have happened unless self-sufficient, food-producing peasants had become market-oriented, capitalistic farmers. It could not have happened until the large medieval family had become the so-called modern European family with fewer children left at home during the parents' peak earning years. It could not have happened unless reformation and secularism had spawned a pluralistic world in which individuals found a separate existence from church, state, and class. It is clearly part of the process that historians call modernization.[15]

In the New Historians' scheme of things, it forms a junction

[15] From a growing literature, several especially suggestive studies are Fernand Braudel, *Capitalism and Material Life* (London: George Weidenfeld & Nicholson, 1973); Immanuel Wallerstein, *The Modern World System* (New York and London: Academic Press, 1974); Jan DeVries, *The Economy of Europe in an Age of Crisis, 1600–1750* (Cambridge and New York: Cambridge University Press, 1976); B. A. Holderness, *Pre-Industrial England: Economy and Society from 1500–1750* (London: J. M. Dent & Sons, 1976); D. C. Coleman, *The Economy of England, 1450–1750* (Oxford, London, and New York: Oxford University Press, 1977).

between the microscopic studies of "how people lived" in families and communities and the ocean-spanning investigations of economic organization. Three questions are basic to economic systems everywhere: What commodities are to be produced, how, and for whom. Historians have hardly touched either the first or the last. Their studies of the Industrial Revolution have concentrated mainly on *how* the tidal wave of new consumer goods was produced, a technological story in the main. *What* was produced, that is, why the demand for certain commodities arose when it did, is not a question even economists are asking, for "demand" is the given in all economic equations. Nor have scholars answered the *for whom* questions. What *was* the full effect of the Industrial Revolution in democratizing material culture? How did the ways it changed people's lives change society itself?[16]

There are historical problems here to keep historians busy for twenty years. That is just the way it ought to be. History, as I have said, is a problem-solving discipline. A historian is someone—anyone—who asks open-ended questions about past events, which he answers with selected facts arranged to form a logical, reasoned explanation. Students of material culture tackle problems too, but they have not been people problems very often, or, when they have, they have rarely been people problems that artifacts were best qualified to solve. My scholar's hunch tells me that is changing. Artifacts are no longer just evidence; they are part of what the New History is all about.

Events in recent years—Watts, Vietnam, and Watergate—have deepened many Americans' understanding of historical process. We have learned—perhaps relearned—that even our most forceful leaders are constrained by circumstances outside their control and that the highly visible events they participate in often belie true states of affairs. More and more, we demand to see behind appearances; we want to know how things really work; we recognize that everyone is in the same social boat, sink or swim. We have asked our historians, the keepers of our collective memory, for a new

[16] For a preliminary excursion into these subjects, see Barbara and Cary Carson, "Styles and Standards of Living in Southern Maryland, 1670–1752," and Lorena S. Walsh and Lois G. Carr, "Personal Consumption Patterns in Southern Maryland, 1658–1776" (papers delivered to the Southern Historical Association, Nov. 12, 1976).

kind of history. They are responding with a history of people, not just personalities, and of process, not patriotism. Insofar as the new requirements focus on social institutions and economic systems, artifacts assume a prominence they never had before. For once students of material culture are sitting on the main chance. If my hunch pays off, it won't be long before they—or someone—can answer the question we started with the right way round.

The Artifact in American Culture:
The Development of an Undergraduate
Program in American Studies
James V. Kavanaugh

Among those concerned with the future of American Studies and
its potential contribution to an understanding of American culture,
there is a consensus that American *culture* is the true subject mat-
ter of the field. It is also agreed that the methods for interpreting
American culture should be interdisciplinary or multidisciplinary
in nature. This consensus has promoted the establishment of dis-
ciplinary integrity and departmental autonomy for American Stud-
ies in academia, but unless subject matter and methodology are
better defined, and American Studies provided with a coherent
center, students in the field might as well carry on their work
within the American divisions of such traditional disciplines as
history, literature, political science, and sociology. This is the case
in many institutions where American Studies is no more than the
sum of the American parts of the traditional curriculum.

For American Studies to have a coherent center may not be of
immediate concern to scholars at work in the field, but it is of very
much concern in any attempt to introduce American Studies to
undergraduates. In this context, it is important to describe the
diversity of the field: methodological techniques ranging from
those of the "myth-image-symbol" school in the humanities to the
quantitative analyses of the social sciences; subject areas ranging

from the high or elite culture as representative of the basic tendencies of American culture to mass or popular culture as the most accurate index of majority beliefs and attitudes; the cultures of ethnic and racial minorities and their interaction with the majority —all of these seen from an historical perspective.

The purpose of this paper is to suggest a model for American Studies based on the anthropological concept of culture emphasizing the interpretation of the accumulated material evidence, or artifacts, of the culture. The model is particularly useful in introducing undergraduates to the field. It has been implemented in the two-semester "Introduction to American Studies" at Hobart and William Smith Colleges. The concept of culture is central to the model; it can be described in terms of Edward B. Tylor's classic 1871 definition of *culture*: "Culture or Civilization, taken in its wide ethnographic sense, is that complex whole which includes knowledge, belief, art, morals, law, custom, and any other capabilities and habits acquired by man as a member of society."[1] Tylor's definition is a holistic concept of culture and suggests the approach of consensus historians and students of the "essential" American character. The proposed model, on the other hand, recognizes not only macro-American culture of official English language, common legal, economic, and political systems but also the complex cultural matrix interwoven with a variety of ethnic, regional, social, political, religious, and other subcultures. Claude Lévi-Strauss's definition of the parameters of a single culture is useful here: "a fragment of humanity which, from the point of view of the research at hand and of the scale on which the latter is carried out, presents significant discontinuities in relation to the rest of humanity."[2]

Where the suggested model for American Studies differs from many other cultural models proposed for the field is in its emphasis on the interpretation of the accumulated man-made material evidence of the culture. The artifact, defined here as any man-made material (to mean not simply physical but phenomenal) evidence

[1] Edward B. Tylor, *Primitive Culture: Researches into the Development of Mythology, Philosophy, Religion, Art and Custom,* 2 vols. (1871; reprint ed., Gloucester, Mass.: Peter Smith, 1958), 1, 1.

[2] Claude Lévi-Strauss, *Structural Anthropology,* trans. Claire Jacobson and Brooke Grundfest Schoepf (1953; reprint ed., New York: Basic Books, 1963), p. 295.

of a culture, becomes the primary source of information about the culture. The student of American Studies adopts an almost archaeological approach to interpreting the culture which these objects represent. This does not exclude a concern with contemporary American culture, but it is assumed in the model that the existing culture is continuously contributing to this world of man-made things. History begins with the created object or, as George Kubler phrased it so memorably, "the moment just past is extinguished forever, save for the things made during it."[3] The world of produced objects alone survives to represent the evolution of the culture; which is not to say that it is itself culture but, simply and significantly, it is the sensuously perceptible form of culture.

Ward Goodenough, one of the spokesmen for the "new ethnography," has written that "it is obviously impossible to describe a culture properly simply by describing behavior, or social, economic, and ceremonial events and arrangements as observed material phenomena. What is required is to construct a theory of the conceptual models which they represent and of which they are artifacts."[4] The proposed culture-artifact model for American Studies does not conflict with the new ethnographers' notion of culture as the conceptual models with which individuals in a society perceive, organize, and interpret the phenomena of their culture. It does, however, assume that individuals in a society "create themselves" or define themselves culturally through the objectification of those conceptual models in culturally prescribed phenomenal forms. Thus, the deep structure of the conceptual model is embodied in the artifact whatever surface form the artifact assumes.

The activity of objectification which results in this world of man-made things closely resembles G. W. F. Hegel's concept of alienation. For Hegel, it is an essential characteristic of the human mind to produce things, to express itself in objects, to objectify itself in physical things, social institutions, political systems, religion, philosophy, and cultural products. This world of created things

[3] George Kubler, *The Shape of Time: Remarks on the History of Things* (New Haven: Yale University Press, 1962), p. 79.

[4] Ward Goodenough, "Cultural Anthropology and Linguistics," in Dell H. Hymes (ed.), *Language in Culture and Society: A Reader in Linguistics and Anthropology* (New York: Harper, 1964), p. 36.

mediates between the human organism and the natural environment, and, in its material manifestations, documents the culture of a society. Properly interpreted, or de-alienated, through knowledge, the world of objects reveals the organic relationship between the culture of a society and the material evidence created through it. Hegel writes in his *Philosophy of Art*:

> [Art] fulfills its highest task when it has joined the same sphere with religion and philosophy and has become a certain mode of bringing to consciousness and expression the divine meaning of things, the deepest interests of mankind, and the the most universal truths of the spirit. Into works of art the nations have wrought their most profound ideas and aspirations. Fine Art often constitutes the key, and with many nations it is the only key, to an understanding of their wisdom and religion. This character art has in common with religion and philosophy. Art's peculiar feature, however, consists in its ability to represent in *sensuous form* even the highest ideas, bringing them thus nearer to the character of natural phenomena, to the senses, and to feeling.

Divested of the rhetoric of German transcendental philosophy and interpreted in an anthropological context, Hegel's remarks become especially significant in relation to the proposed model. If the concept of works of art can be extended to include the universe of all man-made things (Kubler makes such a leap at the beginning of *The Shape of Time*),[5] then as students of culture we have available to us the accumulated material evidence of the culture which in varying degrees, dependent upon the nature and complexity of the artifact, embodies both the deep structure of the new ethnographic model of culture and the manifestations of culture which constitute Tylor's "complex whole."

American Studies can be seen, then, as a division of cultural anthropology. Its primary concern is the interpretation of the historical evolution of American culture as represented by the material evidence of that culture. One might well ask why such a task has not already been undertaken by cultural anthropologists. Traditionally, the field of anthropology in the United States has devoted its attention to exotic and primitive cultures. It was only

[5] J. Loewenberg (ed. and trans.), *Hegel: Selections* (New York: Charles Scribner's Sons, 1929), p. 314; Kubler, *The Shape of Time*, p. 1.

in 1969 that the Council of the American Anthropological Association passed a resolution recognizing "the legitimacy and importance" of research and training concerned with "contemporary American society." The resolution suggests not only a sociological rather than a cultural orientation in the work it encourages but indicates a contemporary bias in anthropological research into American culture. A recent anthropological textbook, *The Nacirema: Readings on American Culture* (1975), presents a cross-section of current anthropological literature about American culture. Almost all of the forty-one articles included, except two which deal with the values and world view of Americans and two which describe future archaeological explorations of an extinct American culture, deal with contemporary American society and culture. These are valuable contributions to the understanding of contemporary American culture and, along with the work of historically minded anthropologists and historical archaeologists, will constitute a fertile literature for all students of American culture.[6]

The culture-artifact model for American Studies, the assumptions of which have just been described, is particularly useful in introducing undergraduates to the study of American culture, and the model has been implemented in the two-semester "Introduction to American Studies" at Hobart and William Smith Colleges. The first semester, "The Artifact in American Culture," operates as an "above-ground" archaeological expedition, to use John Cotter's appropriate term, with an expeditionary team composed of the coordinator of the American Studies program and faculty and guest speakers in the humanities and social sciences, each of whom interprets a particular artifact related to his or her field of study.[7] (Part of the appeal of the culture-artifact model is the willingness of scholars of widely different points of view and methodological approaches to participate in an endeavor unified by such a concept. The faculty of the colleges is also uncommonly generous in its support of interdisciplinary programs.) The artifacts range from a book to a building, a painting to a machine, a piece of

[6] Resolution of the Council of American Anthropological Association, as quoted in James P. Spradley and Michael A. Rynkiewich, *The Nacirema: Readings on American Culture* (Boston: Little, Brown & Co., 1975), p. 2.

[7] John L. Cotter, "Above Ground Archaeology," *American Quarterly*, 26, 3 (Aug., 1974), 266–280.

music to furniture, contemporary advertising to archaeological sites. They represent a wide range of geographical origin, social setting, and historical period in American culture. In keeping with the nonlinear and empirical basis of the course, the artifacts are presented in no particular order, and this permits the emergence of themes and continuities characteristic of American culture. Further, it departs from traditional course formats in which a reading list of secondary works is supplemented by lectures and discussions. Concern with the object precedes any discussion of second- and third-level generalizations derived from that empirical reality.

This sampler of Americana has included such artifacts as the *Sears Roebuck Catalogue* of 1902; the original town plan of Salem, Massachusetts; Norman Vincent Peale's *The Power of Positive Thinking*; the Corliss engine; the Kanadesaga Seneca Indian site (an archaeological site on the outskirts of Geneva, New York); Scott Joplin's "Maple Leaf Rag"; early nineteenth-century samplers; television soap operas; Yiddish immigrant poetry of the Lower East Side of New York City, 1880–1910; St. John's Chapel (the Gothic Revival Hobart College Chapel designed by Richard Upjohn and completed in 1865); the Conestoga wagon; women's costumes of various periods; *Double Indemnity* (an American *film noir* of 1944); Conan Comics; a Federal period room at the Geneva Historical Society; presidential campaign speeches; a videotape of a professional football game (the media-packaged sports event as artifact); and the Hobart and William Smith Colleges as an archaeological site. The list is infinitely expandable and variable according to the needs of the course and the expertise of the faculty. It should be added that, given the extent and complexity of the larger American culture, it seems reasonable to select unique and significant artifacts which are capable of providing the richest insights into American culture. An archaeologist uncovering the remains of American culture centuries hence and discovering only simple functional artifacts, such as highway signs and cooking utensils, would have to be content with those finds, but they would not go far in suggesting the diversity and complexity of American culture. In primitive cultures with few artifacts, those few objects take on special significance and become symbolic carriers of social relationships and cultural values, but in a technologically advanced society it seems appropriate to concentrate on

those objects whose potential yield of information seems greatest, and not necessarily those of greatest simplicity or function.

A brief look at the interpretation of artifacts studied in the course will provide a more specific context for the above-ground archaeological expedition. Students are introduced to the archaeological point of view through a discussion of one of several excavations in the Finger Lakes region. For example, George Hamell, an archaeologist with the Rochester Museum and Science Center, lectured on the museum's continuing work at the Kanadesaga site. Once the eastern capital of the Seneca Indians, Kanadesaga is rich in artifactual information about the culture of the Seneca and offers an appropriate model for a discussion of the aims and methods of archaeology. In a related exercise, the students are asked to interpret the physical environment of their campus as though it were an archaeological site. Their involvement in this interpretation effects the transition from field archaeology to above-ground archaeology.

A facsimile edition of the *Sears Roebuck Catalogue* of 1902 is a source book of commonplace artifacts of American consumer society in the early twentieth century. The catalog is itself a primary artifact of mail-order merchandising, an indigenous American form of business, and its pages illustrate and describe a variety of artifacts including men's and women's clothing, furniture, tools, farm machinery, firearms, musical instruments, and home medicines. Intended for a rural clientele whose purchasing potential was limited by the small inventory and high prices of local merchants, Richard Sears's "wish book" documents the growth of a capitalistic consumer economy as well as the pervasive urbanization of American culture barely a dozen years after the traditional closing date of the frontier.

The interpretation of Scott Joplin's "Maple Leaf Rag" (composed in 1897 and published in 1899) extends the artifact concept to the realm of physical sound. At one level, Joplin's piano rags assume material form in the sheet music that served as the principal medium of their enormous popularity. The cover art of this sheet music often illustrates racist stereotypes of black life and is interesting in its own right, but it is the music itself that is important. The rags embody a unique synthesis of Afro-American music, especially its syncopated rhythmic character, with such

Anglo-American musical forms as the post–Civil War march. The rag is, therefore, a cultural hybrid that documents in sound the interaction of the black minority culture with the Anglo-American majority culture. Its popularity marks the recognition by white Americans of a distinctive black contribution to the American arts.

Conan Comics, published by the Marvel Comics Group, document what can be described as a new wave of comic-book art that far transcends the simple drawings and straightforward narratives of the traditional comic. Barry Smith, the illustrator of Conan Comics from 1970 through 1973, combines the careful rendering characteristic of the illustartor's craft with a wide range of cinematic techniques including closeup, longshot, tracking, zooms, and parallel cutting. Conan, the muscular and belligerent swordsman of these heroic fantasies, is the creation of Robert Ervin Howard, a writer for pulp magazines in the late 1920s and early 1930s. The character of Conan embodies a projection of Howard's personal lifestyle as a rugged outdoorsman living on a ranch in northern Texas and partakes not a little of the primitivism of Jack London and Edgar Rice Burroughs, two writers whom Howard greatly admired. The Conan adventures recount the hero's uncomplicated mastery over situations through brute force and appeal to an audience composed largely of adolescent males. The advertising and reader services that constitute the packaging of the comics also reflect the preoccupations of American male youth.

These and other artifacts studied in the course are intended to suggest the larger world of man-made material objects available to students in their study of American culture. The above-ground archaeological expedition format of "The Artifact in American Culture" course establishes an empirical basis for this study.

The second semester course, "Theories of Culture and Methodologies of American Studies," operates in a more traditional manner. The assumptions about the nature of culture in the first course are explored in greater depth through discussion of texts such as David Kaplan and Robert A. Manners, *Culture Theory*; and Leslie White, *The Science of Culture*. This is followed by discussion of a selection of studies in American culture grouped around a central theme. One year, for example, the theme was the idea and the reality of the American land. The bibliography in-

cluded Wilbur Zelinsky, *The Cultural Geography of the United States*; John Conron (ed.), *The American Landscape: A Critical Anthology of Prose and Poetry*; Richard Slotkin, *Regeneration through Violence: The Mythology of the American Frontier, 1600–1860*; Leo Marx, *The Machine in the Garden: Technology and the Pastoral Ideal in America*; Henry Nash Smith, *Virgin Land: The American West as Symbol and Myth*; John W. McCoubrey, *American Tradition in Painting*; David M. Potter, *People of Plenty: Economic Abundance and the American Character*; and Daniel J. Elazar, *American Federalism: A View from the States*.[8]

The movement of the two courses is from the empirical to the theoretical and its application; from the specific artifact to generalizations about the nature of American culture. This plan is similar to the format of Roland Barthes's *Mythologies*.[9] The distinguished French critic and leading exponent of semiology explores in a series of short essays the mythic determinants of such contemporary mass cultural phenomena as soap detergents, toys, eating habits, the striptease, a wrestling match, and automobiles followed in the second half of the work by a theoretical discussion of myth as semiological system. Readers of *Mythologies*, even those who find Barthes's approach rather heavy-handed, are stimulated into a new appreciation of the cultural significance of the commonplace. With that awareness comes the recognition that McDonald's ham-

[8] David Kaplan and Robert A. Manners, *Culture Theory* (Englewood Cliffs, N.J.: Prentice Hall, 1972); Leslie White, *The Science of Culture: A Study of Man and Civilization* (New York: Farrar, Straus & Giroux, 1969); Wilbur Zelinsky, *The Cultural Geography of the United States* (Englewood Cliffs, N.J.: Prentice Hall, 1973); John Conron (ed.), *The American Landscape: A Critical Anthology of Prose and Poetry* (New York: Oxford University Press, 1973); Richard Slotkin, *Regeneration through Violence: The Mythology of the American Frontier, 1600–1860* (Middletown, Conn.: Wesleyan University Press, 1973); Leo Marx, *The Machine in the Garden: Technology and the Pastoral Ideal in America* (New York: Oxford University Press, 1964); Henry Nash Smith, *Virgin Land: The American West as Symbol and Myth* (New York: Vintage Books, 1957); John W. McCoubrey, *American Tradition in Painting* (New York: George Braziller, 1963); David M. Potter, *People of Plenty: Economic Abundance and the American Character* (Chicago: University of Chicago Press, 1954); Daniel J. Elazar, *American Federalism: A View from the States*, 2d ed. (New York: Thomas Y. Crowell Co., 1972).

[9] Roland Barthes, *Mythologies*, trans. Annette Lavers (New York: Hill & Wang, 1972).

burger stands, highway designs, media-packaged professional football games, in fact, all the artifacts that constitute our cultural environment are resources for the understanding of American culture. In a modest way, the "Introduction to American Studies" sketched here attempts to bring about the same kind of cultural awareness, not only for the objects of the immediate present, but for the accumulated evidence of the past as well. And just as the artifact concept allows for wide-ranging exploration within American culture, so the concept of culture unifies that endeavor and provides a common center for the field of American Studies.

Artifacts of the Indians
of the Southwest
Bernard L. Fontana

The Indians of the Southwest have attracted more anthropological attention than Indians of any other cultural or geographic region in North America. Since the late 1880s there have been hundreds of books as well as thousands of articles in popular magazines and scholarly journals discussing everything from the pitch accent in Apachean languages to the land tenure of Havasupai Indians. There are dozens of essays alone which describe every aspect of the Hopi snake dance, including speculations concerning whether or not the rattlesnakes are milked of their venom before they are carried in a public ceremony.[1]

Running parallel to interest in such matters as languages, land-tenure systems, and religious ceremonies has been a steady concern—again since the late nineteenth century—for the artifacts of native southwestern peoples. Even the Spaniards were fascinated by the products of Indian manufacture. As early as 1540 Francisco Vásquez de Coronado took considerable pains to make a shipment, from near what is now Zuñi, New Mexico, to Viceroy Antonio de Mendoza in Mexico City, consisting of "a cattle [i.e., bison] skin, some turquoises, and two earrings of the same, and

[1] See the various bibliographic references in George P. Murdock and Timothy J. O'Leary, *Ethnographic Bibliography of North America*, 4th rev. ed., 5 vols. (New Haven: Human Relations Area Files Press, 1975), 5, 175–393, noting that no other region includes a comparable number of entries.

fifteen Indian combs, and some boards decorated with these tur-
quoises, and two baskets made of wicker, of which the Indians
have a large supply." He also sent "two rolls, such as the Indian
women wear on their heads when they bring water from the spring,
the same way they do in Spain," as well as "a shield, a mallet, and
a bow and some arrows, among which there are two with bone
points." Finally, he included two painted blankets, all destined to
be carried on foot and horseback more than 1,700 miles even by
the shortest possible route.[2] All the interest in southwestern Indian
artifacts on the part of non-Indians has not been the sole province
of private individuals collecting curiosities or potentially valuable
objets d'art. Museums throughout the world have collections of
prehistoric and historic Indian artifacts from the region. Many
archaeological as well as ethnological expeditions made their ways
into Arizona, New Mexico, southern Utah, and southern Colorado
during the late 1800s and in the early part of the present century.
All of them managed to preserve for posterity a considerable
legacy of native manufactures. In the 1970s the process continues.
Museums still acquire the fruits of labors in archaeological sites in
the Southwest; they continue to build their collections of ethnolog-
ical specimens, both historic and current.

What are the meanings of these many artifacts? Why, in fact, do
we preserve them? What are the rationales for contemporary col-
lection programs? Are Indian artifacts removed from their native
contexts anything more than curios? Have they values other than
monetary or artistic? Finally, how might some reflection on the
artifacts of the Indians of the Southwest relate to the broader
concern of material culture and the study of American life?

Clyde Kluckhohn and his coauthors of the classic work, *Navaho
Material Culture*, have pointed out that "Ethnologists, archaeolo-
gists, museum directors, and collectors of all sorts have been deal-
ing with traits of material culture for over a century without
particular concern for the problem of definition." Possibly the
person who attempted the earliest definition of the concept of
material culture was Clellan S. Ford. Formulated in 1937, his

[2] George P. Hammond and Agapito Rey (trans. and eds.), *Narratives of
the Coronado Expedition 1540–1542* (Albuquerque: University of New Mex-
ico Press, 1940), 176–177.

definition emphasizes the action involved in the manufacture and use of the objects rather than the objects themselves. He wrote:

> Culture is concerned primarily with the way people act. The actions, then, of manufacture, use, and nature of material objects constitute the data of material culture. In their relation to culture, artifacts and materials are to be classed in the same category as the substances, such as minerals, flora, and fauna, which compose the environment in which people live. Artifacts themselves are not cultural data, although, to be sure, they are often the concrete manifestations of human actions and cultural processes. The cultural actions of a people cannot be inferred from them without extreme caution, for a number of reasons. Chief among these are the following: (1) instead of being a product of the culture the artifacts may have been imported; (2) the process of manufacture is frequently not implicit in the artifact itself; and (3) the use or function of the artifact is not deducible from the object alone.[3]

Although Ford's strictures on the interpretation of artifacts as material culture may sound too confining to the archaeologist, particularly to the prehistorian who has little other than artifacts upon which to base his analysis of life among nonliterate peoples, most archaeologists would agree that "culture cannot be inherent in the artifacts. It must be something in the relationship between the artifacts and the [people] who made them and used them."[4]

It is precisely because archaeologists, more than those in other academic disciplines, depend on their understanding of artifacts for their interpretations of history that they have agonized and published more on the subject of artifactual analysis than others. This is especially the case among archaeologists who specialize in prehistory or in the archaeology of nonliterate societies, such as those of North American Indians. However, to consider the

[3] Clyde Kluckhohn, W. W. Hill, and Lucy W. Kluckhohn, *Navaho Material Culture* (Cambridge: Harvard University Press, Belknap Press, 1971), p. 1; Clellan S. Ford, "A Sample Comparative Analysis of Material Culture," in George P. Murdock (ed.), *Studies in the Science of Society Presented to Albert Galloway Keller* (New Haven: Yale University Press; London: H. Milford, Oxford University Press, 1937), p. 226.

[4] Irving Rouse, "Prehistory in Haiti," *Yale University Publications in Anthropology*, 21 (1939), 16.

myriad problems of artifact association, attribute analysis, archaeological inference, research design, statistical models, phenomenological approaches, and other conceptual matters related to our understanding of material culture would take us beyond the confines of the present discussion.[5] Nonetheless, because the concern here is with artifacts and with material culture, we have to establish a framework within which to proceed.

If we are willing to accept Ford's notion that "material objects constitute the data of material culture," that "they are . . . the concrete manifestations of human actions and cultural processes," then we should also be prepared to accept the notion that they are historical documents as well. Alfred Kroeber asserted that, "cultural material is, in the wider sense . . . historical material."[6] He might as well have said "material culture."

It is, then, as historical data that the artifacts of Indians of the Southwest will be considered in this paper. But, to echo Kroeber, "by 'historical' I refer . . . primarily . . . to a basic and integrative intellectual attitude," to "integrative reconstruction," and not merely to sequences.[7]

The use to be made of historical data depends, obviously, on their relevance to whatever problem is being considered. The use of artifacts as historical data is as old as archaeology, but the ways in which these data have themselves been considered are many and varied. In the present century Kroeber and many of his students and colleagues engaged in culture element distribution surveys, plotting on maps and by tribes various elements of culture, both material and nonmaterial. These surveys had many aims, but, at their inception, the most important among them was to reconstruct the culture histories of native Americans who were without written record of their own but whose artifact distributions, properly interpreted, might be read as historical documents. This aim went largely unfulfilled. Nevertheless, the attempt represented perhaps

[5] For an overview of the kinds of approaches being explored currently by archaeologists in their efforts to understand material culture, see Sally R. Binford and Lewis R. Binford (eds.), *New Perspectives in Archeology* (Chicago: Aldine Publishing Co., 1968), and Michael B. Schiffer, *Behavioral Archeology* (New York: Academic Press, 1976).

[6] Alfred Kroeber, "History and Science in Anthropology," *American Anthropologist* 37, 4 (Oct.–Dec., 1935), 545.

[7] *Ibid.*, 558.

the first major effort in North America, outside the realm of archaeology, to understand the culture history of American Indians via a study of the distribution and comparisons of their culture elements.[8]

One reason that Kroeber and his followers were unable to reconstruct culture history through element distributions is that they were rarely sure of either the absolute or the relative ages of the elements with which they dealt. There was the tendency to equate wide distribution with age, an assumption often not supported by any data. These investigators were working with an "ethnographic present," a kind of idealized notion of an essentially timeless aboriginal culture, one untainted by influence from Europeans.

We know, however, that elements of culture, including the material ones, are susceptible to change. We know, too, that peoples of separate cultures who come into contact with one another, either in person or indirectly, influence one another's cultural behaviors. We call change that is the result of such influences acculturation. And we also know that artifacts, as the "concrete manifestations of human actions and cultural processes," are capable of reflecting such acculturative change.[9]

In 1951, George Quimby, then Curator of Exhibits in the Department of Anthropology at the Chicago Natural History Museum, along with Alexander Spoehr, that museum's Curator of Oceanic Ethnology, made a study of museum collections to devise

[8] For an example of the aims and methodology involved in the culture element distribution studies, see Stanislaw Klimek, "Culture Element Distributions: I. The Structure of California Indian Culture," *University of California Publications in American Archaeology and Ethnology* 37, 1 (Dec., 1935), 1–70. For a critique of the entire so-called culture-historical school, of which culture element distribution surveys were a part, see Fred W. Voget, *A History of Ethnology* (New York: Holt, Rinehart & Winston, 1975), pp. 317–359.

[9] One of the liveliest discussions of the influence on our own culture of diffused artifacts and ideas is in Ralph Linton, *The Study of Man* (New York: Appleton-Century-Crofts, 1936), pp. 326–327. In the final paragraph he writes: "When our friend [the solid American citizen] has finished eating he settles back to smoke, an American Indian habit, consuming a plant domesticated in Brazil in either a pipe, derived from Indians of Virginia, or a cigarette, derived from Mexico. If he is hardy enough he may even attempt a cigar, transmitted to us from the Antilles by way of Spain. While smoking he reads the news of the day, imprinted in characters invented by the Semites upon a material invented in China by a process invented in Germany. As he absorbs the accounts of foreign troubles he will, if he is a good conservative citizen, thank a Hebrew deity in an Indo-European language that he is 100 percent American."

a categorization of artifacts in terms of acculturation.[10] Their category A included all types of artifacts introduced to native peoples through contact by Europeans; category B consisted of native artifacts modified by contact with Europeans. Each category was further subdivided as follows:

Category A. New types of artifacts introduced through contact.
 1. Objects imported through trade or other contact channels. (Example: jew's-harps, made as musical instruments in European culture but used in unmodified form as neck pendants by some Indians.)
 2. Forms copied from introduced models, but reproduced locally of native materials. (Example: Oceanian wooden copies of European steel-bladed knives.)
 3. Introduced forms manufactured or decorated locally, partly from native materials and partly from imported trade materials. (Example: an Eskimo-carved wood and bone gunpowder flask with a metal stopper.)
 4. Introduced forms manufactured locally from imported materials through the use of an introduced technique or a native technique similar to the introduced one. (Example: a rag rug of Potawatomi Indian manufacture which substitutes for a traditional style of Potawatomi mat.)
Category B. Native types of artifacts modified by contract.
 1. Native artifacts modified by the substitution of an imported material for a local material that is inferior in physical properties or lacking in prestige. (Example: an Eskimo ivory harpoon head with an iron blade rather than a stone blade.)
 2. Native artifacts modified by the substitution of an imported material whose use involves a different technological principle, although the same end is achieved. (Example: Eskimo snow goggles with a wooden frame and sooted lenses of glass.)
 3. Native types of artifacts modified by the introduction of a new element of subject matter. (Example: a Haida woodcarved figurine depicting a non-Indian sea captain.)

[10] George I. Quimby and Alexander Spoehr, "Acculturation and Material Culture—I," *Fieldiana: Anthropology*, 36, 6 (July, 1951), 107–147.

Quimby and Spoehr concluded: "We consider this study incomplete, and we plan to develop our ideas further, aided by additional analyses of museum specimens showing unmistakable evidence of culture change brought about by culture contact."[11] Unhappily, further development of the study seems not to have occurred. In 1966, while discussing the archaeology of the historic period in the western Great Lakes region, Quimby reintroduced the 1951 scheme, but he neither modifies it nor uses it in any serious way.[12] In 1969 the archaeologist Annetta L. Cheek borrowed the ideas of Quimby and Spoehr and classified them in tabular form. She put her classification to the test in a 1974 study (Table 1).[13] Cheek

Table 1
The Cheek Classification Table

| | European Material | | Native Material | |
	EUROPEAN TECHNIQUE	INDIAN TECHNIQUE	EUROPEAN TECHNIQUE	INDIAN TECHNIQUE
European form	A	B	C	D
Indian form	E	F	G	H

hoped to analyze artifacts recovered from Indian archaeological sites of the early historic period (i.e., sites occupied by Indians at the time of contact with Europeans or soon after) in an effort to understand degrees and rates of acculturation. In theory, a known Indian occupation site with a preponderance of artifacts made with European materials by European techniques and in European forms would indicate that the people were more acculturated than those whose occupation area had a preponderance of artifacts made with native materials by native techniques and in native forms. The jury is still out, however, trying to decide what it means when artifacts of the intervening classes are found in archaeological assemblages. As potentially useful as the models of Quimby,

[11] *Ibid.*, 147.
[12] George I. Quimby, *Indian Culture and European Trade Goods* (Madison: University of Wisconsin Press, 1966), pp. 9–11.
[13] Annetta L. Cheek, "Contact and Change in Aboriginal Sites in North America," M.A. thesis, University of Arizona, 1969, p. 31; and Annetta L. Cheek, "The Evidence for Acculturation in Artifacts: Indians and Non-Indians at San Xavier del Bac, Arizona," Ph.D. diss., University of Arizona, 1974.

Spoehr, and Cheek may be for the study of particular artifacts and culture change, they should be used with caution because their scientific appearance might influence one toward spurious or incorrect conclusions.

I propose a different approach, one that will consider the artifacts of the Indians of the Southwest and their relation to acculturation in a less complicated form than the Quimby-Spoehr and Cheek models. Let us think of the artifacts in terms of four categories. First is the artifact made prehistorically and, therefore, by definition, subject to no influences from non-Indians. Second is the artifact made by Indians for Indian use, but which, through one or more attributes, clearly expresses white influence on native culture. Third is the artifact made by Indians solely in response to white culture. Fourth is the artifact made by non-Indians but which is now widely used by Indian people. These too are artifacts of the Indians of the Southwest, although we are not generally inclined to consider them that way.

ARCHITECTURE

Although we are used to thinking of artifacts as relatively simple objects which will rest easily on museum shelves, as the ultimate product of man's hands they can just as well reach monumental proportions. It is thus that architecture provides us with a class of artifacts.

Depending on the population size or social complexity of the particular group of prehistoric peoples, architecture might include public as well as private structures. It could be sacred or secular. Prehistoric southwestern Indian architecture ran the gamut from a rude circle of rocks laid on the desert to provide an overnight windbreak to the towering magnificence of Pueblo Bonito in Chaco Canyon, New Mexico. Built between 919 and 1067, at its peak Pueblo Bonito is believed to have had 800 living rooms, 39 kivas, and to have housed as many as 1,200 people. Constructed of stone masonry and laid four stories high, in its day it was probably the largest single dwelling in the world.[14]

[14] Harold E. Driver, "Indian Wealth—Is It Only a Myth?" in Robert Iacopi, Bernard L. Fontana, and Charles Jones (eds.), *Look to the Mountain Top* (San Jose, Calif.: Gousha Publications, 1972), p. 70.

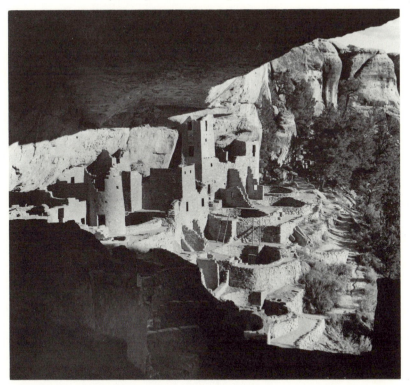

Figure 1. Cliff Palace, Mesa Verde National Park, Colorado. (Arizona State Museum: photo, Helga Teiwes.)

Nor was Pueblo Bonito, as it was named by archaeologists, the only multistoried and multiroomed structure in the prehistoric Southwest. The Four Corners region is famed for its prehistoric Pueblo Indian architecture which consists of dry masonry buildings often constructed in rock shelters on the sides of cliffs. Thousands of tourists each year visit the Cliff Palace at Mesa Verde in southwestern Colorado, a complex of edifices erected through an enormous expenditure of human energy (Fig. 1). Less imposing, perhaps, but just as important to our understanding of southwestern Indian history are the remains of pit houses, scooped out depressions in the earth leaving their patterns of post holes, hearths, storage bins, and entryways. It is from such evidence as

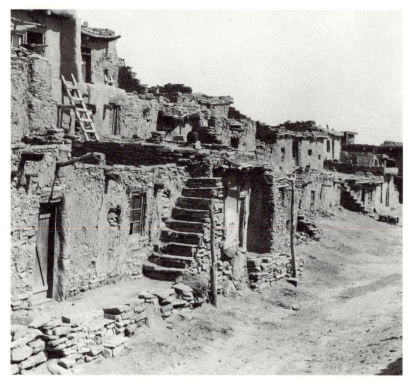

Figure 2. Hopi village, Oraibi, Arizona, 1927. (Arizona State Museum: photo, Emil W. Haury.)

this that archaeologists attempt to reconstruct on paper the original architectural design.

What characterizes most prehistoric southwestern Indian architecture is that building materials were obtained locally and that construction tended to be dry rather than wet. Water is scarce in the Southwest, and it is only where there are rivers that one is likely to find the use of much mud, such as in puddled adobe walls, in construction. Stone masonry or local plant materials were part of the environmentally imposed building code of the day.

After the coming of the white man to the Southwest in the late sixteenth century, we begin to detect changes taking place in Indian architectural construction. Of all Indian dwellings extant in

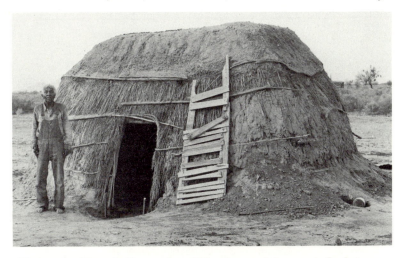

Figure 3. Pima Indian and traditional round house at Snaketown, Arizona, 1934. (Arizona State Museum, Gila Pueblo Collection.)

the Southwest today, perhaps some of those on Pueblo Indian reservations show the least signs of non-Indian presence. But even here the doors of milled lumber, door frames, window frames, and glass betray a foreign influence (Fig. 2), to say nothing of the electric lines, water tanks, power poles, and television aerials omnipresent in many Pueblo communities. Other aboriginal survivals to the present or near present have included such single-dwelling units as the Apache wickiup and tepee, the Navajo hogan in its various forms, and the Pima *shaish ki* (brush house) (Fig. 3).

The picture one perceives from looking at prehistoric and historic aboriginal architecture in the Southwest is that in many areas types of prehistoric structures persisted into the historic period, sometimes until the 1970s. But the persistence, where it has occurred, has been in basic form and basic building material. Changes have come about through the Indians' acceptance of new materials, such as those made of metal, or of old materials worked with European techniques, such as milled lumber. What is suggested is a white influence on Indian architecture, but one in which the Indian remains in control. It is still the Indian who does the construction; it is still the Indian who is architect. Moreover, one

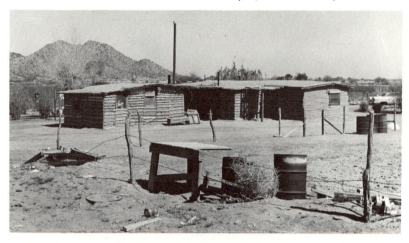

Figure 4. Pima Indian sandwich houses, Bapchule, Arizona, 1972.
(Arizona State Museum: photo, Helga Teiwes.)

gets the impression from some of these buildings that elimination
of the non-Indian additions would have no particularly far-reach-
ing affect on those who use them.

Another aspect of Indian responses in architecture to white
presence is seen in the acceptance of wholly new forms. The bee-
hive oven and corner fireplace, for example, represent a Spanish
introduction to the inventory of southwestern architectural fea-
tures. A merger of non-Indian influence and Pima native dry
architecture is the sandwich house, a rectangular structure of
coursed layers of mud held in place by horizontal boards inside
and out (Fig. 4). Even here, however, the materials are still ob-
tainable locally and the Indian can be his own building contractor.
The architecture remains essentially one of a vernacular tradition.

A deeper influence on native life is depicted in Indian-used
buildings that are nonnative in almost every way. Some have been
modified by the addition of native feature, such as a brush arbor
abutting the prefabricated house of an Apache. The houses built of
adobe bricks, for all practical purposes, represent Spanish influ-
ence in the Southwest. Although adobe bricks occur prehistori-
cally, it is only in rare and isolated instances. Their widespread use
among Indians after the 1500s is attributable almost wholly to

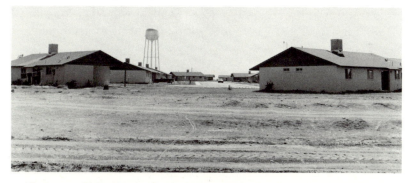

Figure 5. Federally funded housing project for the Gila River (Pima) Indian Reservation, Sacaton, Arizona, 1972. (Arizona State Museum: photo, Helga Teiwes.)

Hispanic influence. Thus it was that for the first half of the twentieth century the preferred building material among Papago Indians was the sun-dried adobe brick. Whole settlements were built of such materials. As the building materials changed, so did the settlement pattern. Houses that were formerly only within earshot of one another in the desert sometimes came to be grouped in clusters around a plaza in the Mexican manner.

In the 1970s it is not unusual on southwestern Indian reservations to see houses made by non-Indians, with nonnative materials in wholly foreign architectural styles which are arranged with reference to sewer connections and water lines rather than in accordance with the Indians' own sense of community planning (Fig. 5).

Finally, white influence has also affected public and religious architecture in Indian settlements. The Hispanic-style churches of the Pueblo reservations in New Mexico and the neoclassic and Mission Revival styles of the twentieth century seen in churches on the Pima and Papago reservations are cases in point.

By and large, Indian-style architecture as a southwestern artifact has all but disappeared. Indians do not design and build houses for white men. The general practice at present is for white men to design and to build houses which, incidentally, will be lived in by Indians. Occasionally white men will hire Indians to do the labor, or even to supervise it. But the building materials, the de-

signs, and even the various uses made of a house or other structure are from outside the native proclivities of Indian communities.[15]

PAINTING

Far less evidence of prehistoric southwestern Indian painting has survived than that for native architecture. The best-known form of prehistoric visual imagery is found in rock art, both pecked or incised and painted. Only in the past twenty years or so has serious study been given to petroglyphs in the Southwest, and, while regional styles and gross time periods are now generally recognizable to the few authorities specializing in their study, the reasons why such art was created remain largely a mystery. Some examples may represent doodling; some may involve the deepest of man's religious devotion and aspirations.

Human, animal, and floral figures occur, as do representations of mythological beings and geometric designs. The art occurs on the walls of caves and cliffs (Fig. 6), in kivas, and on boulders exposed to the weather. There was also painting on basketry and fabrics (Fig. 7), on ceramics (Fig. 8), bone, wood, shell, and human bodies. Designs were predominantly geometric; colors were limited to those which could be made from materials at hand. Red, brown, yellow, black, and white are the most common.

Except for an occasional petroglyph showing Europeans and European-introduced animals such as the horse, southwestern In-

[15] Studies of architecture among southwestern Indians are innumerable. Some of the better known include Jesse W. Fewkes, "Casa Grande, Arizona," *Annual Report of the Bureau of American Ethnology*, 28 (1916), 25–179; George Kubler, *The Religious Architecture of New Mexico* (Colorado Springs: Taylor Museum, 1940); Cosmos Mindeleff, "Aboriginal Architecture in the United States," *Bulletin of the Geographical Society*, 30 (1898), 414–427; Victor Mindeleff, "A Study of Pueblo Architecture, Tusayan and Cibola," *Annual Report of the Bureau of American Ethnology*, 8 (1887), 13–234; and Stanley A. Stubbs, *Bird's-Eye View of the Pueblos* (Norman: University of Oklahoma Press, 1950). A good source for prehistoric architecture in general is Alfred V. Kidder, *An Introduction to the Study of Southwestern Archaeology* (New Haven: Yale University Press, 1962) with an introduction by Irving I. Rouse. Two outstanding studies of Papago Indian religious architecture are James S. Griffith, "Franciscan Chapels on the Papagueria, 1912–1973," *The Smoke Signal*, 30 (Fall, 1974), 233–256, and James S. Griffith, "The Folk-Catholic Chapels of the Papagueria," *Pioneer America*, 7, 2 (July, 1975), 21–36.

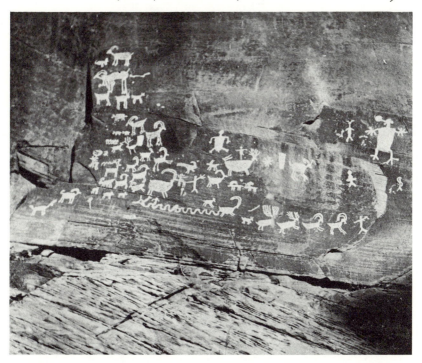

Figure 6. Prehistoric Indian rock art, Clear Creek, Arizona. (Arizona State Museum, Wetherill Collection: photo, L. Lowe.)

dian painting tended to remain peculiarly Indian until the late nineteenth century. Although Hopi Indians probably painted simulated tiles on the walls of the Franciscan mission at Awatovi in the seventeenth century, not until the advent of pencils, pens, paper, and new pigments in the nineteenth century did Indians produce many drawings and paintings done in a manner and subject matter wholly recognizable to non-Indians. By 1919, with the start of what has been called the "Santa Fe movement," we begin to see large numbers of southwestern Indians painting Indian scenes and themes, but almost wholly in response to the non-Indian market. In short, these are paintings created for a new patronage rather than for the immediate use or enjoyment of Indians themselves (Fig. 9). The trend in Indian painting has now brought us to the point at which some Indians are producing what might be thought

Figure 7. Prehistoric painted Salado cotton blanket from Sycamore Canyon, Arizona. (Arizona State Museum: photo, E. B. Sayles.)

of as Indian "protest" art. We also have art being created by Indians that is no longer recognizably Indian in style. In short, there are now southwestern Indians whose painting styles have become fully assimilated into those of the mainstream of American art.[16]

[16] The three standard works about southwestern Indian painting are J. J. Brody, *Indian Painters and White Patrons* (Albuquerque: University of New Mexico Press, 1971); Dorothy Dunn, *American Indian Painting of the Southwest and Plains Areas* (Albuquerque: University of New Mexico Press, 1968); and Clara Lee Tanner, *Southwest Indian Painting: A Changing Art*, 2d ed. (Tucson: University of Arizona Press, 1973).

Figure 8. Prehistoric Hohokam plate, southern Arizona. (Arizona State Museum: photo, Helga Teiwes.)

TEXTILES

Long before the birth of Christ, people living in the Southwest had developed textile crafts to a high degree. Small weaving included sandals, bags, bands and belts, tump straps, and a few other objects. Materials included cultivated cotton as well as cordage from several wild plants such as yucca, agave, and juniper. By 1100 the vertical loom was in widespread use in the Southwest and beautiful cotton blankets and garments were being woven (see Fig. 7). Cotton was spun into thread on a simple spindle. It was twined as well as woven (Fig. 10).

The best-known and most dramatic response to the presence of Europeans in the realm of textiles is seen in the history of Navajo weaving. It is likely that Navajos learned the craft of weaving from

Figure 9. Gerald Nailor, *Navajo Debutante*, 1938. Gouache on white paper. (Arizona State Museum, James T. Bialac Collection: photo, Helga Teiwes.)

Pueblo Indians early in the 1700s. The material with which they wove was principally sheep's wool. Sheep were introduced to the Southwest by Spaniards as early as the sixteenth century. The Spaniards are known to have obtained wool blankets from Navajos for export to Mexico in the late eighteenth and early nineteenth centuries. From the very outset it appears that most Navajo weaving was an economic response to non-Indian markets.

By the late nineteenth century, a system of trading posts in the Navajo country insured a steady demand for Navajo woven products, and innumerable changes began to occur. New dyes, imported yarns, and new designs and sizes, both of blankets and rugs, changed the face of Navajo weaving with breathtaking rapidity (Fig. 11). Navajos wove clothing and blankets, especially saddle blankets, for themselves and for other Indians, but the major influences are directly attributable to non-Indian presence. Vegetal

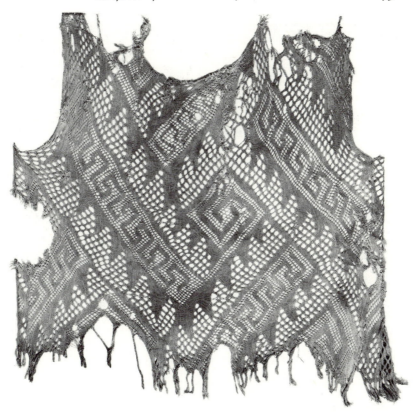

Figure 10. Prehistoric twined cotton shirt, Tonto National Monument, Arizona. (Arizona State Museum: photo, E. B. Sayles.)

dyes from plants, some locally obtained and others bought in packages at trading posts, were added to the inventory of aniline dyes and to the natural color of wool. In 1919–20 a Navajo weaver named Hosteen Klah broke with tradition and began to weave Yeibichai figures and dry paintings into his tapestries. Rugs began to be made in sizes that could be spread or hung only in the largest homes, hotels, or museums. In the 1970s Navajo textiles are so expensive that few Navajos can afford to buy them even if they want to. Although Navajo textile art is pre-eminently an Indian response to white demands, it is one that remains literally in Navajo hands.

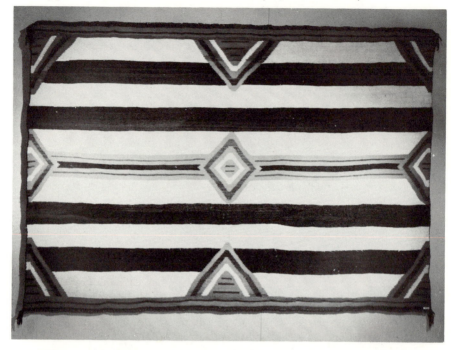

Figure 11. Navajo wool blanket, ca. 1900. (Arizona State Museum: photo, E. Tad Nichols.)

Elsewhere, as in Arizona's southern desert, the Pima Indians, who aboriginally wove plain white cotton blankets on horizontal looms, relinquished the craft soon after the middle of the nineteenth century when machine-manufactured textiles became easily obtainable. But in the north, Hopi and other Pueblo Indians continued weaving with native cotton to make the fabric for ceremonial costumes even after the coming of Europeans. By the end of the nineteenth century Hopi women were still commonly dressed in dark woolen blanket, shawl, Hopi-woven wool belt, and puttee-style buckskin moccasins (Fig. 12). In the 1970s, the usual Hopi dress, except for ceremonial occasions, consists entirely of machine-made fabrics.[17]

[17] An excellent discussion of southwestern textiles, including a good bibliography, is in Clara Lee Tanner, *Southwest Indian Craft Arts* (Tucson: University of Arizona Press, 1968), pp. 40–84. The standard source on prehistoric

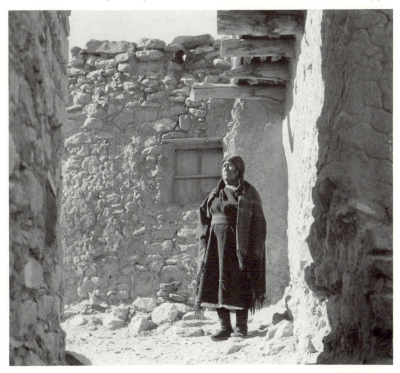

Figure 12. Hopi woman standing in a street at Hano, First Mesa, Arizona, 1926. (Arizona State Museum: photo, F. Hanna.)

BASKETRY

No discussion of the evolution of southwestern Indian artifacts would be complete without mention of basketry. Its prehistoric beginnings in the Southwest, as exemplified by the split-twig figurines found in caves in the Grand Canyon and which were made two millennia B.C., are possibly as old as stone tools in this locale (Fig. 13).[18] Prehistoric baskets have been found in many dry

southwestern textiles is Kate Peck Kent, "The Cultivation and Weaving of Cotton in the Prehistoric Southwestern United States," *Transactions of the American Philosophical Society*, 47, pt. 3 (Nov., 1957), 457–733.

[18] Robert C. Euler, "Willow Figurines from Arizona," *Natural History*, 75, 3 (March, 1966), 62–67.

Figure 13. Prehistoric stick figurine, Grand Canyon, Arizona. (Arizona State Museum: photo, E. Tad Nichols.)

caves and rock shelters in the Southwest, and it is clear from the range of types that they were used for many purposes.

In the historic period, Indians continued to fashion baskets for their own use. Until very recent times Apaches made pitch-covered twined *tus*, or water jars, for their own use (Fig. 14), and Papagos made plaited baskets as fetish containers well into the twentieth century. Hopis continue to make plaited sifters from bleached and unbleached yucca. But as with weaving among the Navajo, most basketry produced by Indians in modern times is made for and sold to non-Indians on the cash market. In some cases, as among Apaches and Hopis, a response has been to elaborate on native forms and designs to produce a finished product that is at once

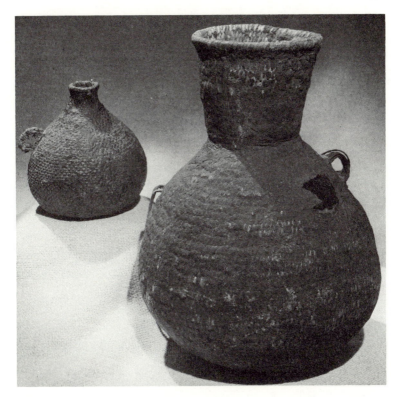

Figure 14. Apache Indian pitch-covered water bottles. (Arizona State Museum: photo, Douglas Lindsay.)

useful, decorative, and well made. Pimas and Papagos have made miniature baskets of yucca and horsehair, some in traditional forms and others as whimsical mice or turtles (Fig. 15). In the 1970s, Papago Indians make more baskets for sale than any other Indians in the United States. The variety of forms, including all manner of figurines, is almost endless. There are even Papagos who have made baskets in the shape of life forms, if basket is the correct word, out of colored telephone wire.[19]

[19] Tanner, *Southwest Indian Craft Arts*, pp. 7–39.

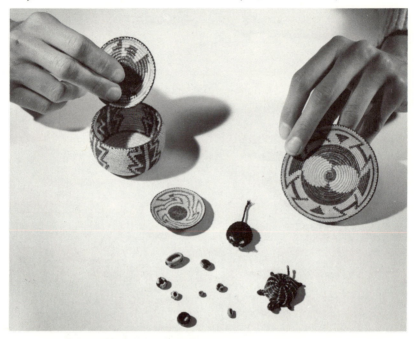

Figure 15. Modern miniature Pima and Papago Indian baskets. (Arizona State Museum: photo, Helga Teiwes.)

METAL

Although it is a little-known fact, metal artifacts, specifically copper bells shaped as crotals or hawk's bells and made by the lost-wax casting process, existed in the Southwest during prehistoric times (Fig. 16). While it is possible that some of these bells were made by Indians in the Southwest, it is more likely that they were imported into the Southwest from Mexico, an area where several kinds of metal working were known.[20]

[20] See Roderick Sprague and Aldo Signori, "Inventory of Prehistoric Southwestern Copper Bells," *The Kiva*, 28, 4 (April, 1963), 1–20, and Roderick Sprague, "Inventory of Prehistoric Southwestern Copper Bells: Additions and Corrections—I," *The Kiva*, 30, 1 (Oct., 1964), 18–24. Casas Grandes, in northwestern Chihuahua, Mexico, was a center of copper production and coppersmithing in the thirteenth century A.D. See Charles C. DiPeso, *Casas Grandes. A Fallen Trading Center of the Gran Chichimeca*, 2 vols. (Dragoon,

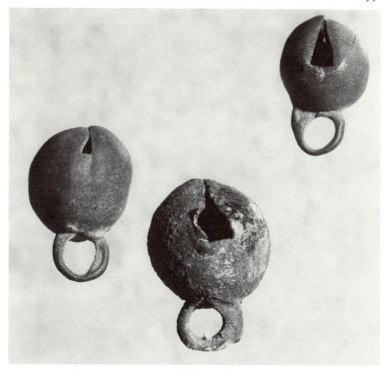

Figure 16. Prehistoric copper bells from Arizona. The largest is about three-quarters of an inch in diameter. (Arizona State Museum: photo, Helga Teiwes.)

What this suggests is that metalwork by historic tribes of the Southwest represents a European-introduced material, a European technology, and a European or non-Indian demand. Although nineteenth-century silverwork among Navajos found its way into the inventory of Navajo horse furniture and Navajo ornament, the overwhelming majority of metal artifacts made by southwestern Indians, which we would call Indian in form and conception, was produced for sale on the cash market (Fig. 17). Today's Navajo and Hopi silversmiths, especially, are known all over the world.

Ariz.: Amerind Foundation, and Flagstaff, Ariz.: Northland Press, 1974), 2, 510–517.

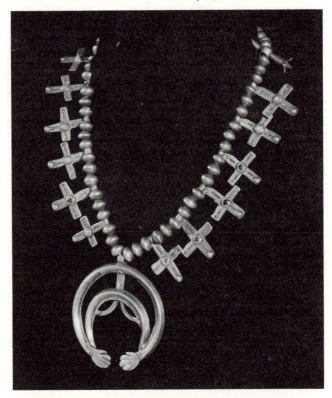

Figure 17. Navajo silver necklace with "naja"
pendant, early twentieth century. (Arizona State
Museum: photo, Douglas Lindsay.)

What is Indian is the art. All else in metal craft is foreign to
southwestern aboriginal culture.[21]

ORNAMENT

Prehistoric ornaments were made principally of shell, usually
marine shells either from the Gulf of California or from the Pacific
Ocean. Beads, hairpieces, and labrets also were made of bone,
stone, wood, and ceramics. Turquoise and jet were used for inlay
material as well as for beads (Fig. 18).

[21] Tanner, *Southwest Indian Craft Arts*, pp. 119–150.

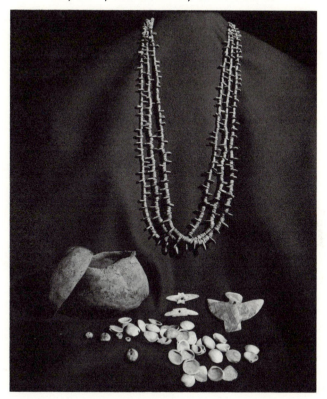

Figure 18. Prehistoric turquoise necklace, shells, and pottery from southern Arizona. (Arizona State Museum: photo, Helga Teiwes.)

From about 900 to 1200, the prehistoric Hohokam peoples of southern Arizona decorated shells by etching them with acid, probably acetic acid derived from the fermented juice of cactus fruits (Fig. 19). The earliest known acid etching in the Old World occurs on armor dating from the fifteenth century A.D. Here is an instance in which a southwestern Indian manufacturing technique predates the same technique among Europeans.[22]

The indisputable excellence of prehistoric Indian jewelry has

[22] Paul Ezell, "Shell Work of the Prehistoric Southwest," *The Kiva* 3, 3 (Dec., 1937), 9–12; J. Anthony Pomeroy, "Hohokam Etched Shell," *The Kiva*, 24, 4 (April, 1959), 12–21.

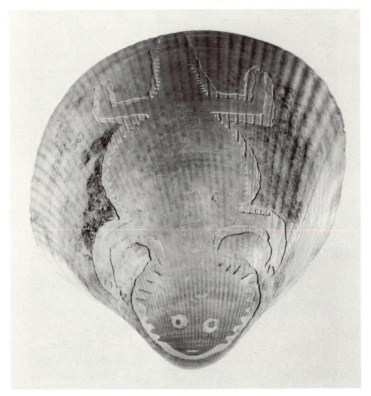

Figure 19. Prehistoric Hohokam etched shell from from Snake-town, Arizona. (Arizona State Museum: photo, Helga Teiwes.)

continued from the historic period until the present. Today's market has been greatly expanded by the addition of non-Indians to the region, to say nothing of the market throughout the world. Modern materials include coral and exotic shells imported from Pacific Ocean locations as far away as Japan and from the Mediterranean area. Materials are now combined in totally new ways and in wholly nonaboriginal forms such as tie clasps, cuff links, and brooches fastened by pins.[23]

[23] Tanner, *Southwest Indian Craft Arts*, pp. 115–119. See also Naurice Koonce, Alan Manley, and Clara Lee Tanner, *Ray Manley's Portraits & Turquoise of Southwest Indians* (Tucson: Ray Manley Photography, 1975).

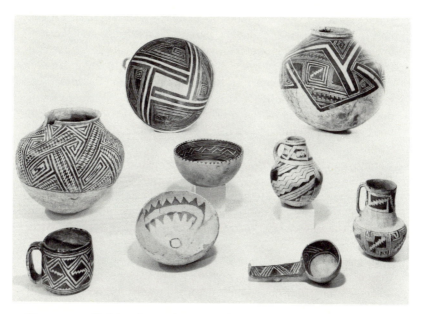

Figure 20. Prehistoric southwestern Anasazi pottery. (Arizona State Museum: photo, Helga Teiwes.)

CERAMICS

Pottery studies are the *sine qua non* of southwestern archaeological studies. Every serious student of southwestern archaeology must become familiar with hundreds of types and varieties of prehistoric Indian pottery and be able to recognize from a single sherd the place and approximate time of the object's manufacture. There are plain wares, painted wares, incised wares, corrugated wares, and wares that are stuccoed, pinched, punched, polished, smudged, and appliquéd. Jars, bowls, figurines, ladles, canteens, and mugs are variously molded, modeled, coiled, scraped, and paddle-and-anviled. Among the end results have been some of the most artistically pleasing ceramics in the world (Fig. 20).

The effect of non-Indian presence on Indian pottery was sudden. The wheel-turned ceramics of European Mexico, overglazed in greens and reds, rapidly made their way into New Mexico. By the

late nineteenth century, a familiar story had repeated itself. Most Indian ceramics that continued to be made were intended for the non-Indian market. Metal pots, pans, ladles, barrels, and the lard bucket took the place of ceramic water and dry-storage vessels and cooking vessels. In New Mexico, among the Pueblo Indians, some styles of pottery survived in something akin to aboriginal excellence—and for Indian rather than non-Indian consumption—until the flourishing of the tourist trade after 1880.[24] In Arizona, however, by the end of the nineteenth century the Hopi Indian manufacture of pottery had all but ceased when a Hopi-Tewa woman named Nampeyo observed the excavation of prehistoric Hopi pottery by Jesse W. Fewkes. She began a revival of this ancient craft on First Mesa, a revival that continues to the present —except that the consumer is now usually non-Indian. Even so most of the designs and forms in Hopi pottery remain steadfastly Hopi (Fig. 21).

In other pueblos, in addition to ceramics of fine craftsmanship, we see salt- and peppershakers painted with poster paints. There are ashtrays, shirt buttons, house-shaped incense burners, and all manner of figurines. Papago Indians have produced eggcups, pencil holders, wall plaques, and even miniature birch-bark canoes out of pottery. One of the prices of such adaptation to nonnative use is represented by the Papago bird effigy saltshaker which lacks an opening large enough for introducing the salt.[25]

Very nearly all the southwestern ceramics produced today are for the non-Indian market. There are Indian potters, both men and women, whose crafts are modern in every respect. The pottery is wheel-turned; clays are commercial; the kilns are electric. Some pieces are even set with turquoise. In 1974 prices ran as high as $3,000 for a single pot.[26]

[24] The best surveys of historic New Mexico Pueblo Indian pottery are Francis H. Harlow, *Matte-Paint Pottery of the Tewa, Keres and Zuni Pueblos* (Santa Fe: Museum of New Mexico Press, 1973), and Larry Frank and Francis H. Harlow, *Historic Pottery of the Pueblo Indians 1600–1880* (Boston: New York Graphic Society, 1974).

[25] Bernard L. Fontana, "The Cultural Dimensions of Pottery: Ceramics as Social Documents," in Ian M. G. Quimby (ed.), *Ceramics in America* (Charlottesville: University Press of Virginia, 1973), pp. 1–13.

[26] See *Arizona Highways*, 50, 5 (May, 1974), an entire issue devoted to modern southwestern Indian pottery. See also Tanner, *Southwestern Indian Craft Arts*, pp. 85–114, and Charlotte Cardon (ed.), *Ray Manley's South-*

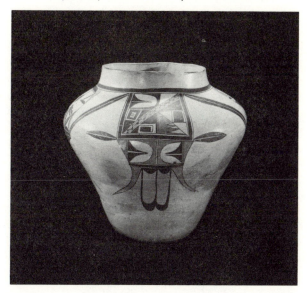

Figure 21. A large Hopi olla by Nampeyo, 1900–1928.
(Arizona State Museum: photo, Helga Teiwes.)

MISCELLANEOUS CRAFTS

This survey of southwestern Indian artifacts does not take into
account prehistoric crafts and tools of stone. Knives, blades,
projectile points, hammers, crushers, grinders, and all manner of
utilitarian tools were fashioned from stone by methods involving
pressure flaking, percussion flaking, abrading, and polishing
throughout the known thirteen thousand years of southwestern
Indian history. Nor have we considered masks and kachina dolls
made of wood, feathers, plant materials, hide, and cloth. Nor does
it include southwestern Indian glass beadwork, a craft introduced
to some parts of the Southwest as early as the late sixteenth cen-
tury and which gains in popularity today because of an expanding
market. The trends in these crafts would be the same: a progres-
sion from artifacts made by and for Indians to Indian-made ob-
jects reflecting an ever greater response to non-Indian demands.

western Indians Arts and Crafts (Tucson: Ray Manley Photography, 1975),
pp. 35–52.

CONCLUSION

Southwest Indian artifacts in prehistoric times reflect ways of living that were largely dependent on the immediate environment. With rare exceptions—such as prehistoric trade items, most of which were matters of luxury than of necessity—artifacts were made from materials at hand through the skills and ingenuity of the people. Some of the artifacts also suggest that ideas were borrowed and traded among Indians over wide geographic areas. It may be, for example, that the monumental southwestern Indian architecture owes a considerable debt to the great civilizations of Mexico.

With the onset of the historic period, we begin to see acculturative changes reflected in the forms of Indian artifacts. Native materials and techniques of manufacture generally persisted longer than the native forms, but in time these, too, were altered by new ideas coming to Indians via strangers to their land.

A third stage in the process—and the process is neither universal nor irreversible—is seen in Indian-made artifacts that are produced solely in response to white patronage. Virtually all of these products are viewed as "arts and crafts" by their consumers; from the point of view of their producers, the meaning of such objects is an economic one.

In this connection, there has been a shift from the total anonymity of the craftsman in prehistoric and early historic times to artifacts which are now clearly identified with the names of individual artists and craftsmen. For much of the twentieth century we have known the names of Indian painters. They sign their art. And in the last thirty years the jewelers, silversmiths, and potters have been marking their wares with individually identifying marks. There are now collectors who specify particular weavers before buying a basket or a rug.

Such a change is highly indicative of a shift from small, relatively isolated and sociologically integrated communities of Indian people to communities that now display varying degrees of social disintegration and which look increasingly to the outside world for their cultural, to say nothing of their physical, sustenance. Indeed, it may be—ironic as it appears—that Indian craftsmen continue to

produce their wares not only for economic gain, but for the survival of separate cultural identity. Overlay silver jewelry stands for Hopi in the face of continued pressures toward assimilation by the non-Hopi world. To fashion coiled yucca baskets is to be a Papago, but whether the craft continues because of white man's presence or in spite of it is an open question.

Finally, there are also artifacts that are Indian in the sense that they are used by Indians or have been integrated into the cultures of Indians, although everything else about them is nonnative. We think of a Navajo astride his horse, seated on a western saddle which is thrown over a wool blanket, and holding reins to a metal bit and metal-decorated bridle as being very "Indian." We have more trouble, however, thinking of Navajo boys sitting on their imported Japanese motorcycles as being typically Indian. Few anthropology museums would refuse to accept a well-documented Navajo-used saddle, saddle blanket, bridle, and bit, but how many of them would be willing to accession and catalog an equally well-documented saddle from a Navajo Yamaha? Or the whole motorcycle, for that matter?

In the same vein, a wooden plow with steel plowshare held by a Pima Indian and pulled by two horses may be worthy of museum consideration. What, then, about the Pima-owned and -operated Allis Chalmers combine? If we are serious about considering artifacts as documents of history, and if one of our concerns is with artifacts of Indians of the Southwest and their usefulness to us in understanding change, should we be giving museum space to such objects and labeling them Indian?

Elsewhere in this collection of papers, Brooke Hindle comments: "Like the individual, society recalls from history whatever information it needs to function in a given direction at a given moment." He has given us a definition of history. The past does not change, but a full retelling of it would require as much time to execute as the original event. It is thus that histories, as selections of past events and interpretations of their meanings, change. "What historians once wrote about the Reformation or the Hanoverian Succession or the American Revolution," noted E. E. Evans-Pritchard, "is not what they now [1961] write, and this is not just because we know more about these events. It is also

because the climate of opinion has changed with vast political and other social changes."[27]

So it is with artifacts of Indians of the Southwest. Depicted in a photograph or resting on a museum shelf, they do not change. They are in the past. But they are also the present. In the hands of those of us who study material culture to enhance our understanding of American life, these objects become a past that is ever undergoing evaluation in the light of the present.

[27] E. E. Evans-Pritchard, *Social Anthropology and Other Essays* (New York: Free Press of Glencoe, 1962), p. 182.

Vernacular Architecture: Historical Evidence and Historical Problems

Nathaniel W. Alcock

Vernacular architecture bears a rather different appearance from an American viewpoint than it does to British eyes. This is because of the variety of building traditions involved—English, Scots, Irish, French, Scandinavian, Dutch, Spanish, Russian, and Indian —and the distinctive transformations these traditions underwent when they were established on a new continent. In this paper the detailed examples are chosen from England (Fig. 1) because of the limitations of the author's knowledge, but some of the problems that are being confronted by scholars in that country certainly have their parallels in the United States—and perhaps their answers.

Viewed as artifacts, as aspects of material culture, houses have some highly distinctive characteristics. Their bulk makes them virtually immobile. There are recorded cases of timber-framed houses being moved, but they are very rare.[1] Similarly, the individual components are massive. This means that distribution maps are usually correct. Houses are hardly ever of one date; it would not be inaccurate to say *never*. They have always been altered,

[1] This practice is less rare in New England than in Britain. There seem to be no historical records of the moving of stone or brick houses.

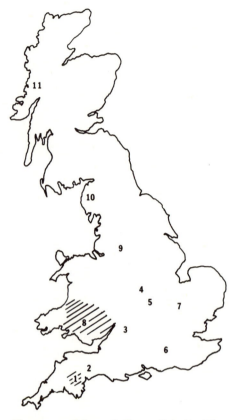

Figure 1. Map of Great Britain. The numbers represent selected areas of coherent building traditions. (Drawing, N. W. Alcock.)

added to, or—worse—subtracted from. There will, therefore, be technical problems of separating the various phases, as well as the normal problems of dating any unstratified series of artifacts. These problems may, of course, be mitigated if one has additional excavated evidence or if the building itself is dated. Such evidence is much rarer in the United States than in England where some areas (especially those with stone buildings) have a high proportion of dated houses from the late sixteenth century onward.

There was a distinctive and intimate relationship between the craftsman and the client. Building contracts provide the most direct evidence of this; they are often written in such technical language that they must, in their essentials, have been dictated by the craftsman.[2] The carpenter or mason held in his domain the technical design and the constructional details. But to what extent did he control continuity or innovation in plan and layout? It is here that the client—and his wife—had a vital interest in the end product.

Four aspects of the interaction of houses with history are examined in the rest of this paper. As far as possible the technical problems of construction or dating are avoided. The first is fairly well known, stemming from the observation some twenty-five years ago by W. G. Hoskins of a large group of houses of clearly defined character.[3] In comparison to their medieval predecessors they are thoroughly modern, with full upper floors, and chimneys often serving upper- as well as ground-floor rooms. They are attributed by style, or from inscribed dates, to the fairly short period from the 1570s to about 1640. More important, they are widely distributed. Examples in southern England can be cited almost at random (Fig. 1) from East Devon (no. 2), the Cotswolds (no. 3), Leicestershire (no. 4), Northamptonshire (no. 5), Surrey (no. 6), and Cambridgeshire (no. 7).[4] In some of these areas (e.g., the Cotswolds and Cambridgeshire) they constitute a majority of the existing vernacular buildings.

These houses led Hoskins to propose the "Great Rebuilding." He explained it as a consequence of the inflation of the second half of the sixteenth century. Farmers could accumulate profits from the imbalance between the rising prices of primary products and their relatively fixed rents and expenses. Unfortunately, more recent work does not support the neat chronology of this theory. For example, on the western slopes of the Pennines in Lancashire (no. 9), there are many buildings dating from the second half of the

[2] For example, see N. W. Alcock, "Warwickshire Timber-Framed Houses: A Draft and a Contract," *Post-Medieval Archaeology*, 9 (1975), 212–224.

[3] W. G. Hoskins, "The Rebuilding of Rural England," *Past and Present*, 4 (Nov., 1953), 44–59.

[4] For a general survey covering all these areas, see M. W. Barley, *The English Farmhouse and Cottage* (London: Routledge & Kegan Paul, 1961).

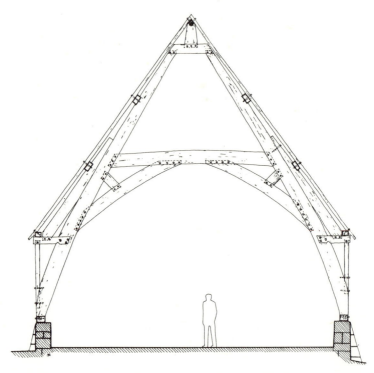

Figure 2. An example of cruck construction: the barn at Leigh, Worcestershire. A cruck can be defined as a single timber reaching from ground level to the apex of the roof. From N. W. Alcock, *A Catalogue of Cruck Buildings* (London and Chichester: Phillimore & Co. for the Vernacular Architecture group, 1973), frontispiece. (Drawing, F. W. B. Charles).

seventeenth century. Further north still, in Cumberland and Westmoreland (no. 10),[5] there is a still later building period, approximately 1700 to 1750, with very few houses indeed predating it. With this confrontation with what appeared to be a nice illustration of economic history, we leave for the moment the dates of houses.

A second type of evidence is distributional; it is illustrated here

[5] R. W. Brunskill, *Vernacular Architecture of the Lake Counties* (London: Faber & Faber, 1974).

by the constructional technique shown in Figure 2.[6] The celebrated "cruck truss" has attracted the interest of architects and antiquaries since at least the middle of the last century. As a consequence, it is probably better known than any other aspect of vernacular architecture. It is generally an early technique, passing out of use by the early sixteenth century in southern England but probably continuing through the seventeenth century in the north. It was also very popular; more than two thousand examples survive. The distribution is well defined, with a main eastern edge, and with smaller areas lacking crucks in southwest England and southwest Wales.[7] But the pattern of distribution shown by the map (Fig. 3) provides both the evidence and the problem.

Other distributions of carpentry methods and framing techniques have been studied, including some of sixteenth- and seventeenth- rather than fifteenth-century features.[8] None shows any sign of having the same distribution as crucks, but they have the same main characteristics; the distributions are well defined, *and* they bear no resemblance to any distribution to be expected on the basis of known historical facts. They are clearly evidence of something, but of what? We should perhaps interpret them in terms of the spread of ideas and the influence of one carpenter on another, but in detail they are obscure.[9]

The third aspect of the interaction of houses with history is illustrated by Townsend, Stockland, East Devon (Fig. 4). Apparently an example of the Great Rebuilding, it has a two-story porch and stone ovolo-molded windows and fireplaces, all dating perhaps to 1620.[10] But an exploration of the roof-space shows it to be thickly coated with soot from the smoke of an open hearth. This house, therefore, is not seventeenth century at all; it is medieval and of high enough quality when built, around 1450, to

[6] N. W. Alcock, *A Catalogue of Cruck Buildings* (London and Chichester: Phillimore & Co. for the Vernacular Architecture group, 1973).

[7] The northern edge is less certain because of a lack of fieldwork.

[8] J. T. Smith, "Timber-Framed Buildings in England," *Archeology Journal*, 122 (1965), 133–158.

[9] For a further discussion of the cruck distribution, see J. T. Smith, "Cruck Distributions: An Interpretation of Some Recent Maps," *Vernacular Architecture*, 6 (1975), 3–18.

[10] N. W. Alcock and Michael Laithwaite, "Medieval Houses in Devon and Their Modernisation," *Medieval Archeology*, 17 (1973), 100–125.

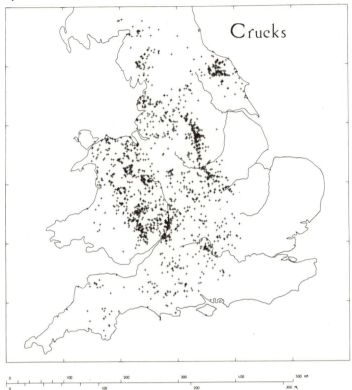

Figure 3. Distribution map of cruck buildings. Shown are 2,045 examples. From N. W. Alcock, *A Catalogue of Cruck Buildings* (London and Chichester: Phillimore & Co. for the Vernacular Architecture group, 1973), [p. 16], fig. 2.

have remained acceptable to the present day (with the insertion of upper floors and chimneys).

It does not stand alone. Within the space of six square miles along the little river Yarty, there are more than twenty medieval houses of similar plan and character to Townsend (Fig. 5).[11] In

[11] This is based on an unpublished intensive survey of the area shown in Figure 5 by the author. Less detailed fieldwork suggests that a similar concentration of early house exists over most of East and part of North Devon, extending into West Somerset. There are concentrations of early houses in other parts of England, most notably Kent and Essex.

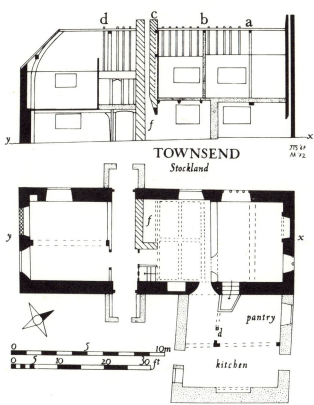

TOWNSEND
Stockland

Figure 4. Townsend, Stockland, Devon. Plan and long section. The original walls are solid black and the sixteenth-century chimney is shaded. Stippling and cross-hatching indicate later work. A reconsideration of the evidence suggests that the parlor end wall should be shown stippled, particularly in view of the reconstruction of the roof at this end. It seems likely that the house was extended somewhat when the room within the hall was converted into a parlor with its own fireplace in the seventeenth century. From N. W. Alcock and Michael Laithwaite, "Medievel Houses in Devon and Their Modernisation," *Medieval Archaeology,* 17 (1973), 100–125.

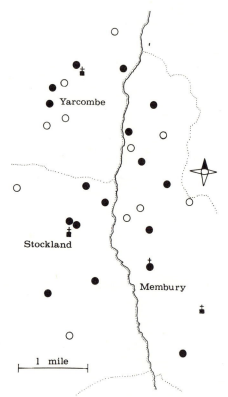

Figure 5. Confirmed medieval houses (black circles) and probable medieval houses (white circles) along the valley of the Yarty in East Devon. The early settlement pattern was apparently one of isolated farms. Parish boundaries are shown dotted. (Drawing, N. W. Alcock.)

fact, allowing for some clusters of later buildings around the parish churches, one third of the *existing* farms can be identified as having been fine houses around the year 1500. This, of course, sounds just like the Great Rebuilding, but for a different period and more localized (probably limited to an area twenty to thirty miles across).

The Great Rebuilding itself, and the other building periods observed in northern England, can be given a simple economic rationale. Surplus wealth was clearly available; further, it was probably not easily used for capital investment, such as the purchase of more land or stock, and so it was used for house-building. But in fifteenth-century Devon, we have no indication of the source of such wealth. It would be more accurate to reverse this and say that the houses provide primary evidence of access of wealth, and then ask documentary historians to corroborate and explain it. Precisely this correlation has been achieved for Deerfield, Massachusetts, where the great majority of the houses date from the 1760s, and have been found to reflect the prosperity of tobacco growing at this period.[12]

Townsend can also be taken as an example of the relationship between houses and social history. Its plan is straightforward and very typical of southwest England in that the original house contained three ground-floor rooms and a cross-passage. The later fireplace in the central room, and the soot in the roof over it, identifies this as the hall, used for living, cooking, and eating in both the medieval and post-medieval periods, before the kitchen was added at the rear in the seventeenth century. But, beyond this, what was the mode of life in this house, and what was the use of the other rooms? By 1600 we find documents that help to answer these very difficult questions. Particularly useful are a few estate surveys that itemize the rooms in houses. By extrapolation from these, it can be inferred that at Townsend, the room across the hall might have been a buttery (food storage) or a dairy, while the inner room was probably a ground-floor sleeping chamber.

These sources, however, pose problems of their own. As the seventeenth century progresses, we find that the term *chamber*, for this ground-floor room, begins to be superseded by *parlor*. What probate inventories there are do not indicate any obvious difference between the two, but it is clear that people were making a

[12] Information from Abbott L. Cummings about documentary research by Mrs. R. Miller. See Richard M. Candee, "American Vernacular Architecture," *Journal of the Society of Architectural Historians*, 34, 4 (Dec., 1975), 302–303.

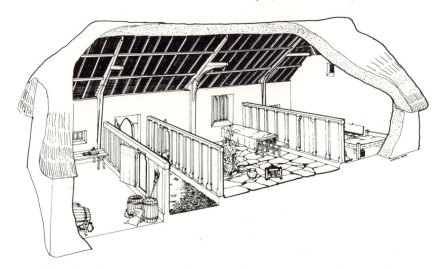

Figure 6. Reconstruction of the interior of a medieval house in East Devon. (Drawing, Cary Carson.)

distinction. What was the use of a parlor in a house like this that distinguished it from a chamber?[13]

Looking at Townsend in its original form gives unusual insight into the character of life in such a house. The evidence has been well concealed by the later modernizations, but it indicates unmistakably that when the house was built the partitions between rooms were only six feet high, and the house was undivided above this.[14] A re-creation of such a house, including room use, is shown in Figure 6. In most other parts of England, room divisions went fully to the roof, but low partitions were widespread in Devon, apparently for a straightforward structural reason. Solid walls, either of cob (adobe) or stone, were universal, and the roof-trusses (of cruck or related form) did not need a low level tie-beam because their feet were secured in the walls. Thus, the head-beam of the plank (stud-and-panel) partition did not need to be attached to the truss, but could be placed wherever was con-

[13] The probate inventories might be more useful here were it not that virtually all those for Devon were destroyed in 1942. See M. Cash, *Devon Inventories* (Exeter: Devon & Cornwall Record Society, 1966).

[14] Alcock and Laithwaite, "Medieval Houses in Devon."

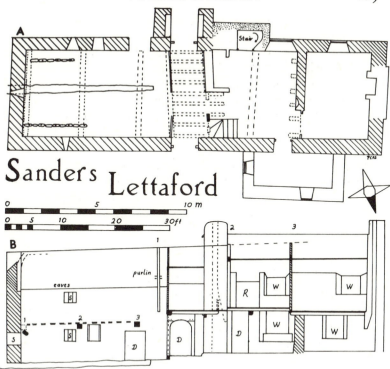

Figure 7. Sanders, Lettaford, North Bovey, Devon. Plan and long section. Original work is shaded; later work is stippled or left blank. Recess (R) slit (s). This is one of the last long-houses to retain its byre unaltered. From N. W. Alcock, M. Laithwaite, and P. Child, "Sanders, Lettaford," *Proceedings of the Devon Archaeological Society*, 30 (1972), 227–233. (Drawing, P. Child.)

venient. It is paradoxical that people who were spending a great deal of money on new houses (and Figure 6 errs if anything in showing the house carpentry too plain rather than too smart), accepted what must have been a remarkably smoky life.

The final example also concerns house plans, but in this case room use is much less of a problem. The illustration (Fig. 7) is chosen again from Devon, from the fringe of Dartmoor, the high central moorland (Fig. 1, no. 1).[15] The house dates from about

[15] N. W. Alcock, M. Laithwaite, and P. Child, "Sanders, Lettaford," *Proceedings of the Devon Archeological Society*, 30 (1972), 227.

1550 but, with an open hall, it is still medieval in character. The building is of unexpectedly high quality, featuring ashlar masonry in granite, that most intractable of materials. In plan, however, it is very much a small farmer's house; the cattle shelter in one end and, because the domestic part of the house is so small, the use of the remainder of the rooms is not difficult to infer. The central room was the hall, and the inner room probably combined both buttery and dairy until the little lean-to dairy was added on the side of the hall. The one original upstairs room, over the inner room, was probably the sleeping chamber. The other chambers, over the passage and the hall, were added (separately) in the late sixteenth and seventeenth centuries. It is an indication of the farmer's priorities that the hayloft, over the byre, was almost certainly present from the beginning.

The problem with this house is not the interpretation of the plan but the reason for it. This "long-house" plan is found in almost all Dartmoor houses, in some houses to the south and west of the moor, and in East Cornwall, but it is not found at all in East Devon where the early houses already described are located. The long-house occurs in some parts of Wales (Fig. 1, no. 8), but is entirely absent from others. It is found occasionally in northern England, notably Cumberland and Westmoreland (no. 9), and also in western Scotland (no. 11).[16]

What is it about these areas, the mode of farming, or some other aspect of their traditions that caused this compact and specialized plan to be used? Essentially, this is another distribution problem, but one that possibly relates more to agrarian than to economic or technological history. It is so far unsolved.

[16] P. Smith, *The Welsh House* (London: Her Majesty's Stationery Office, 1976); Brunskill, *Vernacular Architecture of the Lake Counties.*

The Broadening View of the
Historical Preservation Movement
Charles B. Hosmer

Since the opening of the first historic house museum in the United States in 1850, the preservation movement has been involved in a constant seesaw battle between the forces of "progress" and the small band of prophets who firmly believe in maintaining buildings that speak eloquently of the past.[1] The amateur historians who have formed the front line in this warfare have spent most of their time fighting rearguard actions, and as a consequence the literature on preservation philosophy is almost nonexistent. Perhaps these people have been guided by instinct more than by reason as each crisis has come along. In many instances the public has discovered that a particular historic site was in danger of destruction before the forces of preservation have had time to evaluate the importance of the place. The decision to save these sites has been made at the last minute, and only then have the would-be preservers settled down to formulate their arguments. When one considers the haphazard way in which these campaigns have been conducted, it is rather surprising to see that so many really worthwhile buildings have been saved.

In the century and a quarter since the dedication of the Hasbrouck House in Newburgh, New York, preservationists have been

[1] Charles B. Hosmer, Jr., *Presence of the Past: A History of the Preservation Movement in the United States before Williamsburg* (New York: G. P. Putnam's Sons, 1965), pp. 36–37.

broadening their definition of history. Richard Candee states the challenge very well:

> Today this movement is undergoing widespread redefinition, quite properly expanding the boundaries of the umbrella term *preservation*. More than at any time in the past, those actively engaged in this aspect of environmental conservation have been forced to question their basic assumptions, asking what should be preserved and (just as important) why. Simultaneously, they are seeking new methods to preserve those portions of the built environment that meet the ever-shifting criteria for preservation.[2]

As each new viewpoint toward historic buildings developed within the ranks of the people who saved them, that particular idea has persisted and the new arguments have simply been added to it. Nothing in the field of preservation has become outmoded.

The first generation of preservers, operating during the greater part of the nineteenth century, considered themselves to be in the business of creating and perpetuating shrines. The most obvious example of this trend was the successful campaign conducted by the Mount Vernon Ladies' Association of the Union between 1853 and 1859. This patriotic crusade culminated in the purchase of the Mount Vernon estate just before the outbreak of the American Civil War. Ann Pamela Cunningham, the organizer of the Mount Vernon Ladies' Association, created an informal army of women who were inspired by the character and reputation of George Washington. Apparently the exhibition of Washington's home as a symbol of public and domestic rectitude appealed peculiarly to the popular mind at that time. During the years that followed the Civil War the interest in the homes of great men probably was influenced by the success of the Mount Vernon crusade.[3] Several buildings along the northeast coast that had served as headquarters for George Washington at critical periods in the Revolution were saved. In one instance (in Morristown, New Jersey) the preservationists were men.[4] In the South, the military and political accomplishments of Andrew Jackson led to the purchase of his

[2] Richard Candee, "New Hampshire Preservation Redefined," *Historic Preservation*, 27, 3 (July–Sept., 1975), 20.

[3] Hosmer, *Presence of the Past*, pp. 57–62.

[4] *Ibid.*, pp. 57, 58, 76–84.

home, the Hermitage, outside of Nashville, Tennessee, by the state of Tennessee in 1856. Thirty-five years later, when the Hermitage farm was considered as a possible site for a Confederate old soldiers' home, the women of Tennessee formed the Ladies' Hermitage Association with the intention of maintaining the house and its immediate surroundings as they had been when Jackson occupied the place.[5]

More often than not the organizations that preserved and exhibited landmarks associated with famous men were primarily interested in patriotic education. They had the strong conviction that a visit to one of these shrines would automatically make one a better person. Perhaps the interest in transforming the character of the American people is best expressed by a quotation from a campaign booklet intended to help preserve Harewood, a country home near Charlestown, West Virginia:

> The influence exerted toward good citizenship and a love of country by a trip to such an historic spot as Harewood cannot be calculated. Its educational value upon the young is certain. It helps to keep us in touch with high ideals of an elder day and brings the romance and beauty of Colonial and Revolutionary life before our eyes as can no spoken or printed word. No one can go to such a place as Harewood and walk through its stately chambers and about its beautiful grounds without becoming a better man or woman.[6]

Early in the twentieth century a number of New Englanders who could best be described as antiquaries began to form organizations for the purpose of preserving and exhibiting homes that illustrated the culture of seventeenth- and eighteenth-century America. This second generation of preservationists concentrated most heavily on buildings that had unusual structural features or a high proportion of surviving original material. Their goals represented a shift from the prevailing emphasis on patriotic inspiration to filial piety because they were memorializing the life of their ancestors.

When the Metropolitan Museum of Art began to search for paneling to be installed in the American Wing, the curators and

[5] *Ibid.*, pp. 59–60.

[6] Edwin Fairfax Naulty, *Historic Harewood, of Pleasant Memory and Patriotic Association* (Philadelphia: Washington Manor Association for the Purchase and Preservation of Historic Harewood, 1901), p. 29.

collectors found themselves at war with the antiquaries. William Sumner Appleton, the founder of the Society for the Preservation of New England Antiquities, fought against the museum because he was committed to the idea that shipping rooms to Manhattan Island (or worse yet—to the Midwest) was a form of destruction. By the later 1930s the era of collecting period rooms had subsided and museum specialists and preservationists were able to forge an uneasy alliance.[7]

The real leaders of the preservation movement through the 1920s were an elitist group of amateurs who were concerned about saving buildings that had associational value. Many of these people believed that the public at large needed to have a greater appreciation for the sufferings of the pioneer settlers of America as well as some regard for the contributions of the patriots who had helped to create the new nation. Prior to 1925 the vast majority of historic houses, forts, taverns, and other public buildings that were on exhibition were administered by historical societies and patriotic-hereditary organizations.

The period from 1926 to the outbreak of World War II brought an entirely new generation into the American preservation movement. An activity that had been almost entirely centered in local areas suddenly became a national phenomenon. Several new forces transformed the preservation picture, most notably the commitment on the part of John D. Rockefeller, Jr., to restore the city of Williamsburg, Virginia, and the equally significant decision of Henry Ford to assemble Greenfield Village in Dearborn, Michigan. At this same time it was clear that the automobile was well on its way to remaking the landscape. While it enabled large numbers of Americans to visit historic sites, even in remote parts of the country, the construction of highways, filling stations, and parking lots posed a threat to those old buildings. Toward the end of the 1920s Horace Albright, the director of the National Park Service, concluded that the time had come to push the Department of the Interior into historic preservation in the eastern part of the United States, and in 1930 the federal government took over the battlefield at Yorktown and the George Washington Birthplace National Monument.

[7] Hosmer, *Presence of the Past*, pp. 216–232.

The massive projects administered by Colonial Williamsburg and the National Park Service brought together for the first time a sizable number of professionals in the fields of architecture, history, archaeology, landscape architecture, and engineering. In a few instances people trained as museum specialists also assisted in these endeavors. This third generation, which came into positions of responsibility in the early 1930s, dominated the field of historic preservation from the early years of the Depression until the 1960s. These people helped to draft the Historic Sites Act of 1935 and were still in positions of power and responsibility when the Historic Preservation Act of 1966 became the charter for a greatly expanded federal program.

The restoration of the eighteenth-century capital of the colony of Virginia became an architectural project for two reasons: John D. Rockefeller, Jr., the patron of the whole operation, was greatly impressed with the beauty of the buildings and the charm of the setting; and the only profession that was really ready to undertake the Williamsburg research program was the profession of architecture. The research for the restoration provided a number of talented young architects with an unparalleled opportunity to study both the vernacular and the more formal architecture of Tidewater Virginia on a broad scale over a period of several years. The documentary research for the restoration was carried on largely by talented amateurs who worked diligently to provide the historical references that were needed to transform the buildings that were still standing back to their eighteenth-century appearance. There was no particular emphasis on the future interpretation of the city of Williamsburg at the time the construction operations were taking place. In fact, there was no trained historian on the staff who could argue for the kind of restoration work that would have been necessary to be able to tell the visiting public about the political significance of the city.[8]

In 1930 there was a significant change in the organizational structure at Williamsburg which included the hiring of Harold R. Shurtleff as the director of the Department of Research and Record. Shurtleff was a talented artist and architect who had an instinct for historical research. He realized that most professional

[8] William G. Perry, "Notes on the Architecture," *Architectural Record*, 78, 6 (Dec., 1935), 363–377.

historians had no interest in what was going on at Williamsburg, so he attempted to correct this sorry situation by becoming a historian in his own right. In 1934 Shurtleff began working on an advanced degree at Harvard and attempted to run his department in Williamsburg by means of a taxing commuting schedule. Unfortunately he died in 1938 and was, therefore, not able to participate in the second stage of the Williamsburg restoration which began that year.[9]

The most influential group of consultants that contributed to the Williamsburg experience was the Advisory Committee of Architects who dealt with a great many controversial questions relating to the restoration of the buildings. The dominant figure on that committee was Fiske Kimball, the director of the Philadelphia Museum of Art, who was considered by many to be the dean of American architectural historians. Kimball and his colleagues put together a set of guidelines which called for the retention of old materials and recognition of the importance of honesty in presenting reconstructed portions of the city as new work. But there is no evidence that the architect's committee discussed the significance of the restoration for the American people.[10]

The only person who thought deeply about the meaning of the restoration in this early period was Dr. W. A. R. Goodwin, the rector of Bruton Parish Church, who had initially inspired Rockefeller to undertake the Williamsburg project. Goodwin firmly believed that the restored colonial capital would provide the American people with an important object lesson. But the contribution of Virginians to American history and the study of the society of the pre-Revolutionary South seemed to be a secondary consideration for the architectural scholars who were attempting to master the language and the workmanship of the past. When the reconstructed capitol building opened in 1934, the visitors had their first opportunity to see the impressive result of a determined collaborative effort in architectural scholarship. The beauty and scale of the Williamsburg operation did become a major force in the American preservation movement, but it should be remembered that the people who first toured Williamsburg in those years were given a

[9] Samuel Eliot Morison, "Introduction," in Harold R. Shurtleff, *The Log Cabin Myth* (Cambridge: Harvard University Press, 1939), pp. xiii–xvii.
[10] Perry, "Notes on the Architecture," 370.

museum experience because the talks given by the hostesses tended to be object-oriented. There was an assumption that every article of furniture had to be explained.

The contribution made by the National Park Service staff to historic preservation in the 1930s was an enormous one, but it went in a completely different direction. Historians dominated the planning sessions at the Park Service headquarters, and the first national historical parks were transformed into teaching laboratories for the public. Some architects, most notably Charles E. Peterson (who had lived in Williamsburg), carried out scholarly restorations at Yorktown and at Morristown, New Jersey. But the fact remains that the National Park Service decided quite early in the development of its historical program that there would not be an emphasis on total physical reconstruction of each historic scene but rather concentration on sample restoration, which would demand more on the part of the imagination of the visitor. The historical staff in the Washington office of the Department of the Interior began to sketch out a national plan as soon as the emergency appropriations of the New Deal permitted them to hire historians, archaeologists, and architects who would develop state historic sites. The principal emphasis was on exhaustive research prior to the restoration of the buildings and careful presentation of the cultural context of each historic site to the public.

The decision to restore Williamsburg to its eighteenth-century appearance was made during the fall of 1926, just as Henry Ford was starting to assemble Greenfield Village in a wooded area near his office at the Ford Motor Company in Dearborn, Michigan. The auto manufacturer moved more than ninety old buildings inside the walls of Greenfield Village to illustrate the progress of the United States through invention, agriculture, and the mechanical arts. He was deeply suspicious of the kind of history that he believed pupils were being taught in the schools of his day.

Ford was convinced that if children could be educated in the one-room schoolhouses located throughout the village and then use the machinery and the furnishings set up in the surrounding buildings, a real understanding of the life of the past might be possible. He insisted that every machine housed in Greenfield Village had to be in working order. He fully expected the pupils in his schools and the visitors to watch these devices perform their as-

signed tasks so that they could appreciate the progress of inventions and the way they had transformed a rural America into an urban colossus. He believed that Thomas Edison was the principal architect of this transformation and dedicated a sizable portion of the village to an exact reconstruction of Edison's Menlo Park Laboratory as it stood in New Jersey. Ford actually brought Edison to Greenfield Village to sit in the laboratory and work with his old assistant in any experiments that the aged inventor might intend to carry out. In short, the village buildings possessed in Henry Ford's imagination a sense of historical authenticity given them by the people who had lived in and used them. Once the museum complex opened to the public, the exhibition areas would become a major educative force. Ford repeatedly told interviewers that he would "endow" his village with "youth."[11]

The third major contribution made in the early 1930s in the field of preservation centered in the city of Charleston, South Carolina, where a small group (led principally by architects and journalists) united to carry out a survey and to draft a zoning ordinance that would permanently set aside the battery district of this eighteenth-century seaport. The leading citizens of Charleston were absolutely dedicated to the idea that they should save everything that was worthwhile in their urban landscape.[12] At about the same time that the first Charleston zoning ordinance went into operation, the Garden Club in Natchez, Mississippi, advertised the idea of a Garden Pilgrimage which would bring people from different parts of the United States into the small Mississippi riverport at a time when the economy of that community was in desperate straits.[13] In both Natchez and Charleston alert preservationists became aware of the fact that it would be too expensive for them to preserve anything of value to their communities by saving individual landmarks. Instead they determined to save whole areas if that was at all possible. The interest in historic districts in the

[11] William Greenleaf, *From These Beginnings: The Early Philanthropies of Henry and Edsel Ford, 1911–1936* (Detroit: Wayne State University Press, 1964), pp. 71–100.

[12] Samuel Gaillard Stoney, *This Is Charleston* (Charleston, S.C.: Carolina Art Association, 1944), pp. 134–136.

[13] Bette Barber Hammer, *Natchez' First Ladies, Katherine Grafton Miller and the Pilgrimage* (New York: by the author, 1955), pp. 1–7.

1930s seemed to be restricted almost entirely to cities in the South and West and only surfaced briefly in the North in the city of Portsmouth, New Hampshire.

The preservation leaders of the Depression decade had developed at least four distinctly different uses for historic buildings, and the contrasts that existed among the major restoration efforts clearly illustrated these divergent views. John D. Rockefeller, Jr., and the Williamsburg architectural staff, working under the firm of Perry, Shaw, and Hepburn, appeared to be well on the way to creating a picture of the past which, although it was somewhat idealized, was as visually accurate as their new-found research techniques could make it. The fact that some planners constantly referred to the restoration process as "painting a picture" carried with it the inherent danger of constructing a scene that was all of one piece. The restoration appeared to be entirely consistent within itself when in historical fact the community had not been. The concept of utilizing buildings as harmonious elements in a depiction of a single time period carried with it the idea of arranging the past into some kind of order. The net result was an understandable conviction on the part of visitors that the eighteenth century may well have been a beautiful and harmonious era that they should look back on with nostalgia. Henry Ford wanted the mills, laboratories, and homesteads of his village to serve as living textbooks of mechanical progress. His interest in restoration centered largely on the hope that the visitor would appreciate how much modern day life owed to pioneer inventors and scientists in particular. Ford chose to stress the continuity of human progress rather than to illustrate a period or a place. The National Park Service staff was just as interested in accuracy as was the architectural office at Williamsburg, but the historians at Yorktown and Morristown wanted to be sure that the public understood the broad historical importance of the sites they were touring. The historians wanted to put together a chain of parks that effectively presented the major trends in the development of the United States. It was natural for the interpreters at the Department of the Interior to concentrate on the drama of history as seen through military engagements, shifts in political sentiment, and the homes of famous men. The Charleston preservationists attempted to

maintain an urban landscape as an illustration of a way of life. They preferred to emphasize the charm and grace of a society that had disappeared with the coming of the Civil War.

By 1935 it could be said that the American tourist already had a chance to see history taught through old buildings in three varied ways. In Williamsburg the visitor with sufficient knowledge and imagination could enjoy the architectural context of a vanished civilization, but he had to supply a good bit of his own understanding of American history to appreciate the cultural contribution of eighteenth-century Virginia. The tourist at Morristown and Yorktown in these years would find himself in the capable hands of Park Service historians who worked hard to instill a sense of the importance of these sites in the development of nationhood. Visitors to Charleston and Natchez were treated to an intimate glimpse of the homes of the people who had dominated the society of the pre-Civil War South. It probably could be argued that in both of these cities a romantic picture was being stressed.

All three of these approaches to historic preservation did much to convince the American people that their historical heritage should be used as a teaching instrument. Laurence Vail Coleman, the director of the American Association of Museums, detected this cultural awakening as early as 1932 when he took an extensive journey through the eastern United States, visiting historic house museums. A year later he published the only major book on the subject of house museums to appear for a period of thirty years. Coleman believed that the preservation idea was going to be a significant factor in the future of museum work, and he wanted to do all that he could to convince local historical societies that there already was a professional way to go about restoring and exhibiting these historical relics. Coleman realized that the people who maintained these historic houses still had a long way to go in giving the visitor a meaningful view of the past. He found that most guides operated on the assumption that objects were isolated from any cultural context.[14]

During the 1930s the historians and archaeologists who became associated with Colonial Williamsburg and the National Park Service found that they were often treated as second-class citizens by

[14] Laurence Vail Coleman, *Historic House Museums* (Washington, D.C.: American Association of Museums), pp. 87–95.

their own professional colleagues. Although the great mass of historians and archaeologists had not been prepared to treat old buildings as documents, the young men and women who actually carried out the restorations and guided the visitors through these historical exhibits saw that they were indeed working with a basic research tool.[15]

The minutes of the Advisory Committee of Architects at Williamsburg and the conference reports in the National Park Service files show that during the second half of the 1930s the accuracy of most of the newer restorations came under close scrutiny. The more these architects and historians worked on houses and public buildings as museums, the more concerned they became about the pursuit of historical truth in the restoration process. At Williamsburg, William G. Perry, the principal member of the architectural firm hired to carry out the restoration, quickly learned that it was difficult to subdue his own artistic taste as an architect and to stick to the building practices of colonial Virginia.[16] Nevertheless, Perry and his alert staff of draftsmen learned to do just this. In the National Park Service the historians, architects, archaeologists, curators, and engineers gradually locked themselves into a procedure that guaranteed certain scholastic safeguards for every major restoration project. By 1938 the director of the Park Service decreed that every restoration in the park system had to have a full documentary and archaeological justification before any alterations could begin. The group of people who carried on this research made a great contribution to historical studies because they gradually developed a coherent restoration philosophy. They gained an increased respect for their sister disciplines, and they eventually concerned themselves with the development of an interpretive policy. There is no question that the visitors who came to Williamsburg or to the National Historical Park at Morristown discovered an exciting new dimension in history in the later 1930s.

The expansion of the activities of the federal government during the Depression inevitably broadened the horizons of historic pres-

[15] Interview with Jean C. Harrington, May 18, 1970; interview with Frederick L. Rath, Jr., July 13, 1970; transcripts in the author's possession.

[16] William G. Perry, "General Statement on the Restoration of Colonial Williamsburg" (Dec. 31, 1946), Architectural Reference Library, Colonial Williamsburg Foundation, Williamsburg, Va. pp. 7–9.

ervation in several directions. In 1933 the Department of the Interior, working closely with the American Institute of Architects and the Library of Congress, sponsored the first Historic American Buildings Survey. This operation continued in a sporadic fashion until the outbreak of World War II. Teams of architects spread across the United States photographing and measuring thousands of buildings, usually concentrating on places of local historical interest that were in danger of demolition. The catalog for that first survey contains an index that lists the newly recorded landmarks according to their building types, and the breadth of coverage is bewildering. Here are a few typical subject headings from the 1941 index: barns and sheds, blacksmith shops, canal locks, convents, dairies, dog-run-type buildings, fences, fire stations, furnaces, jails, kilns, observatories, pounds, railroad stations, shot towers, well structures, and windmills. It should be noted that only ten years before the publication of the HABS catalog in 1941 probably none of these building groups would have been considered to possess any historic interest.[17]

Following the passage of the Historic Sites Act of 1935, the newly constituted Branch of Historic Sites in the National Park Service undertook a nationwide survey of historic sites and buildings. For a few years a group of historians traveled throughout the United States trying to catalog the most important buildings under a set of historical themes that had been outlined by the Advisory Board of the Park Service. Although only a few of the sites listed in the first survey were saved as a consequence of the Park Service study, the experts on the board that met regularly to advise the Secretary of the Interior studied the buildings, and this tended to enlarge the whole concept of history as it was illustrated through American architecture. By 1941 the Park Service staff had located hundreds of important places in nearly every part of the country, and the board members approved a great many of these sites as possessing national significance.

The lack of interest in historic preservation within the existing professional organizations contributed to a splintering effect in the worlds of architecture and history. In 1940 the architectural

[17] U.S. Department of the Interior, National Park Service, *Historic American Buildings Survey* (Washington, D.C.: Government Printing Office, 1941), pp. 438–470.

scholars who had been teaching in American colleges and universities in the field of art history separated themselves from the existing professional groupings and formed the American Society of Architectural Historians.[18] During its first years of existence, the infant organization devoted a considerable amount of space in its magazine to the problems involved in historic preservation. At about the same time the American Association for State and Local History separated from the larger American Historical Association and began to deal with the interests of the librarians, administrators, and museum technicians who worked with local and state historical societies. The appearance of these new professional societies showed that there was a natural desire to communicate with people who had a common interest in the study and interpretation of historic sites.[19]

The first purely local historic survey of any great significance was sponsored by foundation grants in Charleston, South Carolina, in 1941. Miss Helen McCormack carefully photographed and recorded the architecture of the oldest part of the city of Charleston. During the war the results of her survey were published by the Carolina Art Association and the Civic Services Committee under the title *This Is Charleston*. The real-estate brokers and city planners quickly recognized that the book had increased the property values in the battery district.[20]

The coming of World War II ended many preservation projects in this country because the funding for such activity dried up and many of the younger professionals went off to war. But there already was a generation of trained and dedicated preservation specialists who represented a number of fields. These people had administered large projects and had learned to work with each other while they developed a preservation philosophy of their own. Most of them had been associated with either state or federal programs and, by virtue of their civil service status, had time to devote to preservation research even when budgetary restrictions were imposed in the postwar years.

[18] "A.S.A.H. Beginnings: A Report," *Journal of the Society of Architectural Historians*, 1, 1 (Jan., 1941), 20–22.

[19] *Annual Report of the American Historical Association for the Year 1940* (Washington, D.C.: Government Printing Office, 1941), pp. 102–109.

[20] Stoney, *This Is Charleston*, 2d ed., rev. (Charleston, S.C.: Carolina Art Association, 1960), pp. ix, x.

Ronald F. Lee, the chief historian of the National Park Service, was probably one of the most broad-minded thinkers in the field of historic-sites management. After World War II Lee became the center of a farseeing group of people from all over the United States who saw that the country was facing a new preservation crisis. He realized that the techniques and organizations developed in the 1930s were simply not an adequate defense against the threats posed to America's architectural and historic heritage by the expansive peacetime economy. Lee and his friends set about remedying the situation in several ways. They spent considerable time founding a national preservation organization which came into being in 1947 under the title National Council for Historic Sites and Buildings; in 1949 the same group assisted in creating the National Trust for Historic Preservation which merged with the council in 1953. Within the Department of the Interior, Lee was largely responsible for finding a regular system for disposing of surplus forts that had been put up for sale by the War Assets Administration. He also was a central figure in developing a program of salvage archaeology which was intended to save as much as possible of the recoverable material located in river valleys threatened by flood-control programs.[21]

The new National Council for Historic Sites and Buildings became a central focus for the preservation movement in the later 1940s under its first director, Frederick L. Rath, Jr. Rath and Lee worked together to help private and governmental organizations in their efforts to catalog the historic riches of America and to exchange information on restoration problems and preservation techniques.

During the tense years of the cold war, the federal money that had been so important in the 1930s was not available to carry out elaborate restorations or to finance new surveys. Instead, the proponents of preservation began to promote smaller programs that were calculated to achieve the same ends. For example, Jean C. Harrington, a noted archaeologist who was superintendent of the Colonial National Historical Park, sponsored a conference in 1946 to try to bring together academic historians and archaeologists who had worked at historic sites. The university teachers who

[21] Ronald F. Lee, *United States: Historical and Architectural Monuments* (Mexico City: Instituto Panamerico de Geografia e Historia, 1951), pp. 56–64.

came to view the programs at Williamsburg, Yorktown, and Jamestown admitted to Harrington that they had learned a great deal from their encounters with the staff professionals; but there is little evidence that the conference had any particular lasting effect on the teaching of history.[22]

During the 1950s the preservation movement in the United States experienced a renaissance. A few old programs were greatly extended, such as the Historic American Buildings Survey, which came back into being under a new directive permitting the teams of architects to measure and photograph architectural ensembles in parts of the United States that had not been adequately covered through the make-work projects of the Depression years. The movement toward surveys of historic districts in American cities began to blossom again in the later 1950s, most notably with the College Hill study in Providence, Rhode Island. At the same period, following the zoning of Beacon Hill in Boston in 1954, there was a greatly increased interest in historic zoning as a means of preserving the older portions of our cities.[23]

Two other new techniques came into being. The National Park Service greatly expanded its public-contact services through the construction of visitor centers at many historic areas under the program known as Mission 66. This ten-year developmental scheme had much to do with the rejuvenation of the National Survey of Historic Sites and Buildings. The program calling for the creation of Registered National Landmarks became a substitute for the cooperative agreement negotiated under the Historic Sites Act. It seemed more satisfactory to the Park Service officials to designate registered landmarks after a sufficiently detailed study of each major historical theme than it had been to respond to congressional pressure for the creation of separate National Historic Sites.[24]

The 1950s also brought a number of threats to the field of historic preservation in the form of the interstate-highway pro-

[22] J. C. Harrington to regional director, Region One, National Park Service, May 10, 1946, Record Group 79, National Park Service, Colonial National Historical Park, Conferences, National Archives, Washington, D.C.

[23] Robert G. Garvey and Terry Brust Morton, "The United States Government in Historic Preservation," *Monumentum,* 2 (1968), 26.

[24] Albert Rains (ed.), *With Heritage So Rich* (New York: Random House, 1966), pp. 208–210.

gram, the construction of parking lots, and urban-renewal activity. In the cities the danger was especially great because often the proponents of slum clearance selected the areas that contained the greatest percentage of old buildings for their pilot projects. By the early 1960s after experimenting with a restoration in Portsmouth, New Hampshire, the officials connected with renewal became more cooperative and found that there were instances where they could plan their programs with the assistance of preservation leaders.

During the past decade and a half the preservation movement has moved from its earlier emphasis on historic houses to a much broader view. This change was codified in 1966 with the passage of the Historic Preservation Act. The major shift was from the isolated museum to an emphasis on the total architectural environment. Historians, archaeologists, and architectural historians who are immediately concerned with preservation activity have attempted to unite the preservation movement with the environmentalists.[25]

The latest trend turned the preservation community from a heavy concentration on historic zoning ordinances in the direction of survey work done in all of the states with a listing of major and minor sites of all types on the National Register. The power base first moved from the National Park Service to the cities and then to the states. There is adequate federal funding for these programs, which has been a tremendous help in the survey work and in some of the restoration projects.

Popular magazines and some guidebooks have begun to view the American heritage in the broader context of what might be called the historical landscape. This has meant that the process begun under the Historic American Buildings Survey and the National Survey of Historic Sites and Buildings in the 1930s has actually accelerated, and we are now finding that we have a great many more treasures than we had suspected. But at the same time these areas cannot be saved as private museums or as parts of state and federal park systems. Instead, with increasing frequency they have been put to some productive adaptive use. This innovative thinking has appeared at a particularly opportune time for the preservation movement.

[25] Candee, "New Hampshire Preservation Redefined," 20–23.

Since the creation of the Winterthur Program in Early American Culture in 1952 and Columbia University's program for training architects in 1964, there has been a steady increase in the number of graduate and undergraduate institutions that have prepared students for careers in historic preservation through architecture, planning, or conservation. Here in the middle 1970s it is possible to survey the field and discover a surprising number of young trained professionals who already have amassed several years of experience in historic preservation work. They have sought to give a sense of order and authenticity to a movement that has been dominated by amateurs.

There is no question that many of the problems that have plagued preservationists since the nineteenth century are still with us today. There is still some philosophical confusion as to what preservers are trying to do and why they are doing it. There is a considerable lack of information about what is happening in different parts of the country in spite of the valiant efforts of the National Trust and the American Association for State and Local History. Conferences and short courses have helped to some degree, but the uniqueness of each preservation situation has made it difficult to draft meaningful guidelines for all of the people who set out to save old buildings. There continues to be an unfortunate gulf that separates the historical profession and sizable proportion of architects from the historic preservation field. *The Harvard Guide for American History* has relegated the preservation movement to a brief article entitled "Non-documentary Sources." The American Historical Association has not had a session on preservation work at any of its annual meetings since 1963. Preservation conferences themselves have often ended up as panels of experts talking to the converted about subjects already treated numberless times before in other meetings. Just as the states are receiving funds for survey work, they are discovering the phenomenal abundance of their historical and architectural treasures; yet state officials still seem to lack the creative imagination and the determination to save a substantial proportion of that heritage.

In almost all instances the individuals or groups that have saved historic landmarks have done so in reaction to reports of impending destruction. They usually made a crucial decision to preserve something, and then they erected a set of criteria. This process has

tended to make preservation appeals in both spoken and published form rather disorganized. For example, preservationists who seek support from the public sometimes claim that the building they are interested in is the finest example of its type or the only surviving structure in a particular architectural mode. In most instances they actually have no idea about the correctness of these assertions because they have never had the opportunity to study the results of competent surveys.

The national catalog instituted by the Historic Preservation Act of 1966 should definitely change the tone of preservationist rhetoric. Once we have begun to evaluate the sites that are already accepted on the National Register, we will be able to understand which buildings are really notable and which ones represent a reasonably common or typical style.

One of the most remarkable things about the broadening of the preservation movement is the persistence of the crusading zeal of pioneer restorationists. Practically every argument and every organization that characterized the early years of the movement are still with us today. The changes have largely been through accretion rather than through any serious transformation. It is possible to find today groups who are eager to save buildings of a type that have only recently been recognized as possessing any historic interest whatsoever. At the other extreme, organizations like Colonial Williamsburg Foundation, the Mount Vernon Ladies' Association of the Union, and the Society for the Preservation of New England Antiquities proudly carry on traditions that go back half a century or more. This unplanned growth has tended to give the preservation community an eclectic flavor so that the public at large still equates the activities of an organization like the National Trust for Historic Preservation exclusively with the standard historic house museum. Actually the National Trust has focused on several areas of newer preservation techniques including scenic easements and adaptive uses.

In spite of the fact that the number of volunteer workers and professional consultants has grown steadily over the years, the wanton destruction of worthwhile portions of our architectural heritage has continued at an increasingly accelerated pace. It would appear today that only a determined effort on the part of the National Trust will effectively educate the public at large about the

need for saving sections of our cities from the forces of change. Heretofore it has been assumed that progress could only be achieved when new construction programs had been initiated to replace obsolete buildings. The new generation of preservationists views the retention of the architectural environment as an essential evidence of our growth. It is possible that we face an era of great promise, because, if the 1930s is a dependable model, the healthiest thing that can happen to the field of history and historic preservation is an economic crisis. In current architectural periodicals considerable interest is now being given to the recycling of old buildings. Why? Because it's cheaper. Because that is where the jobs are going to be. And suddenly practicing architects are going to shift over and become preservationists. Professionals are going to be aware of the fact that they have to take the general public, including the amateur preservers, seriously. And perhaps that leads to one further point: the new generation of scholars takes itself too seriously. Historians, planners, architects, archaeologists, and curators need a little more humor; they are too concerned with what is "right" and what is "wrong," and they see these matters as moral causes. Their arguments create a wall between them and the public.

If the future of the historic preservation field can be gauged from its past, then the next quarter century may witness a revolution in widely held attitudes toward city planning and urban growth. The historians of the future may discover that the old buildings their predecessors had ignored will prove to be the most obvious links with America's past. The school-trained preservation technicians of the future should be able to analyze and defuse crisis situations even before they develop. It is possible that these experts will be the first generation to produce a coherent philosophy to guide the private and public agencies that save old buildings. The American people may enter the twenty-first century with a renewed respect for the historic sites that have escaped the apostles of progress and the overzealous restorers of the past. The United States may be just as proud of its cultural maturity in the year 2000 as it is today of its gross national product. If the recent past of the preservation movement is a fair indication, these things will come about.

Museums, Merchandising, and Popular Taste: The Struggle for Influence
Neil Harris

The relationship between the museum and that elusive phenomenon labeled public taste has always been problematic. By that is meant two things: first, that the relationship has more often been assumed than defined and, therefore, exists in an unspecified limbo, making any judgments difficult to defend; and second, that partly because of this obscurity, results have always been outstripped by expectations. Vagueness and imprecision have led invariably to disappointment and suspicion about what in fact museums can do to influence public taste.

Like so much else in the world of American art, justifications for museum support have been instrumental. They were never more so than in moments of institutional formation. Whatever their psychological, social, and economic motives, museum founders, trustees, and donors emphasized, publicly and privately, the potential influence of museums on every aspect of national life.[1]

<hr>

[1] For more on the ideals of early museum founders, see Daniel M. Fox, *Engines of Culture: Philanthropy and Art Museums* (Madison, Wis.: State Historical Society of Wisconsin for the Department of History, University of Wisconsin, 1963); Helen Lefkowitz Horowitz, *Culture and the City: Cultural Philanthropy from the 1880s to 1917* (Lexington: University of Kentucky Press, 1976). See also Neil Harris, "The Gilded Age Revisited: Boston and the Museum Movement," *American Quarterly*, 14, 4 (Winter, 1962), 545–566. Many

Founders assumed that they were competing for money and attention with other worthy enterprises—hospitals, colleges, libraries, and settlement houses—and, therefore, would have to demonstrate the importance of museum support.

Thus, high hopes were married to a sense of crisis in the late nineteenth century, that period when so many of our great art museums were established. The crisis—symbolized to some by the quality of American achievements in the Centennial Exposition— was an impoverished national taste, a struggling and depressed class of artists, and a debased and vulgar stock of consumer goods. Americans had supposedly been suborned by the machine or deluded by national conceit into an affection for meretricious ornament and sentimental, crudely wrought art. In the arena of international competition, which once again the Centennial Exposition highlighted, Americans looked crudely mercenary and badly educated. Museums were meant to redeem the fortunes spent creating them by raising the level of public taste.

Now what was public taste? Although rarely specified, it seems probable that the notion meant then, and means now, the aesthetic knowledgeability, experience, and preferences of the entire population. But because taste involves some kind of expression, the population can be divided, by transaction, into three separate groups: producers, sellers, and consumers. Together they make up the national market place. Influencing public taste, therefore, means increasing knowledge, expanding experience, and shaping preference for all or some of these groups. These were the objectives that lay behind the grand rhetoric of educators, millionaires, and curators when they laid cornerstones, cut ribbons, opened exhibitions, and generally performed the rites of passage for the new museums. There existed then, however, and there remains now, a large problem. Museums were intended to have a broad impact and appeal. But producers, sellers, and consumers of art represented only a tiny fraction of the American public. How, then, could museums of art create the results that they promised?

museum histories also contain statements by founders. Among others, see Winifred E. Howe, *A History of the Metropolitan Museum of Art*, 2 vols. (New York: Gillis Press, 1913–46), vol. 1; and Walter Muir Whitehill, *Museum of Fine Arts, Boston: A Centennial History*, 2 vols. (Cambridge: Harvard University Press, Belknap Press, 1970).

Several strategies were available and museum officials debated their relative value. One was to concentrate upon artists and designers in museum schools, hoping that the accumulation of objects would help improve the future producers of textiles and furniture, as well as the coming painters and sculptors. Another was to assume that comprehensive, well-planned exhibitions would increase public knowledge of design principles by exposure to the history of the world's art. And, finally, some argued for intensive aesthetic experiences, avoiding comprehensiveness for specific effect; by accompanying the art with carefully chosen accouterments, the lessons of harmony and joy that aesthetic mastery could teach would inspire visitors with a sense of new standards. The arguments were often confused and imprecise. But clearly museums' success, as their founders defined it, depended upon their effectiveness in reaching a large lay audience, capturing its attention, increasing its knowledge, and shaping its sense of possibility.

But by the early twentieth century, even more clearly by the 1920s, art museums had apparently abandoned their lay clients; according to critics they had turned into storehouses, paradise for the curator or researcher, but hell for the serious amateur and the ordinary visitor. The art museum, it appeared, had become a depository, a subtreasury of art and valuable artifacts, with only a peripheral influence on knowledgeability and public preference. How this view developed, and why, is the subject of this paper. The argument can be stated briefly. In the period of their founding, museums opted for a consumer orientation to justify their existence. They faced competition but a competition that merchandised in a similar or an analogous fashion. During the interwar years, however, the museum, as a setting, fell behind in its techniques of display, and thus built up a fund of resentments. Making up for lost time, starting in the late 1930s but increasing dramatically in the postwar period, the museum did indeed become a more self-conscious and successful merchandiser of taste, or at least of knowledge and experience, but there have been costs involved which deserve further mention. The late nineteenth century makes a good starting point for discussion.

Besides the museum, there were two other settings, both enjoying their vigorous youth in the Gilded Age, where objects were

exhibited in great number and variety, and which had strong connections with public knowledgeability. The first was the ritual of the World's Fair. Beginning, in a systematic way, in 1876 (previewed in 1853), great expositions appeared regularly in the United States.[2] Between the early 1880s and World War I they loomed every four or five years. Major exhibitions were held during this era in New Orleans, Atlanta, Chicago, Saint Louis, Buffalo, Nashville, San Francisco, San Diego, Seattle, Omaha, and Portland. They were supplemented by great industrial fairs, the series held in Cincinnati and Saint Louis, for example, and by state and county fairs. Contemporaries perceived both the aesthetic and the educational values that expositions projected. Many Americans had their first contact at fairs with serious art, and with a series of major innovations: autos, typewriters, airships, telephones, new furniture and construction methods, electricity, synthetic materials. In booths and pavilions thousands of objects were available for handling and close comparison.

The fair's educational work was universally recognized. The very word *exposition*, which was first applied to fairs in London in the 1750s, referred to the great change that overtook the modern fair. No longer primarily a merchants' encounter, an exposition's primary appeal was now to consumers. It became a giant advertising organ rather than a protected site used to seal commercial transactions. Thus the spectacle of the fairs became steadily more

[2] A useful summary of World's Fair activities can be found in Kenneth Luckhurst, *The Story of Exhibitions* (London and New York: Studio Publications, 1951). For the influence of fairs on American architecture and city planning, see John W. Reps, *The Making of Urban America* (Princeton: Princeton University Press, 1965), ch. 18; William H. Jordy, *American Buildings and Their Architects*, 4 vols. (Garden City, N.Y.: Doubleday, 1972), vol. 3, ch. 6; and Thomas S. Hines, *Burnham of Chicago, Architect and Planner* (New York: Oxford University Press, 1974), chs. 5–6. The best recent study of an American fair is John Maass, *The Glorious Enterprise: The Centennial Exhibition of 1876 and J. H. Schwartzmann, Architect-in-Chief* (Watkins Glen, N.Y.: American Life Foundation, Institute for the Study of Universal History through Arts and Artifacts, 1973). See also David F. Burg, *Chicago's White City of 1893* (Lexington: University of Kentucky Press, 1976). For the impact of foreign displays, see Neil Harris, "All the World a Melting Pot? Japan at American Fairs, 1876–1904," in Akira Iriye (ed.), *Mutual Images: Essays in Japanese-American Relations*, Harvard Studies in American-East Asian Relations, no. 7 (Cambridge: Harvard University Press, 1975), pp. 24–64.

extensive and more elaborate. The "Short Sermon for Sightseers," in the *Art Handbook* of the Pan-American Exposition of 1901, advised its readers, "Please remember when you get inside the gates you are part of the show."[3]

Because of their size and complexity, the fairs quickly developed their own groups of experts trained to supervise everything from architecture and lighting to sanitation and landscaping and who moved from one exposition to another, increasing their skills in handling large crowds and exploiting sites. Charles Howard Walker is one example; a Boston-born architect who became a vice-president of the American Institute of Architects, he was a member of the planning board for the Louisiana Purchase Exposition and designed the Massachusetts Building and the Electricity Building for the same fair; his firm prepared the general plan and designed the Administration Building for Omaha's Trans-Mississippi Exposition. William J. Hammer is another; a consulting engineer for the Edison Company, both in England and America, he installed the lighting for London's 1882 exposition and built for it the first electrical sign ever made; took charge of the eight Edison exhibits at the International Electrical Exposition the Franklin Institute held in Philadelphia in 1884; was appointed in 1888 as consulting engineer to the Cincinnati Centennial Exposition, and designed its lighting; in 1889 represented Edison at the Paris Exposition; and helped organize the International Electrical Congress and served on a jury at the Saint Louis Fair. Bradford L. Gilbert, architect and inventor, designer of railroad stations for Octave Chanute, completed a special station for Chicago's 1893 fair; supervised and designed the construction of the Atlanta Cotton States Exposition in 1895; and was architect for the South Carolina Interstate and West Indian Exposition of 1901. Charles Kurtz, director of the art department for Louisville's annual Southern Exposition; became assistant chief of the art department for the Columbian Exposition; was given the art directorship of the annual Saint Louis Exposition in 1894; aided the art department of the Trans-Mississippi Exposition; became assistant director of fine arts for the United States Commission to the 1900 Paris Ex-

[3] Sophia A. Walker, "An Art Impression of the Exposition," *Independent*, 53, 2746 (July 18, 1901), 1678.

position; and in 1901 was appointed assistant chief of the Louisiana Purchase Exposition.[4] The sole point is that planners and department chiefs moved from fair to fair, building up a capital of experience to make the sophisticated, innovative, and effective displays which comprised the expositions.

Attendance was vast; the Chicago fair of 1893, the best attended, recorded close to 25 million visits (in a population of 70 million). Philadelphia, Saint Louis, and Buffalo were also particularly well-attended expositions. Fair-going was a typical experience for the American at the turn of the century.

If fairs are defined as competitors to museums in their ability to present large selections of the world's art and artifacts, arranged according to specific principles of classification and designed both for aesthetic pleasure and edification, their presence must be taken seriously. However, although the fairs were run generally by different people and contained more inclusive exhibits, they did not really challenge the basic thrust of the new museums. For one thing, expositions preserved the hierarchical approach to classification, a hierarchy basic to the museum's principles of organization. Exhibits were segregated. Almost all the art work, for example, was housed in a separate building (or palace). The highest encomia were usually reserved for these canvases and statues gathered from all over the world and presented in close juxtaposition under one roof. Art, then, was granted a special, reserved, and lofty status among the interests of the world, set off from more mundane pursuits, and glamorized by pompously ornate settings.

Indeed, fair buildings generally resembled museum structures in their turn-of-the-century expression; they were heavily reliant upon classical forms—the Chicago buildings were the single most influential ensemble (Fig. 1)—but even Philadelphia, as John Maass has shown, set a precedent for future museums in Schwarzmann's Memorial Hall. Those fair buildings that were designed for permanence usually became museums; this happened in Saint Louis, Chicago, Philadelphia, San Francisco, and Buffalo, among others. And fair collections, at Chicago, for instance, and at Cincinnati, became the basis for future museum foundings.

[4] Information on these fair officials has been gathered from fair histories and from various biographical encyclopedias.

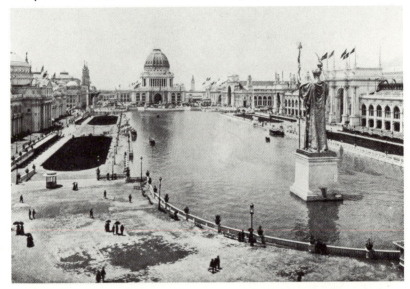

Figure 1. Court of Honor, looking west. From James W. Shepp and
Daniel B. Shepp, *Shepp's World Fair Photographed* (Chicago: Globe
Publishing Co., [1893]), p. 23.

Not only did the expositions present hierarchies of function,
they protected hierarchies of quality as well. Juries and panels of
experts awarded gold, silver, and bronze medals to distinguished
entries, in somewhat the same manner that art exhibitors had tra-
ditionally been rewarded. Fair organizers insisted that while the
exposition must be inclusive, it also had to represent a culling of
the best of the world's goods. To be sure, a subversive principle
was at work here, subversive, at least, of the premise of the major
art museums: the best beer, the best roller skate, the best sewing
machine could get as much serious attention from a panel of
judges (and as elaborate a medal) as a painting or bas-relief. And
this should not be underestimated in evaluating the total effect of
the fairs. Nevertheless, in format, influence, and organization, the
expositions, like the turn-of-the-century museums, functioned as
educational pleasure grounds, designed or at least intended to have
a pervasive if vaguely defined improving effect upon the practice of
the arts and the sciences. And they treated the traditional organiza-

tion of human ideas and activities, particularly intellectual activities, with reverence. Fairs of ideas coincided with the expositions of material objects at both Chicago, which hosted the Parliament of Religions in 1893, and Saint Louis, which hosted the Congress of Arts and Sciences in 1894.

Animal pleasures and pastimes, trivial delights, Little Egypt, and the ice cream parlors were also present, but given allotted spots outside the fairgrounds, on the midways or pikes. But even in the official areas of the fairs, great efforts were made at differentiation. Most visitors to the Columbian Exposition, according to the *Chicago Record* which chronicled the history of the fair, "must have been impressed by the great contrast between their southern section and their northern one. In the first, the effect aimed at is that of the formal, the academic, the ceremonial. In the second, art makes some concession to nature and the balance and symmetry required by the classic style give way to an adjustment that permits a free expression of the informal and the picturesque."[5]

Some displays were sophisticated and technically impressive. Expositions were electrical innovators; Luther Stieringer pioneered with lighting by glow, reflecting rays from a dull white surface at Chicago, Portland, and Omaha. At Omaha, Stieringer did light paintings by hiding and juxtaposing lights with different voltages, highlighted the building's architectural ornaments with multi-colored lights, and experimented with indoor lighting as well.[6] Frederick W. Putnam's anthropological displays brought great praise at Chicago as did the general use of relief maps.

But many interiors were still crowded with oddly assorted piles of objects that leaned toward the ingenious rather than the impressive (Fig. 2). Like museums, fairs seemed intent on showing everything they had all at once. And the displays reflected the still heavily agricultural character of the country. As the *Chicago Record* pointed out, if Philadelphia had its Sleeping Beauty sculpted in butter "the present exhibition has its prune horses and orange lighthouses from California and its cows and horses and spread-eagles done in Iowa corn."[7] The *Nation* charged that

[5] *The Chicago Record's History of the World's Fair* (Chicago: Daily News Co., 1893), p. 89.
[6] "The New Art of Lighting," *Literary Digest*, 32, 14 (April 7, 1906), 515.
[7] *Chicago Record's History*, p. 98.

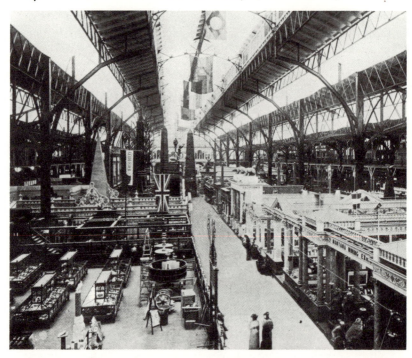

Figure 2. Mines and Mining Building, general interior. From James W. Shepp and Daniel B. Shepp, *Shepp's World Fair Photographed* (Chicago: Globe Publishing Co., [1893]), p. 213.

Columbian interiors contrasted poorly with their magnificent façades; the installation of machinery exhibits seemed only to heighten the planning defects.[8]

But despite unequal achievements, the fairs had decisive effects upon the respectful crowds, not least upon their manners (another echo of older museum ideals). "You may be crowded with a thousand American mechanics and their wives in the blocked avenues of the Exposition, and you shall not hear an oath or an ill-humoured word," reported the *New York Tribune*. One happy symptom of the American temper, reported the same newspaper, "is the promptness with which the Exposition is recognized and

[8] In 1893 the *Nation* ran a long series of articles summarizing the exposition, examining and evaluating the buildings and exhibits.

received by the masses of our own people, not as a show place but as a school. There is very little idle sauntering. . . . In the groups surrounding an exhibit the faces of Americans, keen, alive, quick-eyed, are distinguishable from all others, and the questions asked by them are unusually shrewd and intelligent." How different from the French, who came to their expositions, according to the *Tribune,* "as to a fete."[9] And Paul Bourget found the multitudes at the Columbian Exposition striking "by the total absence of both joy and repose. . . . They went about examining the interior and the exterior of the Exposition with a sort of blank avidity, as if they were walking in the midst of a colossal lesson in things."[10] Bourget insisted that the visitors were more interested in instruction than in entertainment. The *Scientific American* made the same observations of the crowds at the Saint Louis Fair of 1904.[11]

These expositions, then, were mass encounters with the art and objects of the modern world, dramatic, persuasive, self-consciously designed to produce a maximum effect, and having at least as much influence upon the knowledge and the taste of the American public as all the art museums put together. If fairs did not before World War I challenge the logic of museum presentation, they nonetheless represented an alternative experience.

The second major competitor to the museum as a display area for artifacts was less clearly idealistic and educational than the exposition but also served a consciousness-expanding end. And that was the department store.[12] Many commentators, both

[9] "The First Week of the Exhibition," *New York Tribune,* May 18, 1876, p. 4. This kind of observation could be multiplied a hundredfold in the magazines and newspapers of the day. For example, see Alice Freeman Palmer, "Some Lasting Results of the World's Fair," *Forum,* 16 (Dec., 1893), 517–523; Mary Clemmer, "The Opening of the Centennial," *Independent,* 28, 1433 (May 18, 1876), 1–2; John Bisben Walker, "A World's Fair," *Cosmopolitan,* 15, 5 (July, 1893), 518–519; E. L. Godkin, "Refuse," *Nation,* 57, 1478 (Oct. 26, 1893), 302.

[10] Paul Bourget, *Outre-Mer: Impressions of America* (New York: C. Scribner's Sons, 1895), p. 231.

[11] "The Exposition as an Educational Force," *Scientific American,* 91, 6 (Aug. 6, 1904), 90.

[12] For department-store history, see John William Ferry, *A History of the Department Store,* American Assembly series (New York: Prentice-Hall, Inc., 1960); Daniel J. Boorstin, *The Americans: The Democratic Experience* (New York: Random House, 1973), pp. 101–109, and bibliographical notes, pp. 629–630.

friendly and hostile to the metropolitan museum, have noted the relationship between the store and the great museum, and have pointed to the centralizing principles and merchandising techniques endemic to both. American department stores were approximately the same age as the modern museum. There had been major dry goods stores in the pre-Civil War era, most notably A. T. Stewart's New York establishment, but it was not until the 1860s and 1870s that the set of conditions which define the department store came together in Marshall Field's and The Fair in Chicago, Macy's in New York, and John Wanamaker's in Philadelphia. By the 1890s every large American city had several immense emporia with armies of employees. In New York, Bloomingdale's, Lord & Taylor, B. Altman, Ohrbach's, Bergdorf Goodman were all founded before 1900, to say nothing of firms like McCreary's, Siegel-Cooper, Stern's, Arnold Constable, and Best and Company, which are no longer operating. Outside New York, Strawbridge and Clothier in Philadelphia, Filene's in Boston, Carson Pirie Scott in Chicago, Hudson's in Detroit, Rich's in Atlanta, Bullock's and Robinson's of Los Angeles, and Magnin's in San Francisco were all products of the last decades of the century. The large department stores were determinants of the urban real-estate market, its office districts, its newspaper industry, and its transportation networks as well.

Like museums, department stores were selective concentrations of merchandise, merchandise grouped by functional categories rather than by age and nationality. Novelists, journalists, and ordinary consumers testified, even more than advertisements did, to the overpowering effects of the commodities and settings of the large metropolitan department store. In a sophisticated retail manner, merchandising was really born in the post-Civil War era; John D. Wanamaker declared in 1912 that the art was really less than forty years old. A. T. Stewart's great store in New York, the largest and most overpowering commercial building in America, was not particularly impressive in its interior; floors were uncarpeted, furnishings and fixtures were plain, goods generally were piled casually upon shelves with little attempt made to create special displays. But in the 1870s, 1880s, and 1890s, precisely in those decades that the art museums began operations, shopping manners changed. Innovative merchants realized the advantages

that lay in courting women customers by settings that played upon fantasies of luxury. American retailers traveled abroad, studied the grands magasins of Paris—the Louvre, the Bon Marché—and returned home to lavish on their own buildings handsome restrooms, writing rooms, art galleries, restaurants, and elegant draperies and fixtures. The drama of shopping probably reached its high point in Chicago and its most sensitive cultivation in the great stores of Marshall Field. Field, seconded by Gordon Selfridge, his most aggressive and innovative manager, put on a show in State Street that enthralled the city.

The new store rested on basic changes. Until the late nineteenth century big money was made in the wholesale rather than the retail trade. That was true of Stewart's and it was true of Field's. From 1871 to 1877 Field's retail profits were $300,000 compared with wholesale profits of more than $5 million.[13] But then the retail explosion began. In the words of sociologist Hugh Dalziel Duncan, "Chicago merchants made their stores great stages for the enactment of their roles as 'servants of the public.' Far from being too proud to clerk in their stores, they gloried in the art of presenting themselves to customers as friendly yet elegant hosts and appeared before their clerks as grand masters in all the arts of management. Chicagoans thought of their stores as social centers."[14] The department-store experience, like the museum, was treated respectfully by all participants; clerks and shoppers dressed up for the encounter. Selfridge, for example, who toured Field's several times a day, changed his clothes just as often. As early as the 1868 store, the fittings were designed to bring out the most sensuous materials: displays of furs and silks to tempt the shopper, frescoed walls, brilliant gas lighting. The great new show windows in the department stores presented their own tableaux. "The Loop became a vast promenade of huge glass windows in which mannequins stood as mistresses of taste to teach people how to embody their secret longings for status in things of great price."[15]

In Macy's, with somewhat greater austerity in the windows and

[13] For the history of Marshall Field and Company, see Lloyd Wendt and Herman Kogan, *Give the Lady What She Wants!* (Chicago: Rand McNally & Co., 1952), *passim*.

[14] Hugh Dalziel Duncan, *Culture and Democracy* (Totowa, N.J.: Bedminster Press, 1965), p. 24.

[15] *Ibid.*, p. 116.

the store fixtures, new standards of luxury were created in the 1890s. The ladies' waiting room, placed in the 1891 addition to the Fourteenth Street Store, was, according to advertisements "the most luxurious and beautiful department devoted to the comfort of ladies to be found in a mercantile establishment in the city. The style of decoration is Louis XV, and no expense has been spared in the adornment and furnishing of this room." On their way to it, customers would pass through an art room, containing "a carefully selected line of onyx" and bronzes.[16] In the first decade of the twentieth century, Macy's, Wanamaker's, and Field's all erected giant new stores, with ranks of elevators and escalators, with huge restaurants and elegant tearooms, special departments for costly rugs, jewels, antique furniture, and art. Wanamaker, who was an enthusiastic purchaser of modern academic artists like Munkacsy, Alma Tadema, Troyon, Schreyer, and Bouguereau, filled his stores with pictures, careful to select and hang them to maximum effect. He objected to the crowding of pictures in museums, which he likened to a three-ring circus. "In museums," Wanamaker declared, "most everything looks like junk even when it isn't, because there is no care or thought in the display. If women would wear their fine clothes like galleries wear their pictures, they'd be laughed at."[17] Wanamaker installed in his Philadelphia store the first electrical system placed in any building used by the public. His New York store, which opened in 1907, had built into it a twenty-two-room private home, "The House Palatial," with hall, staircases, and auditorium, and a series of period furniture displays. Field's new store, built by D. H. Burnham and Company, opened sections in various years from 1902 on. It had an enormous glass done by Tiffany (Fig. 3), rare Circassian walnut paneling and blue Wilton carpets for the tearooms, a Louis Quatorze Salon for gowns, an Elizabethan Room for fine linens, an Oak Room for antiques, a French Room for lingerie, and an American Colonial Room. The Belgian sculptor, Gustav Van Derbergen, who would subsequently work on the Saint Louis exposition, de-

[16] Ralph M. Hower, *History of Macy's of New York, 1858–1909: Chapters in Evolution of the Department Store* (Cambridge, Mass.: Harvard University Press, 1943), p. 284.

[17] Herbert Gibbons, *John Wanamaker*, 2 vols. (New York and London: Harper & Bros., 1926), vol. 2, p. 81.

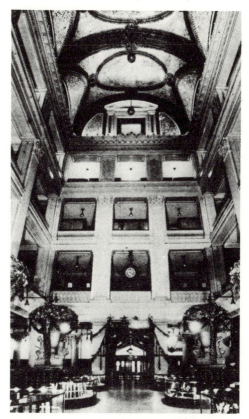

Figure 3. Tiffany dome, Marshall Field & Co., Chicago. From Lloyd Wendt and Herman Kogan, *Give the Lady What She Wants!* (Chicago: Rand McNally & Co., 1952), p. 2.

veloped a series of sculptured motifs on the history of merchandising for the building. The stores proudly seized on expositions held in their cities to publicize their own merchandise, and in advertisements in 1893, Selfridge declared Field's to be "an exposition in itself."[18]

[18] Wendt and Kogan, *Give the Lady What She Wants!*, pp. 218, 308. Field's display of art objects and furniture was so impressive that the Art Institute of Chicago bought several of the interiors.

The department store, then, like the exposition, challenged the monopoly of the new museums in the collection and display of art and of costly manufactured objects. Nevertheless, there were parallels and complementary effects in the store displays. The atmosphere of a great department store was not totally disparate from that of a museum. Academic tastes and traditional formalities dominated both. The deference of the properly dressed and quiet clerks, the doormen at the carriage entrances, the frock-coated managers, formally dressed floor walkers, and elegantly dressed women shoppers gave, to the more fashionable stores, a certain panache. Moreover, the dark wood cases, the cluttered interiors, the sense of compression all paralleled the display techniques of fairs and museums.

Second, the architecture and general design of the stores was traditional and palatial. Although museums typically had colonnaded porticos and pediments (Fig. 4) which the stores lacked, the stores with their greater height, resembled great chateaux looming impressively on city streets. Often built around courtyards to increase their light and air, the huge floors acted like little galleries in themselves. If the atmosphere was less sacred and hushed than in the museum, it was still special and self-contained (Figs. 5 and 6), and buyers respected the same standards of costliness, elegance, and tradition—in higher-priced items—that exposition managers and museum curators had appropriated.

Before World War I, then, if one examines institutional influences on what Americans knew about art and style in objects, one has a giant triptych: museums in the center flanked by fairs on one side and great retail establishments on the other. All were different, but all worked in the interests of an art ideal that stressed continuity with the past and respect for the old masters. All gave to art in its high sense—painting and sculpture—a special place and believed in surrounding it with the marble and fine woods that went into every great house. During the interwar years, however, the great art museum, in its capacity to display, moved out of phase with its two partners. Its ability to influence public knowledge and preferences was called into question. Always vulnerable, the museum became even more so as it was outdistanced by commerce. Changes in the architecture and display methods of expositions and retailers lessened the effectiveness of museum dis-

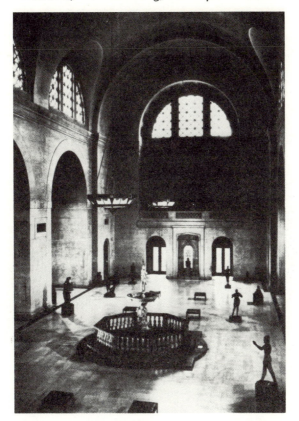

Figure 4. The City Art Museum, St. Louis, constructed for the Louisiana Purchase Exhibition, 1904. From Thomas W. Leavitt, "The Beleaguered Director," *Art in America*, 59, 4 (July–Aug., 1971), 68.

plays, raised public expectations, and so rendered the museum less powerful as a force shaping that abstraction called public taste. Consider briefly the history of expositions during the interwar years.

On the face of it, the power of expositions as an experience had lessened, if the number of major international shows held in the United States is any index. There were really only three of any true

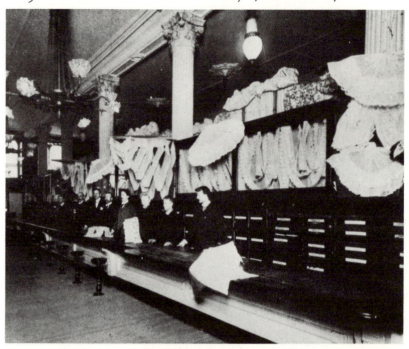

Figure 5. Lace department, Marshall Field & Co., Chicago. From Lloyd Wendt and Herman Kogan, *Give the Lady What She Wants!* (Chicago: Rand McNally & Co., 1952), p. 250.

consequence, all held in the 1930s, in New York, San Francisco, and Chicago, although a number of important events like Philadelphia's Sesquicentennial in 1926 cannot be overlooked. But the three great fairs of the 1930s, taking place as they did during the Depression, were noteworthy events and in their own way became physical symbols for their decade as compelling as the Columbian Exposition or the Saint Louis fair had been for their own days. It does not take long, however, to detect a major difference between the two fair-going generations. Before World War I the fairs were great academic festivals, glorifications of conventional wisdom in the arts and in architecture. They were manned by the orthodox, and their exhibition settings and art, like their exhibition materials themselves, were highly traditional in orientation, even if they were innovative in method. By the 1930s this had changed; to a certain

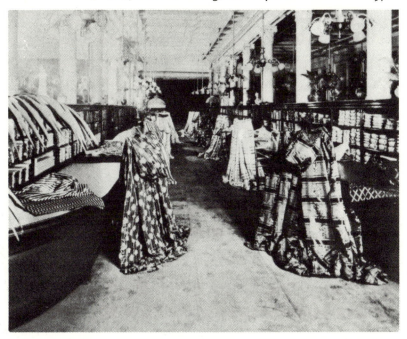

Figure 6. Yard goods department, Marshall Field & Co., Chicago. From Lloyd Wendt and Herman Kogan, *Give the Lady What She Wants!* (Chicago: Rand McNally & Co., 1952), p. 25.

extent the avant-garde, or at least a self-proclaimed avant-garde, took charge of fair planning. Stimulated, perhaps, by the influence of the Paris fair of 1925 on merchandising and style in the decorative arts, the fairs became streamlined and frankly embraced the machine and its culture. The shapes of the buildings, the symbols used for the fairs—abstract pylons or bridges in place of art palaces or giant statues—and, most of all, the lavish and startling exhibition halls put up by huge companies like Ford, General Motors, and General Electric, reflected a world in which the new was worshiped and the emphasis was on sensation and novel perceptions rather than the absorption of data. Prepared for novel experiences by motion pictures and national advertising, the public moved through these fairs in a less reverent and more aggressive fashion than had their nineteenth-century ancestors. Young de-

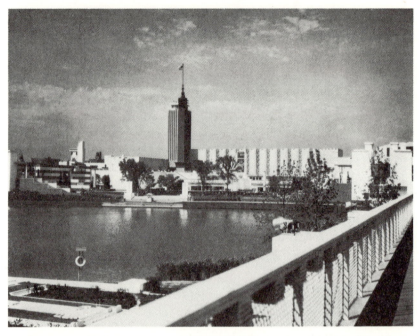

Figure 7. Hall of Science, designed by Paul Cret, Chicago World Fair. From David Lowe, *Lost Chicago* (Boston: Houghton Mifflin Co., 1975), p. 164.

signers like Walter Dorwin Teague and Norman Bel Geddes were able to experiment with new ways of entertaining large audiences. The world of the 1930s was much less certain of its relationship to intellectual generalization than was the world of forty years before; the emphasis now lay on titillation and sensation rather than on synthesis. It was knowing how things worked, rather than knowing what things were, that was important. This concern with process, and its greater relativism, naturally produced a less formal atmosphere. Malls, flags, processions, concerts, uniforms—all these, it is true, still appeared at fairs, but the asymmetrical, stark, glass and metal buildings (Fig. 7) created an atmosphere that was unsettling to traditional ceremonies and experiences. This was the world of the Future seeking objectification; the nineteenth-century fair was the Present, a backward look at many conquests already achieved.

It was hard to know just what the fairs of the 1930s signified to students of the science of display, but that they were different and somewhat innovative seemed clear. With this in mind the Rockefeller Foundation determined to support a tour of the two fairs of 1939, in New York and San Francisco, by museum specialists who could determine the implications of the fairs for museum management. Chairing this group and writing up his general impressions, was Carlos E. Cummings, director of the Buffalo Museum of Science. His book was published under the title *East Is East and West Is West*.[19] The impression of the title—that fairs were fairs and museums were museums and never the twain shall meet—was not quite the argument of this lengthy, discursive, and not always persuasive commentary on exhibition management. Cummings isolated various unsuccessful exhibits and pointed out the many problems and the many opportunities that fairs possessed which museums did not. Although Cummings gleaned a number of important principles from the art of fair display, particularly the tremendous effect of some company pavilions, he did not, however, hit upon the central fact. Visitors touring the fairs of the 1930s had an experience very different from that generally available in museums. They entered interiors that were planned and decorated around a few central ideas. Huge photomontages, movies, and abstract illustrations enhanced the power of the objects under display. Crowd movements became, according to one observer, part of the exhibition. Overhead mirrors and fluid structures, sophisticated neon lighting, and ambulatory stages and auditoria were exploited imaginatively.[20]

In a real sense, selectivity was the key to this success, selectivity

[19] Carlos E. Cummings, *East Is East and West Is West; Some Observations on the World's Fair of 1939 by One Whose Main Interest Is in Museums* (East Aurora, N.Y.: Printed by the Roycrofters, 1940).

[20] Douglas Haskell, "To-Morrow and the World's Fair," *Architectural Record*, 88, 2 (Aug., 1940), 65–72. For some perceptive observations on the changing appearance of American fairs, see John G. Cawelti, "American on Display: The World's Fairs of 1876, 1893, 1933," in Frederic Cople Jaher (ed.), *The Age of Industrialism in America* (New York and London: Free Press, 1968), pp. 317–363. For more on the changing nature of design during the interwar period and for excellent visual materials, see Donald J. Bush, *The Streamlined Decade* (New York: George Braziller, 1975); and Martin Greif, *Depression Modern: The Thirties Style in America* (New York: Universe Books, 1975).

and association with enticing ideas. A designer of the Indian arti-
fact display in the Federal Building on San Francisco's Treasure
Island, summed it up, according to Cummings. He declared that in
each exhibit hall "some single dominating item, displayed in a
conspicuous manner, should be so placed as to arrest the attention
of everyone entering the room before his eyes fall on anything else;
this should instantly create a mental symbol, a main theme if you
choose, under the aegis of which all the items in the room should
be gradually gathered."[21] Cummings called this a "theory of mind-
control or subjective guidance." He was not certain that the plan-
ners were always aware of the psychology involved in their man-
agement, but he was impressed. Not impressed enough, to be sure,
to single it out as the chief lesson of the fairs, but then he never did
draw up a set of detailed conclusions.

The viewers going through the fairs, however, were grateful for
the care taken to attract and hold their attention. The fairs of the
1930s pioneered in client-centered displays which relied upon sur-
prise, arresting juxtapositions, and a high degree of selectivity to
make their points. They no longer needed to present the compre-
hensive products of world civilization. Instead, it was argument
and dramatic impact that counted, a channeling of attention to a
specific quality or effect. The lessons of advertising, an industry
that had grown enormously in size and self-consciousness in the
interwar years, were applied to fair merchandising, and the unclear
results still put museums and their directors on the defensive.

Just as merchandising and architectural motifs had changed
considerably in the fairs, they had changed in the great stores of
the interwar years. The modern department store of the 1930s was
a considerable modification of the environments planned by Levi
Leiter, Gordon Selfridge, and John D. Wanamaker. Store moderni-
zation, in fact, had become a lucrative specialty among architects,
and dozens of articles were published in professional journals dur-
ing the 1920s and 1930s, indicating the kinds of changes that
could be wrought in store interiors without necessarily tearing
down the whole structure. Although conditions worsened during
the Depression, hard times had come to many retailers even during
the boom years of the 1920s. In 1923 the average net profits of

[21] Cummings, *East Is East*, pp. 39–40.

stores doing an annual business of over $1 million were only 3.6 percent of net sales; in 1924 they dropped to 2 percent; in 1927 to 1.7 percent; and by the 1930s they were almost zero.[22] In this competition for increasing sales, American retail establishments could not move much further in the direction of increased efficiency; instead, they turned to the architecture of merchandising, hiring well-known architects and designers to dress up their stores; change their show windows; modify their internal shopping arrangements; add new technologies of lighting, cooling, and heating to increase client comfort; improve parking facilities; and generally stimulate customer imagination. Dramatically different new stores appeared in major cities, like Bullock's on Wilshire Boulevard in Los Angeles; Saks Fifth Avenue in Chicago and New York; Jay-Thorpe and Bonwit Teller in New York. By 1937 retail merchants were spending almost $70 million annually for modernization of existing facilities; Franklin Simon, Lord and Taylor, Macy's, Field's in Chicago, and Burdine's in Miami were among the big spenders, as were chains like Woolworth, Montgomery Ward, and Sears. Small stores shared the spirit, streamlining their exteriors, putting in neon lighting, removing excess counters. Architectural firms like Ross-Frankel specialized in commercial modernizations, prefabricating and assembling complete stores in New York and then disassembling them and shipping the parts to small towns throughout the United States. High-priced specialty stores, like Peck and Peck, went even further, hiring well-known interior designers to manufacture interiors that gave a maximum of encouragement to the eager customer.[23] Antique dealers and specialists in valuable curios of all sorts did the same thing when they could afford it. Israel Sack of Boston, one of the country's major dealers, produced the King Hopper Store on Chestnut Street, a handsome

[22] Lee Simonson, "Redesigning Department Stores," *Architectural Forum*, 58, 5 (May, 1933), 374–378.

[23] Architectural journals of the 1920s and 1930s are filled with articles about the value of redesigning store interiors and exteriors. Among many others, see Ely Jacques Kahn, "The Modern European Shop and Store," *Architectural Forum*, 50, 6 (June, 1929), 789–804; John Matthews Hatton, "The Architecture of Merchandising," *Architectural Forum*, 54, 4 (April, 1931), 443–446; the entire issue of *Architectural Forum*, 40, 6 (June, 1924); James B. Newman, "A Modern Store," *Architectural Forum*, 53, 5 (Nov., 1930), 572–578; and "Store Modernization Gets Big Play," *Business Week*, 454 (May 14, 1938), 38–40.

Palladian shop front with more than 1,500 feet of display, including a seventeenth-century room. John Russell Pope, the architect who worked on Yale's college system and the Lincoln Memorial, designed a small rug shop, Whittall's, using paneling and antiques to show off a large assortment of rare old carpets.[24] Both furniture stores and department stores began to arrange their merchandise in room models; some had as many as several dozen complete rooms; Macy's at one time had sixty-five. Although museums had pioneered with period rooms at the start of the century, by the 1920s and the 1930s the stores had far outdistanced them.

The department stores, moreover, now went in for more overt cultural activities. At one store in the late 1930s, as many as 3,000 people attended a single lecture and lamp display, an exhibition of the history of lighting "from 600 B.C. to the present." Other store exhibits demonstrated how customers could save space by rearranging or buying double-duty furniture.[25] Cooking classes, art classes, child-development classes, and classes in glass and new materials like plastics supplemented store exhibits. As educators in the quality of American design, these great displays were probably more popular and even more influential than any but a few museums. The thrust of the merchandising revolution within the stores was to lighten the interiors, to be more selective in displaying objects, to lessen clutter and dramatize blank spaces and lighting, to surround the shopper with a sense of adventure, and to underline this by the continual display of new objects (Fig. 8). If the dark mahogany and traditional styling of the department stores complemented museums at the turn of the century, by the 1930s stores had moved to different settings altogether and were challenging rather than supporting the museum atmosphere. The shared monopoly of the early years was no longer effective, and, as arbiters of American taste, despite their lecture series and occasional exhibitions of industrial design, the museums were slipping. One president of the Metropolitan Museum of Art, Robert W. de Forest, actually told a group of department store executives to re-

[24] The Sack store is described in *Architectural Forum*, 45, 2 (Aug., 1926), pls. 22–24; Whittall's is described in the *Architectural Forum*, 49, 1 (July, 1928), 86–87.

[25] For department stores and cultural activities, see Edith M. Stern, "Buy-Paths to Learning," *Reader's Digest*, 32, 193 (May, 1938), 90–92.

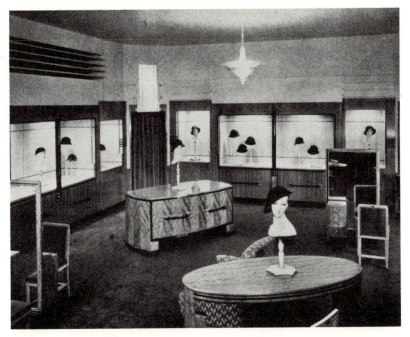

Figure 8. Hat department, Meier & Frank Store, Portland, Oregon. From "Eight Modern Department Stores," *Architectural Forum*, 58, 5 (May, 1933), 366 (top).

member that their influence was far greater than that of all the museums combined. "You are the most fruitful source of art in America," de Forest exclaimed, urging them to become missionaries for beauty.[26] In some cases department stores themselves retailed original paintings, etchings, and antiques. Douglas and Elizabeth Rigby have amusingly described the use of store outlets to dispose of part of the enormous Hearst collection. At Gimbel's, Field's, and Saks Fifth Avenue, valuables were sold by the thousands. Gimbel's took over the Clarence H. Mackay sale and the collection of Warner S. McCall. "Have you always wanted one piece of genuine old Wedgwood, but thought it was forever beyond you?" the department store asked. "Come find one here—browse

[26] Quoted in Zelda F. Popkin, "Art: Three Aisles Over," *Outlook and Independent*, 156, 13 (Nov. 26, 1930), 515.

around to your heart's content." Implicit in many of the advertisements was hostility to the museum, now associated with snobbish seclusion. "Artists never made them [art works] for museums and galleries. They made them to be worn, to be used, to be looked at, to be appreciated, to be loved."[27] Apparently, the department store could encourage appreciation more than the art palace.

Although critics of museums during the interwar years frequently berated them for their gargantuan size and holdings, they nonetheless liked big department stores; their criticisms clearly reflected the new standards of customer service that the stores had developed. In the *Century Magazine* Forest H. Cooke entitled his attack, "Culture and Fatigue," rebuking poor ventilation, superfluity of exhibits, and the absence of resting places; museums, he insisted, by their very size and stolidity were projecting a civilization based on quantitative rather than qualitative criteria. However well they preserved the past, they gave little inspiration for future work, according to Cooke. "The rooms open to the public should be of great beauty as rooms, well ventilated, restful, and inviting leisure. They should contain very few objects of exhibition, and these should be so placed as not to detract from each other. There should be comfortable, movable chairs."[28]

Although Cooke did not speak specifically of modern stores in this article, they exemplified what he had in mind: merchandising which maximized physical comfort and exploited the dramatic possibilities of empty space and selectivity. Some museum directors, like the iconoclastic John Cotton Dana of the Newark Museum, insisted that the buying public learned more about fine art from shop windows and travel than from museums. Heaping scorn on the museum's claim to hold a monopoly on influencing public taste and legitimizing objects, Dana argued that the average citizen exercised his taste when he selected "a cravat or a table cover or a rug or a chair." He should transfer to the "designer of good umbrella handles" the same respect he felt for the artist

[27] Douglas and Elizabeth Rigby, *Lock, Stock and Barrel: The Story of Collecting* (Philadelphia, New York, and London: J. B. Lippincott Co., 1944), p. 503; for a detailed description of the department-store art sales, see pp. 499–503.

[28] Forest H. Cooke, "Culture and Fatigue," *Century Magazine*, 3, 3 (Jan., 1926), 295; see also *Atlantic Monthly*, 144 (Dec., 1929), 770–772.

dignified by museum exhibition.[29] The *Saturday Evening Post,* complimenting the Metropolitan on the installation of its American Wing, and the Philadelphia Museum on its period rooms, urged other museums to move away from being "bleak storage warehouses for the protection of art objects" into popular displays which better exploited modern technology. The department store entered the *Post's* editorial inadvertently. The magazine spoke warmly of the recent transformation of the public library into a community center, a change forced upon readers "by arts just as skillful as those employed by department-store proprietors to crowd their aisles with eager customers."[30] Writing in the *Commonweal Magazine,* Frederic Thompson called American art museums tombs and safe deposit vaults. He insisted that there was "scarcely any attempt to make museums, inwardly or outwardly original in design, or beautiful in themselves."[31] He urged philanthropists to help living artists, rather than museums.

Specific reforms surfaced. Set designer Lee Simonson was not complimentary in comparing the museum with the department store, for he thought museums had overexpanded and produced a new malady named "museum fatigue." Museums themselves were overstocked and stuffed full, because their directors had never properly conceived of "the problem of organizing countless 'art objects' in a way that will make their aesthetic value clear and their social importance effective." Curators had assumed that it was enough simply to show sufficient numbers of bronzes, marbles, and paintings, in order to "endow the uneducated with an abiding sense of the good, the beautiful and the true." In actual fact, the business of a museum "is not to chronicle art as a fact but to enact it as an event and to dramatize its function. Its role is not that of a custodian but that of a showman." And the way to make this possible was through the simplest application of a few principles of stage setting and architectural arrangement."[32] Instead of organiz-

[29] John Cotton Dana, "The Use of Museums," *Nation,* 115, 2998 (Oct. 11, 1922), 375.
[30] "Art Museums Humanized," *Saturday Evening Post,* 200, 40 (March 31, 1928), 26.
[31] Frederic Thompson, "Beauty for the Masses," *Commonweal Magazine,* 10, 1 (May 8, 1929), 14–15.
[32] Lee Simonson, "Skyscrapers for Art Museums," *American Mercury,* 10, 2 (Aug., 1927), 401.

ing "in a procession of showcases" five-thousand examples of Japanese art, swords, lacquer, vases, and paintings, museums should build a Japanese room, arrange within it the one painting it was meant to frame and select the other appropriate details. Although the objects might amount to one five hundredth of those now displayed in any important Oriental collection, the most casual visitor would receive a better impression of the true meaning of Japanese art. What was true of Japanese art was true also of Swiss or American or Hungarian.

The skyscraper tower of twenty or thirty stories that Simonson proposed permitted concentration by avoiding the inevitable distractions visitors faced when they walked from collection through collection in order to see specific objects. Irrelevant objects inevitably distracted the student or art critic. Traditional museum arrangements depleted "the kind of attention that opens into criticism as effectively and methodically as it fails to focus on the visitor who comes in without any specific purpose whatever."[33] A skyscraper needed no skylights and so would avoid the repetitive use of parallel walls and their parade of pictures, arranged in "regimental perspective," permitting new and critically more appropriate hanging methods. If museums are to become alive, Simonson concluded, they had to do more than hold occasional exhibitions of silverware or furniture. "Unless they are structurally reconceived, the really formative moments in the development of American taste will be the moments when increasing hordes of Winter and Summer travelers stand for the first time under the columns of the Parthenon, or see the roseate temple, Der el Bahari, across the Nile at Luxor."[34]

Simonson is quoted at this length, not because his skyscraper museum possessed peculiar virtues, or because his indictment made so much sense. But his call for a structural reconception typified the phenomenon that I have been describing. In the 1920s and 1930s a series of experiences—on stage and screen as well as in fairs and retailing—called attention to new and dramatic possibilities of museum rearrangement. Merchandising techniques had become so numerous and impressive, that museums were now being asked to exploit possibilities that they had in fact originated

[33] *Ibid.*, 403.
[34] *Ibid.*, 404.

—such as period rooms—but which they had nonetheless failed to develop fully. The planning, reconstruction, and building of museums during the interwar years, recognized some of the necessary changes. But it was a slow conversion given the heavy capital investment museums had in their existing physical settings. In his 1950 survey of museum buildings, Laurence Vail Coleman dated a massive shift of design to 1933. He argued that by 1942, when the war interrupted further construction, more than fifty modern museum buildings had been constructed, including Goodwin and Stone's Museum of Modern Art, and art museum buildings in Hartford, Colorado Springs, Dallas, West Palm Beach, and Des Moines.[35] But if Coleman had numbers on his side, the exceptions he named were obviously of much greater importance in terms of their collections and their audiences. The later classical buildings included Philadelphia's Franklin Institute, the National Gallery in Washington, and the art museums of Kansas City and San Francisco. Building additions, while modern in some aspects, continued to echo the more traditional monumentality, and some of the new buildings themselves were simply a transcribed form of the older verities without much change in display methods.

It is, nonetheless, impossible to deny that museum planners were becoming sensitive to new possibilities and aware of the advances that stores and fairs had made in influencing public taste. The arrival of émigrés like Alexander Dorner also had some influence.[36] Lighting, more effective use of space, new materials, improved visitor facilities, novel display cases and cabinets, more varied room sizes and greater tolerance for ordinary and novel objects reflected the many studies undertaken by the American Association of Museums in these years. Nevertheless, the fruition of these efforts would await the postwar period, and the museum's position as a monopolizer of art and objects was further challenged

[35] Laurence Vail Coleman, *Museum Buildings* (Washington, D.C.: American Association of Museums, 1950), pp. 4–6. For useful information on the evolution of art-museum designs, see also Joshua C. Taylor, "The Art Museum in the United States," in Sherman E. Lee (ed.), *On Understanding Art Museums*, American Assembly Series (Englewood Cliffs, N.J.: Prentice-Hall, 1975), pp. 34–67.

[36] See the study of Dorner by Samuel Cauman, *The Living Museum, Experiences of an Art Historian and Museum Director: Alexander Dorner* (New York: New York University Press, 1958), *passim.*

by completely new developments in the mass media, most notably in film, which fall outside the realm of this paper.

To sum up the interwar years, then, the merchandising revolution which overtook fairs and department stores, and which spread to smaller stores as well, placed museums in a laggard position, which helped feed the resentments expressed in the press. As an influence on public taste, the American museum faced powerful challenges. Knowledgeability, experience, and preference patterns, the three elements of public taste, were all more dramatically shaped by other institutions. That museums recognized the new source of energy can be seen in one of their chief responses: displays of industrial art and consumer design in which the Museum of Modern Art and the Metropolitan Museum hosted.[37] As popular and interesting as they were, these exhibitions nevertheless consisted of selected reactions to the power, prestige, and inventiveness of another world of merchandising. A certain legitimation was, of course, conferred by museum approval, but the true source of influence was merely acknowledged, rather than transferred, through these exhibitions.

The postwar decades, however, took a different direction. Among many other changes six factors have helped somewhat to shift the balance of influence away from certain competitors and back to the museum. The first change is the decline in strength of the central city, particularly of its retailing. The litany of downtown woes is long and depressing and unnecessary to repeat here. Among the major casualties, in terms of relative influence, has been the great downtown department store. In the last three decades, dozens of apparently permanent establishments have gone out of business or shifted their primary emphasis to the suburban shopping center.[38] Shopping-center settings are often highly

[37] For a survey of these exhibitions and some interesting comments on the relationships between museums and department stores, see Jay E. Cantor, "Art and Industry: Reflections on the Role of the American Museum in Encouraging Innovation," in Ian M. G. Quimby and Polly Anne Earl (eds.), *Technological Innovation and the Decorative Arts* (Charlottesville: University Press of Virginia, 1974), pp. 331–354.

[38] Among recent articles on shopping-center design, see "Shopping Centers," *Architectural Record*, 147, 3 (March, 1970), 119–123; Martha Weinman Lear, "A Master Builder Sites a Shopping Mall," *New York Times Magazine*, 122, 42,204 (Aug. 12, 1973), 12–13, 77–84; Gurney Breckenfeld, " 'Down-

dramatic spatial ensembles, and they have continued and expanded upon the advances in lighting and merchandising developed during the interwar years. However, if the techniques of display are more impressive, the collection of objects in the center cannot compete with the older department stores and central cities; for various reasons—the size of the stores, the financial needs of the centers which rest upon franchised operations, the character of the suburban market—there is an extraordinary degree of replication in goods and services offered within the shopping center and from one shopping center to another. It contains few surprises, a factor which perhaps has led to its innovativeness in designing an overall setting. As merchandising competitors, retail establishments have suffered from this decentralization.

The other great competitor of the museum, the fair, has itself ceased to be an important factor in introducing people to new goods and services, partly because new media, like television, and increasingly easy travel, have made the fairs superfluous except as a purely promotional or symbolic device. Among the three great central institutions that once shared control over object display, the museum has retained its essential power better than the others, simply because it has not decentralized, and its exhibits are less easily replicable.

Second, the museum itself, while retaining its collection of objects, has modernized its settings to an extent just dimly forecast in the late 1930s and 1940s. An extraordinary variety of museum environments have been created in this country since 1950; the plans, scale, materials, and the logic of museum display have all excited considerable debate and controversy. But this controversy reflects the fact that museum design, instead of reflecting the most traditional wing of architectural practice, has attracted innovative practitioners who have seized public attention, if not public approval.[39] The Guggenheim was an early example of the modern

town' Has Fled to the Suburbs," *Fortune*, 86, 4 (Oct., 1972), 80–87, 156–162; and Neil Harris, "Spaced Out at the Shopping Center," *New Republic*, 173, 24 (Dec. 13, 1975), 23–26.

[39] Among many recent comments on the new museums, see *Time*, 102, 18 (Oct. 29, 1973), 108; and Douglas Davis, "The Museum Explosion," *Newsweek*, 82, 12 (Sept. 17, 1973), 88–89.

controversial museum; since then, California, New York, and Texas have hosted dozens of new settings—suspended, underground, undulating, rectangular, monumental, domestic—which incorporate almost every possibility for manipulating objects, and bring to bear upon the museum-goer the whole force of a broad repertory of designer methods. These great settings, according to some critics, detract from the primacy of the object on display. Nevertheless, they have added to the dramatic appeal of museum-going and to the sense of luxury associated with the institution, an association which attracted bitter commentary and hostility in the late 1960s, but which increased the theatrical impact of the museum experience in much the same way that movies were aided by their fantasy palaces and department stores by their rich appointments. In their variety and ingenuity, modern museum display techniques rival, and often outdistance, the most advanced retail methods.

A third factor that has increased the museum's influence on public knowledgeability is a spectrum of publicity gestures, the most notable example of which is the great purchase. Once again, we encounter a practice that has borne the brunt of considerable criticism, but whose impact upon museum consumers has been undeniable. Perhaps the most famous, although no longer the most expansive of these gestures, was the Metropolitan's purchase of Rembrandt's "Aristotle Contemplating the Bust of Homer." In a sense, the great purchase simply is an extension of commercial advertising methods that were well established before the postwar years. Merchant princes like Wanamaker and Field well understood the customer appeal of such dramatic gestures, and benefited from the resultant publicity. The art museum becomes, therefore, in the public mind at any rate, the kind of dramatic arena where gestures like this can be expected, and a pecuniary symbol of considerable importance. The ultimate value of these gestures may well be open to question, but they do enhance its ability to influence a heterogeneous clientele that has few aesthetic assumptions or pretensions. While the glamor of the shopping and exposition rituals has dimmed the glamor of the art museum experience has become either a target for criticism or an experience to cherish. If the ability to influence requires the association of honorific and

attention-getting devices, the museum would seem to have recaptured, albeit in Veblenesque terms, a degree of public attention it had previously lost.

Fourth, museum directors, curators, and exhibition organizers have demonstrated an ability to create exhibitions that have an immediate impact upon observable public taste. Rather than merely reflect this taste, as did the industrial art exhibitions of the interwar years, with proper planning and publicity these exhibitions have shaped it. One case in point is the revival of interest in Art Moderne, sometimes, if too loosely, called Art Deco. It is interesting that the many varieties of modernistic interwar design, which were stimulated in the first instance by a world's fair, were restimulated to a large degree by museum exhibitions, in particular the exhibitions organized at Finch College in 1970, and the Minneapolis Institute of Arts in the summer of 1971, which had the benefit of a catalog text by Bevis Hillier.[40] Many factors stimulated the revival of interest in the furniture, pottery, glass, textile, and skyscraper designs of the 1920s and 1930s, and there were clearly presentiments and publications of importance which occurred before the exhibitions of the early 1970s. But in retrospect (and judging from the attentions of the mass media), the exhibitions seem to have been critical to the dispersion of public knowledge and commercial imitation. By joining the power of media to the dramatic gesture, the museum has shown an ability to use a single exhibition with remarkable effectiveness. Although there apparently are no comparative studies that analyze the effects of museum exhibitions in different periods, the present moment does not seem to indicate a low ebb. If anything it suggests the opposite.

Fifth, the museum as an institution in the postwar years applied direct merchandising methods through the institutionalization of its own retail outlets—stores—which, particularly in the last decade, have become ever-larger, more profitable, and more important elements in the museum's total operation. The museum store sells not only postcards and slides but reproductions of pottery, fabrics, statuary, and jewelry. It handles books, uses greeting

[40] Douglas Davis, "The Streamlined Show," *Newsweek*, 76, 19 (Nov. 9, 1970), 99, and Lawrence Alloway, "Art," *Nation*, 213, 4 (Aug. 16, 1971), 124–126.

cards to popularize knowledge of the museum's holdings, and generally functions as a commercial publicist. The immediate gratification felt by the department store customer in the act of purchase, and the experience of handling objects and learning more about them, which was the joy of the fair-goer, are united in the museum store, and seal the museum-going experience for many visitors. Appropriately enough in our culture, it is a commercial setting which legitimizes an aesthetic setting. However late the discovery was in coming to museums, no one can now accuse them of backwardness in exploiting it. The importance of the store lies not simply in its financial returns but in the means it offers for the museums to influence directly consumer taste. In a sense, they can create their own instant customers. The museum store comes closer than one might expect to the vision of galleries of casts and reproductions which colored the motives of early American museum founders, depressed about the cost of importing masterpieces from abroad.

The sixth and final element in the museum enterprise is a public mood which is difficult to define but pervasive in its effects, and which demands a total immersion in nostalgic evocation.[41] The roots and directions of contemporary nostalgia are still unclear, but they include an affection for physical objects and details that is quite astonishing in its inclusiveness and perhaps in its lack of discrimination. Public absorption with mementos of a past that is continually recorded and yet recedes into memory as styles change can be satisfied ultimately only by total environments. The museum alone has the stock of objects to permit total immersion. There is, for example, an increasing tendency to place building façades, interiors, and details under the shelter of the art museum; for example, in New York the park façade of the original Metropolitan, and in Chicago, the trading floor of the old Stock Exchange, now being placed in the Art Institute's new wing. Exhibitions of costume, quilts, comic books, and other artifacts have become standard operating procedures at major museums, while the displays of period rooms have become more elaborate and more numerous. In a sense, the museum's stock of nostalgia has increased relative to the difficulties of maintaining period buildings

[41] For an attempt to explicate this mood, see Neil Harris, "We and Our Machines," *New Republic*, 171, 21 (Nov. 23, 1974), 24–43.

and objects in the world outside it. Modernization and mobility, twin themes of American social and environmental life, have probably increased the appeal of nostalgia, while they have reduced the ordinary capacity to service it. The museum's age, size, and vast holdings, in the interwar years a handicap in merchandising, have in response to the new public mood become advantages to exploit. A revival of interest in Victorian and Beaux Arts architecture has also helped.[42] The relationship between these new advantages and public taste is not easy to determine except to note, among other things, that museum exhibitions have stimulated manufacturers to produce replicas. Certainly knowledgeability about the history of design has been increased as a result, and the nostalgia boom has helped nourish bands of culturists with commitments to particular kinds of objects and styles.

To summarize then, a series of weaknesses in competing institutions and environments, a set of merchandising advantages and innovations, and a public temper have combined to make the museum stand out today as the single most dramatic setting for the display of art and objects. The costs of consumer-orientation do exist, of course, and were present right from the start in the never-ending debates about the function of museums. If attractiveness and public appeal become the museum's objectives, how in effect does it differ from any commercial institution which exists chiefly for the purpose of selling? Are public knowledgeability and experience increased at the cost of stating any preferences, a practice which might appear unseemly or arbitrary to an audience which simply desires entertainment? Has the museum, as a new entertainment palace, become merely another asylum, an asylum not for objects and art but for special kinds of memory baths and gallery-going rituals, a quantified, certified, collective encounter that may shape purchase patterns but hardly improve them? At one time museums were charged with paying too little attention to the wants and needs of millions of laymen. Now, in another era, they are taxed with pandering to delight in relevance, drama, and popularity. Evaluation of the consequences of this shift must be left to another time, but the changing fortunes of the museum as a

[42] For a comment on beaux arts revivalism, see Ada Louise Huxtable, "Beaux-Arts—the Latest Avant-Garde," *New York Times Magazine*, 125, 43,009 (Oct. 26, 1975), 76–77, 80, 82.

public influence suggest capacities that are great, growing, and endowed with almost infinite variation. Having survived a series of competitive challenges, the art museum must now demonstrate that the victory was worth it, and that its repertory of merchandising techniques can be put in the service of clearly defined, significant, and worthwhile goals.

Interpreting Material Culture: A View from the Other Side of the Glass
Harold K. Skramstad, Jr.

While most of the essays in this volume deal with the question of how the study of material culture can contribute to the study of the American past, another perspective should not be overlooked, and this is the exhibition, the medium rather than the message of material culture. Perhaps by looking through the other side of the glass some further insights may be gained about the relationship between material culture and other humanistic activities.

The exhibition process has never received the attention that the research aspect of material culture has. While assertive literature about the research and teaching value of material culture is voluminous, literature concerned with the exhibition process has been largely left to art critics whose primary interest lies with the individual objects, or to behavioral scientists whose concern is more with the behavior pattern of the visitor than with the content of the exhibit. This is unfortunate because it neglects a basic fact of life for museums: that the selective arrangement of artifacts and other related information in a public display is a museum's most fundamental means of communication, and that such displays or exhibitions are the basic building blocks for exploring the intersections of material culture and its larger constellations of meaning. Perhaps more than anything else a museum's exhibition environ-

ment is an accurate index of its attitude toward material culture.

From the time the very first cabinets of curiosities were assembled, the concern of individual collectors has been not so much with building a collection of artifacts within a taxonomic structure as with attempting to arrange a collection to provoke intellectual stimulation within a setting which has a visual sense of order. An early commentator on such collections remarked that "at the entrance of the collection the visitor's eye should be caught by a few conspicuous specimens, such as a crocodile, a stuffed bear, tiger or lion, a dried whale, or some other objects that would impress people by their 'splendor,' 'venerable character' or 'ferocious looks.' "[1] We see in such comments the concerns characteristic of collectors in late eighteenth- and early nineteenth-century America. For them, the proper arrangement of objects, in many cases objects collected neither systematically nor within any particular intellectual framework, would provide in itself a visual, tactile, and intellectual experience, a starting point that would stimulate further inquiry and insight. Charles Willson Peale, the founder of one of the first great collections of material culture in America, wrote in 1800, "it is only the arrangement and management of a Repository of subjects of Natural History, &., that can constitute its utility. For if it should be immensely rich in number and value of articles, unless they are systematically arranged and the proper modes of seeing and using them attended to, the advantage of such a store will be of little account to the public."[2] Peale realized, as did other early collectors, that the raw data in such collections could not be properly understood or used unless it was organized in such a way that one object could be seen in the context of others, and in conjunction with additional information. Implicit in Peale's statement is an understanding that perhaps the most interpretive level of the exhibition is its visual storage and arrangement. Even for a collection seen only by its keeper or owner, and invited guests, the process by which materials are brought together and displayed provides a key step in provoking further inquiry and stimulating further collecting.

[1] D. B. Major, as quoted in Alma S. Wittlin, *Museums: In Search of a Usable Future* (Cambridge, Mass.: M.I.T. Press, 1970), p. 71.

[2] Charles Coleman Sellers, *Charles Willson Peale*, 2 vols. (Philadelphia: American Philosophical Society, 1947), vol. 2, 113.

This early concern for exhibitions as the first rather than the final step in the process of explaining and revealing insights of material culture can be seen in the American Museum of P. T. Barnum. In Barnum's time the idea of public museums in the United States was still relatively new, and collectors, both private and public, were confronted with the fact that considerable distance was involved between the process of collecting and the actual viewing of the collection. No longer were the collector, the scholar, and the visitor one person or a select circle of friends. Consequently, the exhibition process became more self-conscious and assertive. Barnum realized at the outset that the exhibition of his miscellany of fakes, relics, and objects of everyday life spoke to the need of people from all walks of life to understand and evaluate that which was real or false, important or trivial. Neil Harris, in his perceptive biography of Barnum, writes:

> No great public galleries existed for the public to stroll through, no historic buildings featured ancient murals and statuary. Instead, paintings and sculpture stood alongside mummies, mastodon bones and stuffed animals. American museums were not, in the antebellum period, segregated temples of the fine arts, but repositories of information, collections of strange or doubtful data. Such indiscriminate assemblages made artistic objects take on the innocent yet familiar shape of exhibition curiosities. Contemplating a painting or a statue was not so different from studying Napoleon's cane or wood from Noah's ark; in every instance, a momentary brush with a historical artifact stimulating reflections on its cost, age, detail, and rarity.
>
> The American Museum then, as well as Barnum's elaborate hoaxes, trained Americans to absorb knowledge. This was . . . a delight in observing process and examining for literal truth. In place of intensive spiritual absorption, Barnum's exhibitions concentrated on information and the problem of deception. Onlookers were relieved from the burden of coping with more abstract problems. Beauty, significance, spiritual values, could be bypassed in favor of seeing what was odd, or what worked, or was genuine.[3]

[3] Neil Harris, *Humbug: The Art of P. T. Barnum* (Boston: Little, Brown & Co., 1973), pp. 78–79.

Later in the nineteenth century, the attitude toward the display of material culture jumped several quantum steps upward from Barnum's museum. Interestingly, such exhibitions, or large assemblages of information, took place outside of museums. The most obvious and successful enterprises of this kind were, of course, the Centennial Exposition of 1876 and the Columbian Exposition of 1893. In both fairs great amounts of time were spent on the proper organization of the knowledge to be conveyed by the exhibitions. Pioneering efforts at developing new categories of inquiry as well as revitalizing more traditional categories grew out of preparation for the Centennial Exposition. The same pattern was true in regard to the Columbian Exposition where Daniel Burnham and his group of planners approached and got leading thinkers to explore the possible organization and rationale for the exhibits to be mounted at the Exposition.

The fact that these expositions had an identity as expressive and complex artifacts in themselves is extremely important. Neil Harris has shown elsewhere in his book how these exhibitions were among the first great national arbiters and creators of popular taste; both events, especially the Columbian Exposition of 1893, provided a way in which Americans, both scholars and citizens, were to perceive and interpret American life for decades to come. The fair was not only a record of what had occurred in American life; through its exhibitions, the organization of knowledge and information, it offered a starting point, a new assemblage of material culture, which became a vital contribution to the reordering of reality.

One of the earliest to realize the significance of the 1893 Exposition was Henry Adams. It played a key role in his *Education* where he wrote:

> Jostled by these hopes and doubts, one turned to the exhibits for help, and found it. The industrial schools tried to teach so much and so quickly that the instruction ran to waste. Some millions of other people felt the same helplessness, but few of them were seeking education, and to them helplessness seemed natural and normal, for they had grown up in the habit of thinking a steam-engine or a dynamo as natural as the sun, and expected to understand one as little as the other. For the historian alone the Exposition made a serious effort.

Historical exhibits were common, but they never went far enough; none were thoroughly worked out.[4]

Confronted by a world which deeply disturbed him, Adams turned to the new assemblages of material, the exhibits. To him the exposition, by its interpretation and display of American life, offered a new starting point: "Chicago was the first expression of American thought as a unity; one must start there."[5]

If we look at the major world's fairs of the twentieth century we see much the same pattern. Their design, development, and production required the systematic organization and assemblage of material culture into a new and complex artifact which in turn affected not only popular taste but Americans' perceptions of their society.

Like society at large, museums and other institutions of material culture are transformed by their own exhibition environments. These environments play a fundamental role in changing, defining, and redefining basic museum purposes and policies. Art museums have long realized the importance of exhibits, and it is a relatively simple matter to point to such landmark exhibitions as the Armory Show, in which a particular exhibition provided the basic stimulus for future creative activity and scholarship. We can see much the same thing even closer to the present. The historical questions that arose from the task of creating an accurate reconstruction of Colonial Williamsburg created new kinds of scholarly activity that were undreamed of by the founders of the field of material culture. Another example was the genesis and organization of the National Museum of History and Technology of the Smithsonian Institution, which was conceived and built without any stated definition of purpose except what its title implies. In fact, the major activity for many years, both before and after its opening, was the planning and development of public exhibitions, which in turn provided its basic definition of purpose and which strongly influenced its staffing, collections, and other fundamental programs and policies. Many of its staff consider the intellectual and creative stimulation of developing a major exhibition one of the most important influences on their scholarly careers—and this experience strongly affects

[4] Henry Adams, *The Education of Henry Adams* (Boston: Houghton Mifflin Co., 1918), p. 341.
[5] *Ibid.*, p. 343.

their collecting and research activity. A specific example is the creation of the exhibition "The Growth of the United States." A highly controversial project at the time, it focused the intellectual activities of a great many staff members and actually resulted in the creation of a new curatorial division within the museum having its own collections and staff. Whether this exhibition is judged a success or not, it was an intellectually stretching exercise which acted as a training ground for a number of that museum's best curators.

The interpretive effect of the museum environment itself is an important aspect of the exhibition process. Any person, whether scholar or member of the general public, leaves the real world when he enters a museum and enters a contrived environment devoted to some kind of public display. What is on display is not really important. What *is* important is that the traditional cultural role of the museum has conditioned us and thus has implicitly given value to the objects inside. This phenomenon is easily observed at almost any institution. An old post office in West Virginia, which had been neglected for over one hundred years, was recently dismantled and rebuilt in the National Museum of History and Technology. By moving this artifact into the museum it became, instantaneously, a revered national treasure—in fact so revered that there was serious talk of removing the original shutters and replacing them with exact replicas since the originals contained carvings of the names of Civil War soldiers—safe so long as the structure was neglected, but in serious jeopardy once it was securely in the museum. The ennobling effect of the museum environment affects not only visitors, but staff perceptions as well. For example, when asked what great historical treasures the museum possessed, one curator at the National Museum responded that anything was a national treasure simply by being in the collections.

An exhibition, whatever its content, is a complex artifact with a life of its own. If successful, it becomes a work of art itself which often transcends the value of the objects, or insights, or historical information it may contain and which reflects the culture that created it. More importantly, the process of creating an exhibition is in itself one of the most fundamental steps in exploring material culture. Contrary to what many caution against, I suggest that we

spend less time examining individual artifacts, reading into them personal visions and idiosyncrasies, and instead spend more time examining exhibitions, which may be artifacts of a higher order and which require important and serious critical analysis. The museum exhibition is a particular kind of art, not altogether unlike the novel, poetry, drama, film, painting, or the literary art of history. It has certain ways of bringing together the evidence of raw experience, breathing into it a life of its own and encompassing the qualities of inference, selectivity, and implication that form the touchstone of every artistic experience. The exhibit process, the steps toward a finished product then, became analogous to the various techniques employed by other forms of artistic communication. In the words of the literary critic Mark Schorer, referring to the development of a novel:

> Technique is really what T. S. Eliot means by "convention"— any selection, structure, or distortion, any form of rhythm imposed upon the world of action; by means of which . . . our apprehension of the world of action is enriched and renewed. In this sense everything is technique which is not the lump of experience itself, and one cannot properly say that a writer has no technique or that he eschews technique, for being a writer he cannot do so. We can speak of good and bad technique, of adequate and inadequate, or technique which serves the novel's purpose, or disserves.[6]

Technique, in terms of an exhibition, involves not only the selection of details, objects, and other apparatus necessary to put together an exhibition environment, but it also provides a means of discovering, exploring, and developing a subject, of conveying its meaning, and, finally, of evaluating that meaning. It follows that certain techniques are sharper tools than others, and that the exhibit creator capable of the most exacting scrutiny of his subject matter will produce exhibits with the most satisfactory content, the most richness, the most meaning.

If we look at exhibitions from this perspective, several questions immediately come to mind. The first is the question of a critical method with which to confront exhibitions. It has been pointed out

[6] Mark Schorer, "Technique as Discovery," in John W. Aldridge (ed.), *Critiques and Essays on Modern Fiction, 1920–1951* (New York: Ronald Press, 1952), pp. 68–69.

for years that serious exhibition reviews are just not being done. Certain scholarly criteria have been proposed in exhibition reviews, but, with the exception of the reviews stimulated in the pages of *Technology and Culture* by Thomas Leavitt, the field is almost completely barren. Most exhibitions, both art and history, are still reported as cultural events in the society pages where more attention is paid to those who attended the opening than to the exhibition itself. Notably lacking, even in such slight reviews, is any indication that an exhibition was the creation of anyone; if any credits are given, they usually go to the producing institution, as if the exhibit had sprung full blown from some small inflatable package stored in the basement. There are, however, some glimmers of hope on the horizon. The *New York Times* from time to time includes sensitive and comprehensive reviews of historical as well as artistic exhibitions, and Jay Cantor's review of the Metropolitan Museum's "19th-Century America" exhibition in *Winterthur Portfolio 7*, are important steps in the right direction.[7]

The general lack of critical apparatus is especially disturbing given the fact that the exhibit is a relatively ephemeral medium. Although partially recoverable by catalog, film, and still photography, the exhibition, once disassembled, must have had criticism that will have, at a later date, the ability to revive the essential qualities that made the work succeed or fail. "The Growth of the United States," mounted at the National Museum of History and Technology, was never critically reviewed. Developed at a cost of several million dollars, that fact alone makes it a likely candidate for review. But alas, the exhibit is now demolished and with it the opportunity for all to profit from what critical analysis might have offered.

The uniqueness of the exhibition as a medium tends to be overlooked, a condition reflected in the lack of adequate critical standards for judging exhibitions. If an exhibition is a work of intellectual and artistic creativity, it cannot be judged by the same standards as a textbook or the programmed learning found in the classroom. What distinguishes a successful exhibit is that it is both less and a great deal more than the run-of-the-mill teaching experi-

[7] Jay Cantor, "When Wine Turns to Vinegar: The Critics' View of '19th-Century America,' " in Ian M. G. Quimby (ed.), *Winterthur Portfolio 7* (Charlottesville: University Press of Virginia, 1972), pp. 1–27.

ence. It can offer a new view of history or contemporary experience or whatever, but as a programmed learning experience the exhibition environment can never compete, in terms of cost or efficiency, with other teaching devices. The pioneering efforts of such people as Chandler Screven and Harris Shettel have made a substantial case that, as didactic teaching tools, exhibitions as they are presently planned and executed are relatively unsuccessful. Even if they are planned with the clearest definition of purpose and the best talent, they will remain a relatively expensive and ineffective method of teaching. But if we assume that the exhibition environment provides a different kind of experience, then it can be seen as an opportunity to provide a whole series of more subtle and, at the same time, less quantifiable experiences, which can offer its visitors a new historical perspective and require them to ask new questions of their material culture.

While a look at the exhibition as a distinct and complex art form, with its own particular rules and rhetorical devices, may answer many of the questions about why the exhibit is difficult to evaluate as a learning environment, it raises other questions that are important to the future of museums and to the study of material culture. A work of art must have an artist, a controlling personality to give vision and "solidity of specification" to the finished product, someone to assemble all of the, perhaps, fragmented and unrelated parts into a final product that has both intellectual and artistic integrity. In the past, in most museums that have built exhibitions of material culture, it has been the responsibility of the curator to develop and control the exhibition process as an adjunct to his other duties. This means that a person trained by education and experience to do one thing is put in the position of having to take on a separate task. This does not imply that it is impossible to have a curator who can create great exhibitions, but it does mean that curators cannot assume that the exhibition is a simple adjunct to the process of collecting and research. As long as museums were content to be quiet repositories of information or aesthetic pleasure for the already initiated, this was not a major problem. Under such circumstances the curator was in reality using the exhibition as a process for reordering and reevaluating his date for himself and his colleagues—much in the same way the university professor oftentimes writes his monographs

as if they were to be read only by himself and a few close associates. This results in what may be called the "curatorial fallacy"; that is, the assumption that each viewer brings to an object the same historical knowledge, the same questions, and the same dense web of association as does the curator. This is the modern version of the collector and the private collection, maintained for his own use and for his own benefit. The modern exhibit process does not permit such luxury. To put on display an old saddle, a machine tool, or a nineteenth-century child's toy without exploring its relationship to function and historical context in a way that can be apprehended by someone not versed in the particular subject means that the first criteria of any work of art—its ability to communicate—is not met and the exhibition becomes a dialogue between the curator and himself. This may be an enjoyable exercise for the curator but it is an unproductive and uncommunicative one for his audience. Here the curator must accept what is already accepted among writers of history, that there is a great deal of difference between the scholarly monograph and the exploration of history which is a work of art as well as a contribution to scholarship. And further, that in the greatest works of history an important part of the process of historical discovery can often be found in the actual writing of the work.

But if the curator is not always to be in control of the exhibition, who is? By their nature, exhibitions are collaborative ventures, more akin to architecture or film than to the more personal forms of art which require only the solitary artist for their production. There are many parallels between exhibition and film production. There is the producer who supplies the funds and who has the responsibility for setting out the broad ground rules; there are then the myriad contributions such as script, props, settings, lighting, camera work, editing, etc., which must be brought together into the finished film by the director. Much the same thing occurs in architecture. The client defines the job to be done and the details of engineering, lighting, etc. are brought together by the architect who in the end is responsible for the character of the finished structure.

The museum environment is conducive to the use of such a collaborative system, and, in fact, such a structuring of the exhibition process has produced many of the best exhibitions of the

recent past. The client or institution has the responsibility to identify the best talent to direct, or to be the architect of, each exhibition; that the best person to mount an exhibition in one area is not necessarily the best to do so in another; and that the curator of a particular collection or subject matter is not always the best selection to direct an exhibition that touches his area of specialty. On the other hand, it does not necessarily follow that professional exhibit designers are always the answer to the problem. In short, it means, as in architecture, that only great clients can produce great exhibitions.

Several relatively recent exhibitions that are finished exhibit environments are in themselves processes of discovery, and are good illustrations of the art of the exhibition.

One such exhibition is the installation of the Garvan Collection at the Yale University Art Gallery, a collaborative effort of Charles F. Montgomery, Patricia E. Kane, and Chermayeff and Geismar Associates (Figs. 1–4). The exhibit is entitled "American Arts and the American Experience." Likely, it would be difficult to assess its ability to teach this relationship by traditional means of exhibit evaluation; a film or textbook would probably produce more easily measurable results. But the potential for a stimulating visual and intellectual experience lies within this exhibit. The selective, massed groupings of objects, punctuated by photographs and other media, offer an opportunity to explore many of the subtleties of relationship of one art form to another. The functional details and processes of furniture construction are made available since many objects have been "exploded" to show the details of joints, finish, and the techniques of forming. Great arrays of everyday utilitarian objects are displayed alongside more self-conscious objects of design. Important relationships, both aesthetic and functional, are established by the inclusion of contemporary furniture, prints, photographs, and paintings. Supplemental materials, such as a cross-referencing index of chronology and elements of art, design, and architecture, extend certain relationships that are implicit in the objects on display to the wider world of material culture outside the exhibit. The labels supplement and complement the other elements of the exhibit, providing help, when desired, in establishing necessary functional relationships and a larger cultural context for the objects themselves. The

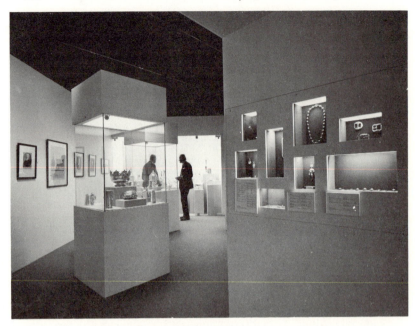

Figure 1. Display of silver, "American Arts and the American Experience." Garvan and Related Collections of American Art, Yale University Art Gallery. (Photo, Cambridge Seven Associates.)

exhibition, in short, is a finished environment. Through the selectivity in arrangement of details, the distortions of time perspectives, the rearrangement of important details from furniture and other elements of the decorative arts, an exhibition *experience* is created that gives a special meaning and creates significant relationships among all its parts. At the same time, it is an exhibition experience which looks outward and enriches our perspective, not only on material culture but upon the cultural context in which it has developed. Thus, the exhibit environment is an exploration and evaluation of material culture presented in both an intellectually stimulating and visually legible manner which has a life and meaning apart from its components. It is interesting to note that this exhibition is a direct linear descendant of a much earlier student exhibition entitled "American Arts at Yale, 1651 to 1971" which opened in 1971. The students who mounted the exhibition

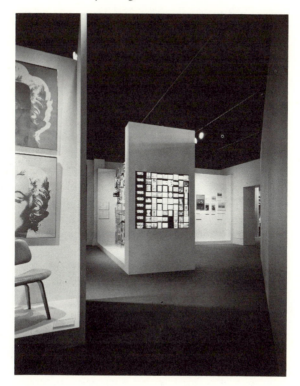

Figure 2. Cross-referenced timeline, "American Arts and the American Experience." Garvan and Related Collections of American Art, Yale University Art Gallery. (Photo, Cambridge Seven Associates.)

testified that the process of putting it together—selecting themes, choosing individual artifacts, and constantly re-evaluating and questioning each theme and artifact—had been a useful way of exploring the relationships between material culture and the larger world of the American experience. And what was especially significant was that each student was aware that this process of discovery had a strong public dimension. It is one thing for the exhibition builder to be convinced of the exhibit's validity but quite another to convince an exhibition visitor uninitiated in the considerable mystery of the American decorative arts.

Another exhibition with similar integrity but which was devel-

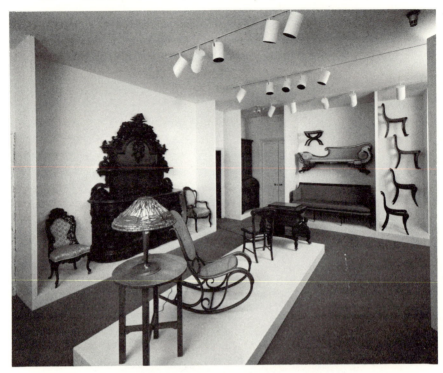

Figure 3. Display of neoclassical and Victorian furniture, "American Arts and the American Experience." Garvan and Related Collections of American Art, Yale University Art Gallery. (Photo, Cambridge Seven Associates.)

oped along entirely different lines is "The World of Franklin and Jefferson," by Charles Eames (Figs. 5 and 6). Here the goal was to plot the outlines of the world in which these men lived, to people it, and to offer a sense of the particular details, visual and intellectual, which gave concreteness and specificity to the one hundred twenty years that span the lives of the two men. An important limitation on the exhibition was the small amount of original material available for use since the exhibit would have a rigorous travel schedule. In "Franklin and Jefferson" Eames avoids any implicit didacticism by eschewing a predetermined visitor path or sequence of exploration. Concerns such as proper visitor flow are

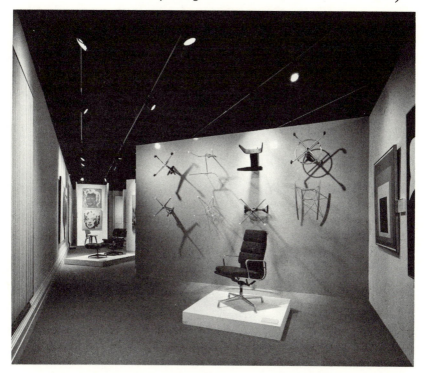

Figure 4. Display of furniture designed by Charles Eames, "American Arts and the American Experience." Garvan and Related Collections of American Art, Yale University Art Gallery. (Photo, Cambridge Seven Associates.)

dismissed and are replaced by an environment which allows the visitor to pick and choose from a variety of visual cues offered by the various components of the exhibit. A subtle hierarchy in the label structure makes it possible to follow up visual clues with concrete information or interpretation, although it is not assumed that a visitor will read all of them, or even all of any one of them. Eames uses color photography in a very special way. There is no intent to confuse the real thing and the photographic image, and yet Eames realizes the power of the camera to pick out the significant detail or aspect of a particular object, or scene, or portrait, and to focus the viewer's attention on it. Although criticized by

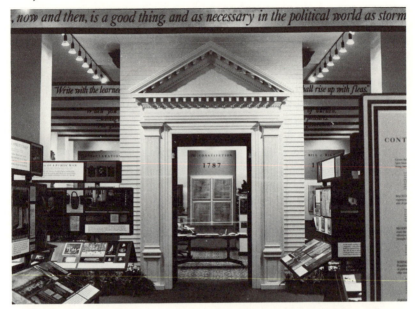

Figure 5. Exhibition area, "The World of Franklin and Jefferson." Grand Palais and other museums, 1975–77. (Photo, Office of Charles and Ray Eames.)

some, this photography gives to certain images a vividness that is more visually powerful than would be the display of the original object. Another important devise employed in this exhibition is the use of photographic assemblages of objects, which are often impossible to display together, and which, through their association with one another create new and subtle intellectual relationships. When original objects are used, they punctuate the combination of photographs and text with new significance. The end product, like the Garvan installation, is considerably more than the sum of its parts. It uses a whole range of rhetorical devices to create an environment that engages the visitor to ask new questions of the material on display, and thus the exhibition offers a unique kind of intellectual and visual experience.

Different in content and execution, but similar in qualities, is an exhibition developed in 1972 by Chermayeff and Geismar Associates in collaboration with James B. Baughman for the National

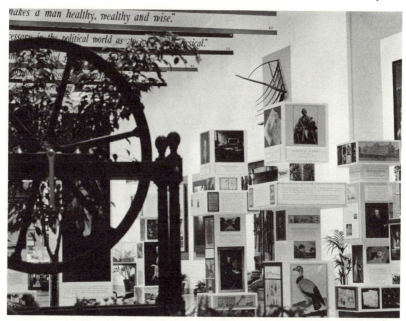

Figure 6. Exhibition monoliths, "The World of Franklin and Jefferson." Grand Palais and other museums, 1975–77. (Photo, Office of Charles and Ray Eames.)

Museum of History and Technology entitled, "If We're So Good, Why Aren't We Better?" (Figs. 7–14). This exhibition is important because it raised some significant questions about the nature of didactic exhibitions of material culture within museums. The purpose of the exhibit was, simply, to take a relatively abstract and, to most people, boring concept, productivity, and explain it in a manner that would be both engaging and intellectually stimulating. The exhibition began with a series of "buzzwords" which bombarded the viewer with confusing concepts. At the end of this section was a simple label which said, "Confused? Don't Be. Understanding Productivity Is as Easy as Understanding Mom's Apple Pie." The next area of the exhibition showed how the production of mom's apple pie was made up of several elements: mom (the worker), her stove and kitchen utensils (tools), ingredients (materials), and a recipe (system). After this introduction,

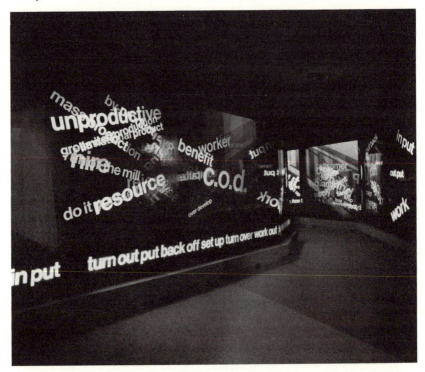

Figure 7. Exhibition entrance ramp, "If We're So Good, Why Aren't We Better?" National Museum of History and Technology, Smithsonian Institution, 1972. (Photo, Chermayeff and Geismar Associates.)

the rest of the exhibition was devoted to defining and exploring these various components of productivity. A huge fiberglass figure of Paul Bunyan's boots made the point that we could increase our productivity by hiring Paul Bunyan to do our work. But Paul Bunyan does not exist; therefore, society must make better use of the things at hand in the real world, such as workers, tools, materials, and systems, if productivity is to be increased. The next section focused on making a better worker through training, safety, education, etc. The following area was devoted to a historical survey of the development of better tools, using the move from the sickle to the modern harvesting combine and from primitive type-

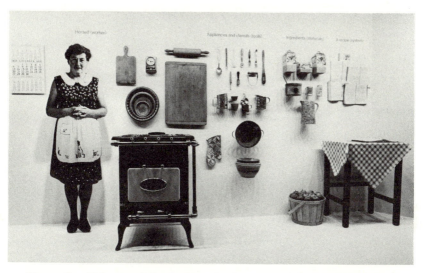

Figure 8. "Mom and Apple Pie" display, "If We're So Good, Why Aren't We Better?" National Museum of History and Technology, Smithsonian Institution, 1972. (Photo, Chermayeff and Geismar Associates.)

writers to modern ones as examples of quantum leaps in productivity in our history. Next was an area devoted to defining ways of developing better materials. The next area focused on the better system. It explained the role of machine tools and showed a variety of mass-produced items that we all take for granted in our daily lives, such as automobiles, newspapers, cigars, and television sets. A short animated film explored how quantity of production, in some areas, inevitably affects the quality of the produced items. This subject was developed more fully in the following section, which showed the costs of productivity, including pollution, job boredom, and urban blight. The last major section was devoted to showing how productivity is affected by a wide variety of factors, some that can be easily controlled and some that are totally independent but in the end affect the productivity calculus. A huge, operating pinball machine was used to express this point. The exhibition ends with a simple label which states that no matter what decisions our society makes, productivity will be a factor in those

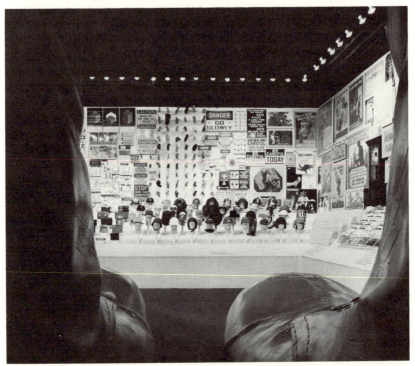

Figure 9. "The Better Worker" display with Paul Bunyan's boots in foreground, "If We're So Good, Why Aren't We Better?" National Museum of History and Technology, Smithsonian Institution, 1972. (Photo, Chermayeff and Geismar Associates.)

decisions and will be affected by them. "Productivity" perhaps represents the far frontier of the didactic exhibition. Here the purpose was clearly defined: to explain a concept and to try, at the same time, to give specificity and concreteness to the explanation. All elements in the exhibit—objects, labels, films, and other materials— were selected or developed to support that goal and any extraneous materials, as interesting as they may have been in themselves, were excluded. Original objects were massed to show their relationship to the exhibition's theme. When original objects were not available or would have been off the point, other media, such as film and slides were used, or in some cases, notably in the case of Paul Bunyan

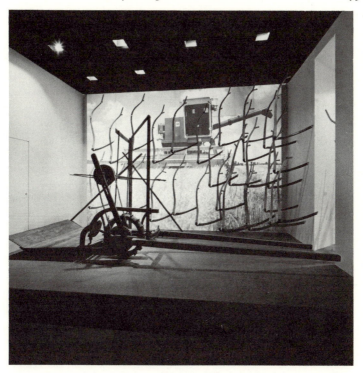

Figure 10. "The Better Tool" display, "If We're So Good, Why Aren't We Better?" National Museum of History and Technology, Smithsonian Institution, 1972. (Photo, Chermayeff and Geismar Associates.)

and the giant pinball machine, artifacts were actually created to make a point. The exhibit planners were extremely careful with their words. Realizing that the exhibit was in a sense a primer, the number of words in the exhibit was limited to a number that a visitor could reasonably be expected to read completely. The label script, which went through many drafts, had a total of slightly less than six thousand words (for an exhibit of eighty-five hundred square feet) and proved extremely successful. During the time the exhibit was on display literally thousands of families passing through it read the labels aloud, and read them completely.

The end product of all of this was a highly controversial exhibit,

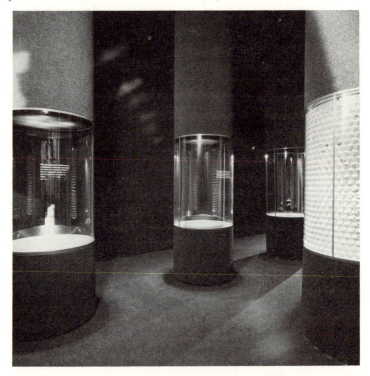

Figure 11. "Better Materials" display, "If We're So Good, Why Aren't We Better?" National Museum of History and Technology, Smithsonian Institution, 1972. (Photo, Chermayeff and Geismar Associates.)

loved by the museum's visitors and hated by its staff. Although there was no formal evaluation of the "learning" gained from the exhibit, there are several indications that may give us a clue. The exhibit was filmed by two universities and the National Education Association for use as a teaching device and the museum received over 130 requests for exhibition scripts and photographs, primarily from classroom teachers wanting material for use in their economics or social studies curriculums.

What is more important, however, is that this exhibit offers a possible prototype for future didactic exhibits, exhibits that attempt to define and to explore concepts, ideas, and other relatively

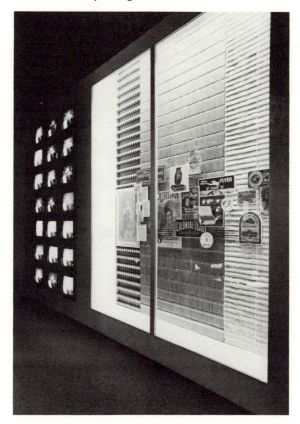

Figure 12. "Mass Production" display, "If We're So Good, Why Aren't We Better?" National Museum of History and Technology, Smithsonian Institution, 1972. (Photo, Chermayeff and Geismar Associates.)

general themes. The question is, do museums want to assume this responsibility? If they assert that their general purpose is to educate, then it seems that they must accept the consequences of that decision, although it means that they will increasingly find themselves going outside their collections and beyond the boundaries of traditional exhibits to incorporate films, slides, and other media within the structure of their exhibitions much as textbook pro-

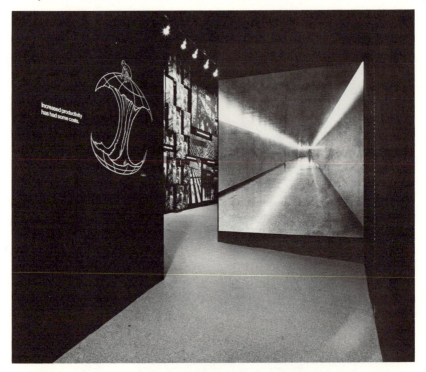

Figure 13. "Productivity Costs" display, "If We're So Good, Why Aren't We Better?" National Museum of History and Technology, Smithsonian Institution, 1972. (Photo, Chermayeff and Geismar Associates.)

ducers are responding to learning needs in the schools by using other than the traditional methods of classroom presentation. If museums are not willing to take this step, then they must be willing to trim their sails a bit and to reduce some of their educational aspirations to a more manageable and realistic level.

To come back to the original point, it means that museums, especially museums of history, have in their keeping materials that are clues to other meanings which can only be explored and discovered by the process of putting together an exhibition. Curators should be spending more time inviting creative historians and

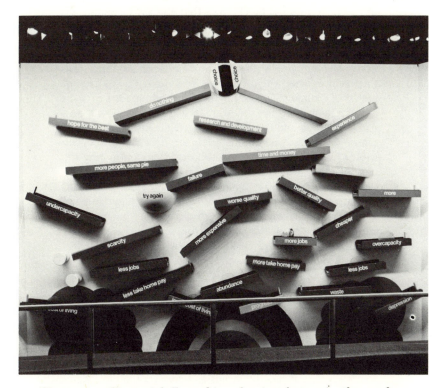

Figure 14. Giant pinball machine showing factors in the productivity calculus, "If We're So Good, Why Aren't We Better?" National Museum of History and Technology, Smithsonian Institution, 1972. (Photo, Chermayeff and Geismar Associates.)

humanists, and indeed artists, to explore with them the basic resources that are their particular responsibility. Only in this way can curators aspire to the kinds of exhibitions that will have the creative and intellectual energy that will stimulate further inquiry in our field. It is ironic that museums, traditionally the custodians of creativity, have so long neglected it in their own productions. Certainly, few works of art are without flaw; and indeed the exhibits referred to here all have flaws. But if the exhibition, the basic medium for the exploration and discovery of the world of material culture, is to be used to its greatest advantage that effort

should not be hampered by the fear that the work created will not be perfect. Again, to return to analogies with more traditional history, the eminent historian C. R. Elton has written:

> Too many supposedly "real" historians seem to think that their work is done when they have completed the finding-out part of it. Among such historians, the taint appears in their attitude to others. They are likely to niggle, to suppose that a striking, novel and imaginative piece of historical writing can be demolished by finding a few errors of detail; they are liable to write reviews full of petty corrections and noting the number of misprints. The antiquarian believes in accuracy. So should we all: inaccuracy and error are faults. But a standard of judgment confined to this one criterion is puny and un-intelligent, and a willingness to discard others because they fail in this one particular is ungenerous and unwise. Accuracy is the beginning of the work; to the antiquarian kind of his-torian it becomes its sole end. The well-trained historian who lacks imagination, enterprise, and the courage to make even mistakes speedily lapses into a kind of antiquarianism which has not even the excuse that its preoccupation with the multi-plicity of facts makes no pretense at being anything but a harmless end in itself. A good deal of historical study, and a larger part of the teaching of history, is still troubled by the censorious attentions of this species of antiquarian; and it is no answer that at least he avoids and corrects the more flam-boyant probably more dangerous influence of the pretentious, superficial, effect-hunting historians whom he conceives it his duty to expose. Two evils do not add up to any kind of good. The way to combat the bogus is to do better that which the bogus do badly, not to deny the validity of the creative mind in the study of history.[8]

To truly explore the ways in which material culture touches and intersects the paths of history and other disciplines, some risks must be taken, and more effective use should be made of a unique form of communication—the exhibition.

[8] C. R. Elton, *The Practice of History* (London: Collins, Fontana Library, 1969), pp. 152–154.

Clio's Dilemma:
To Be a Muse or to Be Amusing
James C. Curtis

The place: a Quaker farm on the outskirts of Philadelphia. The time: shortly after sunrise, shortly before the middle of the eighteenth century. A colonial postrider, bound for New York, stops to talk with the Quaker farmers. Soon he is off on the next leg of his trip. He rides through the verdant countryside, splashes across a few small streams, and arrives safely in New Jersey. (How he forded the Delaware River remains a mystery.) The rider enters Princeton, New Jersey, at precisely 9:30 A.M. We know it is 9:30 because the big hand is on six, and the little hand is on nine, and the clock is plainly visible—at the top of a late eighteenth-century steeple. The ride from the environs of Philadelphia consumed less than three hours. Dallying in Princeton part of the morning to gossip, the postman takes to the road shortly before noon. At last he is headed home. Home turns out to be a Dutch settlement on the east bank of the Hudson River, north of New York City.

The weary traveler arrives shortly before nightfall, dismounts, enters his humble Dutch-colonial abode, settles into his favorite chair, lights his pipe, and reflects on his day's journey. Well might he draw satisfaction from his ride. He has seen the remarkable degree of cultural diversity in the middle colonies. More important, he has set a new land speed record from Philadelphia to New York, one that even a modern motorist might envy.

The foregoing is not a segment from a Mel Brooks western (although the postman rode so fast his saddle may have been ablaze). These scenes came from a 1955 educational film depicting eighteenth-century life in the middle colonies.[1] A noted American educator served as consultant for the project; a major American university still circulates the film for use at both the secondary and college level. Every curator, archivist, museum administrator, and teacher can single out such films. They offend our professional conscience, perhaps because we realize that the worst educational film will receive wider circulation than the best scholarly articles or books.

We cannot ignore the simple fact that we live in a country saturated by mass media. Our children will undoubtedly learn more about America's cultural heritage from film and television than from any textbook. The recent flurry of bicentennial activity underscores this point when, for example, Bicentennial Minutes, like mouthwash commercials, punctuated prime-time television. (I have a fantasy that one night the Shell Oil Company, sponsor of the Bicentennial Minutes, will present Ralph Nader to list all the things that have been dumped in Boston harbor, beginning with the Tea Party and ending with a major oil spill from a Shell tanker.) Even a mecca like Colonial Williamsburg estimates that it reaches more people through its media programs than it attracts to the restored city itself. In fact the director of the Williamsburg audio-visual program estimates "we reach a total audience of about eighty million people a year including all media and all our film and film strip projects."[2] Such figures ought to tell us something; usually we choose not to listen.

The museum profession and the historical profession fail to appreciate the full potential of media as a resource for public education. In part this stems from a certain ingrained elitism. We are never quite sure whether museums should be popular,[3] and whether history should appeal to the masses. In historical circles, *popularize* is a term of derision; usually it is applied to individuals

[1] Coronet Films, *Colonial Life in the Middle Colonies*, 1955, color, W. Linwood Chase, consultant.

[2] Arthur L. Smith to author, June 4, 1975.

[3] "Should Museums Be Popular," panel discussion, April 15, 1975, University of Delaware.

whose books have appeared on the best-seller list which thereby disqualifies them for any scholarly distinctions.

Inexperience reinforces this bias against media as an educational tool. Neither museum professionals nor historians receive adequate training in the use of media. Graduate programs in art history and museum studies rarely provide technical instruction in such basic skills as photography, sound recording, and audiovisual production, let alone in the art of filmmaking. Small wonder that museums, universities, and historical societies contract media specialists or professional filmmakers rather than entrust the job to members of their own staffs.

But there are still larger problems involved. Trained in traditional graduate schools, museum professionals and history teachers prefer literary to visual expression. They communicate research findings through such publications as *The Magazine Antiques, Curator, The American Quarterly, The American Historical Review,* and *Museum News.* Publication in such journals invariably weighs more heavily in matters of advancement than does participation in a media project no matter how sophisticated or successful.

These considerations help to explain why historical films are so unsatisfying. Lacking both the experience to make films and the firm commitment to use films as a legitimate means of scholarly expression, museum professionals have abdicated responsibility for controlling the very mechanisms that can influence the largest number of people. When a museum does make a film, it usually turns outward, not inward, and relies on commercial experts, not scholarly specialists, to produce the finished product. The film currently being made by the Independence National Historical Park is a good case in point. Unable to manage media, the museum professional loses control over the message as well. Consequently, few museum-related films make sensitive use of objects to help interpret American culture. The situation within the historical profession is even more depressing. Historians rarely use films, let alone make them. The usual argument runs something like this: historical films are not scholarly and are, therefore, unreliable.

This paper is a summary of the results of a survey of some forty films dealing with American colonial society. While by no means comprehensive, this survey indicates the major problems with his-

torical films, especially their failure to use artifacts as cultural documents. All too often the historical film merely reflects some literary stereotype of the past; rarely does the filmmaker take advantage of his unique medium to convey new insights to the public. The apparently obvious solution to this problem is for the historian and museum professional to turn filmmaker. For reasons outlined above, this is often unrealistic and expensive. Instead, there may be more practical, inexpensive ways for curators, scholars, and teachers to use media to reach a wider public.

The forty films surveyed deal with different aspects of seventeenth-, eighteenth-, and early nineteenth-century history. Practical considerations dictated the choice of these films. Because there is no comprehensive guide to educational or historical films, one has to rely upon the myriad film catalogs published by commercial distributors and university film libraries. Further, because in most cases one must rent a film in order to preview it, budgetary restrictions limited the scope of the survey. (Eyestrain also played a minor role in this decision.) Time-Life Corporation, thinking I might buy segments of Alistair Cooke's *America*, permitted me to preview this material free of charge. Colonial Williamsburg was extremely generous in making all their films available at no cost. Feature films were not part of the survey because they are designed more for entertainment than for education. (Doubtless many middle-aged Americans think that the Pilgrim fathers all looked like Spencer Tracy.) Nor were television specials evaluated because almost all of them are unavailable for circulation as soon as they are broadcast. While by no means complete, the sample does represent the types of film most readily available to the classroom teacher and museum educator.

Historical inaccuracy must surely rank as the most aggravating and frequent flaw in the films surveyed. Anyone familiar with eighteenth-century transportation might have developed a more realistic and accurate itinerary for the colonial postrider. Similarly, a folklorist could have saved Coronet Films and Sleepy Hollow Restorations some embarrassment in their tour of the Van Cortlandt Mansion.[4] This film makes excellent use of furnished interiors and demonstrates craft traditions from colonial New York.

[4] Coronet Films, *Colonial Life on a Dutch Manor*, 1969, produced by Walter R. Lewisohn in cooperation with Sleepy Hollow Restorations, Inc.

The color is good, the costumes accurate, and the guides are convincing actors, but the music is inappropriate and the script relies heavily on the music. Dulcimers and autoharps came rather late to the colonies and then flourished in the southern Appalachians, not among the Dutch colonial elite. "What shall we do with the baby oh," may have been sung in a Dutch manor but certainly not in the manner of Kentucky's Jean Ritchie. Similar musical errors mar Indiana University's 1972 production *A Pioneer Mill*.[5]

If these films are any indication, eighteenth-century Americans enjoyed the best possible climate—temperate weather, little or no snow, and rarely even a rainfall. In the more than eight hours of Williamsburg films, it rains for no more than five minutes, and then usually for a practical purpose—to demonstrate that handmade shingles shed water. Perhaps the colonial cooper loafed on rainy days because the Williamsburg film showed every step of his craft taking place outdoors.[6]

Of course there are technical explanations for these climatological phenomena. Twentieth-century filmmakers, like eighteenth-century armies, encamp in the winter and come out in force in the spring when they have adequate lighting for their sets. At night they must rely upon artificial lighting. Students of the craft of candlemaking may be amazed to learn that their colonial forebears actually invented a flood candle, or so it seems from the bright interiors presented in these films.

With the best of climates came the best of children. A number of the films reviewed dealt with colonial young people, and consistently stressed their capacity for hard work, obedience, and pioneer sacrifice.[7] With chores to do, errands to run, and skills to learn, children had little time for mischief and apparently no time for frolic. Significantly, none of these films mentioned religion as a powerful force in structuring the family and in determining child-

[5] Audio-Visual Center, Indiana University, *A Pioneer Mill*, 1972, color.

[6] Colonial Williamsburg, *The Cooper's Craft*, 1967, color.

[7] EPI Classroom Films, *Kentucky Pioneers*, 1941, black and white, produced in conjunction with Pioneer Memorial State Park, Harrodsburg, Ky.; Coronet Films, *Boy of a Frontier Fort*, 1958, color, W. Linwood Chase, consultant; Encyclopaedia Britannica, *Colonial Children*, 1650–1700, 1940, black and white, produced in cooperation with the Museum of Fine Arts, Boston; Eastman Kodak, *Eighteenth-Century Life in Colonial Williamsburg*, 1943, color, produced in cooperation with Colonial Williamsburg.

rearing patterns. If the portrayals were unrealistic, at least the casting was accurate: children played children. Yet in films dealing with native Americans, whites played Indians, often with ludicrous results. A filmed re-enactment of William Penn signing the famous treaty with the Indians looks more like a protest rally in which scantily clad white males are urging repeal of the topless ordinance currently in force on several East Coast beaches.[8] Art historians could no doubt defend this portrayal as consistent with the trend in eighteenth-century painting to depict all noble savages as white noble savages. Hollywood, not history, provided the model. It is well known that Cochise looked like Jeff Chandler, Geronimo like Chuck Connors, and Sitting Bull like Victor Mature.

Inaccurate costumes and inappropriate props further erode our sense of history. The French voyageurs were certainly hardy outdoorsmen, dressed to withstand the cutting winds that knifed across the Great Lakes, but where did they manage to purchase Pendleton shirts?[9] If the voyageurs were dressed to kill, the First Families of Virginia came to the New World equipped for an amphibious assault, sailing up the James River in an eighteenth-century man-of-war.[10]

Of those films free from historical inaccuracies, a good many were simply unenlightening, using shopworn historical clichés and primitive stereotypes. Not surprisingly, many of the films of the 1940s and 1950s were wedded to Frederick Jackson Turner's frontier thesis. According to the filmmakers, American colonists were liberty-loving, democratic, peaceful inheritors of the vast continental land mass. Indians were merely obstacles in the path of civilization. Blacks appear in many films, but always in a subservient role. Ironically they are rarely identified as slaves. In fact these films create the impression that slavery was inconsequential in colonial society and that most slaves were trusted domestics, not field hands.

There are exceptions to this otherwise dismal picture. The films produced by Colonial Williamsburg contain few inaccuracies and

[8] Coronet Films, *William Penn and the Quakers,* 1954, black and white, Ralph W. Cordier, consultant.

[9] McGraw-Hill Films, *Fort Ticonderoga: Key to a Continent,* 1959, color, produced in cooperation with the Fort Ticonderoga Association.

[10] Encyclopaedia Britannica, *Captain John Smith: Founder of Virginia,* 1954, Clarence R. Ver Steeg, consultant.

are distinguished by an obvious concern for historical authenticity. No other organization has spent as much money producing educational media dealing with colonial American history.[11] At first glance the investment seems to have paid handsome dividends. The twenty films and ten filmstrips produced by Colonial Williamsburg set high standards of technical excellence. They display meticulous attention to the details of eighteenth-century dress, furnishings, crafts, and customs. Their main flaw is a direct result of such careful focus. By concentrating so heavily on authentic re-creation, Williamsburg films do not stress interpretation of artifacts or craft traditions. These strengths and weaknesses are especially evident in the craft films detailing the work of the cooper, the silversmith, the gunsmith, the basketmaker, and the printer.[12]

By creative use of macrophotography and excellent scripting, these films explain colonial crafts in clear and convincing detail. Purists might quibble about the decision to allow modern craftsmen to narrate as well as to re-enact eighteenth-century crafts, because their occasional lapses into colloquialism detract from the historical atmosphere of the films. On the other hand, master craftsmen such as Wallace Gusler and William de Matteo demonstrate their work more clearly than could any actor. The decision to employ David Brinkley as narrator for *The Gunsmith* seems less fortunate. The viewer has a difficult time remembering that he is looking at a colonial gun shop, not at the NBC News anchor desk. At the end of the film, one almost expects to hear, "Good night Chet and good night from Colonial Williamsburg." The same comment applies to William Pierce's narration of *The Art of the Conservator* (which comes to you from the music shed at Tanglewood).[13] Documentary filmmakers must be ever mindful of the ancient adage:

[11] Interview with Edward P. Alexander, Aug. 2, 1975.

[12] Colonial Williamsburg: *The Cooper's Craft*, 1967, color, George Pettengell, master cooper; *The Gunsmith of Williamsburg*, 1969, color, Wallace Gusler, master gunsmith; *The Silversmith of Williamsburg*, 1971, color, William de Matteo, master silversmith; *Basketmaking in Colonial Virginia*, 1967, color, Mr. and Mrs. Cody Cook, basketmakers; *The Colonial Printer*, 1952, color.

[13] Colonial Williamsburg, *The Art of the Conservator*, 1966, color, Russell Quandt, conservator; William Pierce is the regular television and radio announcer for the Boston Symphony Orchestra.

Of neutral voice let your narrator be
Lest he steal the show and embarrass thee.[14]

For the folklorist and historian of technology these films are extremely helpful. For students of American culture the craft films are limited in scope and lack of clear interpretive thrust. *The Gunsmith of Williamsburg* demonstrates the skills necessary to produce a flintlock, yet it avoids all but the most simplistic comments about the role of firearms in colonial society. Similarly *The Silversmith* fashions a handsome coffeepot. Yet the film does not dwell on the importance of silver as a medium of exchange, nor does it detail the significance of design, the dependence on British models, the impulse to accumulate, and the relationship between the craftsman and the ruling elite.

The staff at Colonial Williamsburg is well aware of the larger social significance of colonial crafts. Indeed they have prepared a thoughtful instructor's manual to accompany each film. For instance, the *Teacher's Manual for the Cooper's Craft* includes a concise description of "Cooperage in the Virginia Colony" and two excellent illustrations of colonial craftsmen at work. But neither words nor pictures found their way into the film. Nor does *The Cooper's Craft* really answer the important questions listed in the manual: "What was a journeyman and how did he differ from the Master Cooper?" or "How do you think the cooper ranked with other craftsmen such as the baker, the silversmith, bootmaker and printer?" These are academic questions and the filmmakers at Colonial Williamsburg apparently feel that such questions are best raised by the instructor rather than by the film.[15]

This attitude is part of a larger belief that a film designed specifically for educational use would not prove popular. "An organization such as Colonial Williamsburg, must and does recognize that the subject matter offered the public educationally must range between the very popular and specialized less popular items," writes the head of Williamsburg's Audiovisual Department.[16] Clearly, Williamsburg has decided to make films that will appeal more to

[14] Anonymous, eighteenth century.

[15] Colonial Williamsburg, *Teacher's Manual for the Cooper's Craft* (Williamsburg, Va., n.d.).

[16] Arthur L. Smith to author, June 4, 1975.

the general public than to the academic specialist. A concern for public relations no doubt figured in this decision.

In seeking to document the crafts and customs of colonial Virginia, the Williamsburg films perform a valuable public relations service for the re-created city. Almost all of the films contain vivid color footage of Colonial Williamsburg and beckon the viewer to come for a visit, as thousands do. This message is most evident in the most recent Williamsburg film, *A Williamsburg Sampler*.[17] One exception to this rule is the fine technical film, *The Art of the Conservator*, mentioned earlier. Art conservation takes place in the laboratory, not on The Green, and is more modern science than ancient craft. Still, by frequent reference to the Abby Aldrich Rockefeller Folk Art Collection, even this film manages to support the image of Williamsburg as a colonial showcase. We can only hope that in the future Williamsburg filmmakers will leave the confines of the village to explore such important and appropriate topics as colonial election practices, the operations of a Southern plantation, staple agriculture, and slavery. Williamsburg realizes the need for "more films that are directly tied to the teaching of history in schools and colleges," but evidently believes that such educational ventures would prove less popular than its current film offerings.[18]

The desire to make popular films inevitably results in the use of such popular formulas as the situation comedy and the small-town romance. Williamsburg's production of *The Colonial Naturalist* follows the bumbling progress of Mark Catesby, "The Colonial Audubon," as he explores the woods and marshes on the outskirts of Williamsburg.[19] Where the craft films use a documentary technique, *The Colonial Naturalist* relies on dramatic re-creation, costumed actors, and dialogue to make its point. In this instance, we learn more of Catesby's antics as shy, eligible bachelor than of his activities as premier naturalist and correspondent of the Royal Society. When Catesby takes to the field in search of wildlife, he sights more species in a few minutes than many naturalists do in

[17] Colonial Williamsburg, *A Williamsburg Sampler*, 1975, color, produced by Arthur L. Smith.

[18] Arthur L. Smith to author, June 4, 1975.

[19] Colonial Williamsburg, *The Colonial Naturalist*, 1965, color.

an entire season. In fact the nature sequences of this film are reminiscent of a Walt Disney outdoor extravaganza, minus the usual technicolor gore. In opting for dramatic re-creation and comic motif, the film makes little use of the most interesting Catesby artifacts, his original drawings. These would have added far more color to the film, especially if compared to the existing wildlife. Preoccupied with the nuances of plot and the glory of the Virginia landscape, *The Colonial Naturalist* says little about the eighteenth-century passion for scientific study of nature.

Passion of a different sort mars *Music of Colonial Williamsburg,* an otherwise effective presentation of the variety of colonial music making. A chance encounter between a transient sailor and a village maid provides the structure for this musical tour of Williamsburg. Some sensitive narration might have been more suitable than this romantic byplay; even the instructor's manual finds the story line "a thin thread." Silly as it is, the situation affords us a glimpse of Pamela Tiffin before she rose to semistardom in Hollywood. The director had other aims in mind. "It is our hope that almost exclusively through musical and visual means the present-day audience can experience the reality and *feel* of another age."[20]

Feel one does; understand one does not. *Music of Colonial Williamsburg* is a collage of interesting but unexplained sights and sounds. For example, there is an excellent sequence of black music that the teacher's manual maintains was a "real slavery-time tune" with West African origins. The film makes no explanation of such origins, nor does it explore the social significance of black music. Instead, it inadvertently reinforces the Sambo stereotype of the happy-go-lucky, fun-loving slave. Recent historical scholarship places great stress on both the role of music in slave society and the meaning of slave songs.[21] This sequence is but another instance of Williamsburg's failure to come to grips with the importance of slavery in colonial society.

The problems attending dramatic re-creation are clearly evident

[20] Colonial Williamsburg, *Music of Colonial Williamsburg,* 1960, color; Colonial Williamsburg, *Teacher's Manual for Music of Colonial Williamsburg* (Williamsburg, Va., n.d.), p. 3.

[21] Colonial Williamsburg, *Teacher's Manual for Music of Colonial Williamsburg,* p. 10; for instance, see Sterling Stuckey, "Through the Prism of Folklore: The Black Ethos in Slavery," *Massachusetts Review,* 9 (Summer, 1968), 417–437.

in the most famous of Williamsburg films, *The Story of a Patriot.* Indeed, the success of this film may explain the adoption of similar formats for *The Colonial Naturalist* and *Music of Colonial Williamsburg.* The staff at Williamsburg estimates that fifteen million people have seen *The Patriot* at the visitor center. In addition, the foundation has sold twenty-five hundred prints of the film, nearly five hundred of these to the Department of Defense. Surely, no other film on colonial American history has enjoyed such phenomenal success; the recent wave of bicentennial enthusiasm no doubt added to *The Patriot's* luster. This popularity comes at a price. Made in 1956, this thirty-three-minute film cost nearly $500,000.[22]

The Story of a Patriot is no modest education film but a true Hollywood production, directed by George B. Seaton and filmed in Technicolor, double-framed Vista-Vision with six-channel stereophonic sound by Todd-AO. Williamsburg designed *The Patriot* for its new visitor center where a special auditorium, equipped with a wide screen and an expensive sound system was constructed. The results are impressive, as anyone who has been to Williamsburg can attest. Visitors come away with a sense of the beauty of the city—this is especially important on rainy days—and an appreciation for the generosity of the late John D. Rockefeller, Jr., who helped to finance the restoration of Williamsburg.

As entertainment, *The Story of a Patriot* succeeds brilliantly. The sweep of Vista-Vision, the impact of Todd-AO, and the presence of a first-rate cast combine to make an exciting experience. Viewers today may have difficulty identifying with the central character, John Frye, a fictional hero "deliberately created as a typical planter-burgess who could fit into the story pattern and mirror the effects of the growing rift with the mother country."[23] It is not that John Frye is unbelievable; it is simply that Jack Lord who plays John Frye has since become Inspector Steve McGarrett of "Hawaii Five O." Devotees of modern television police drama who admire McGarrett's authoritarianism and his refusal to coddle

[22] Colonial Williamsburg, *The Story of a Patriot*, 1956, color; Arthur L. Smith to author, June 4, 1975; interview with Edward P. Alexander, Aug. 2, 1975.
[23] Colonial Williamsburg, *Teacher's Manual for the Story of a Patriot* (Williamsburg, Va., n.d.), p. 1.

criminals may find Frye's reticent rebelliousness a bit frustrating. Ironically, the actors who played real colonial heroes—Patrick Henry, Thomas Jefferson, George Washington—have achieved no such subsequent fame.

As history, *The Story of a Patriot* leaves much to be desired. The script makes a valiant effort to cover the events from 1769 to 1775 in less than a half hour. Time is of the essence. In one sequence the Minutemen assemble in forty-five seconds flat. This compression leads to a superficial treatment of the causes of the Revolution. The film presents highlights of the gathering storm in Virginia, but it never really explores the root causes of discontent, nor does it explain fully why a planter like Frye becomes a revolutionary rather than a loyalist. Had the film spent more time at Frye's plantation examining his economic status, his social standing, and his political activities, the conversion might be comprehensible. But this would have necessitated a much briefer tour of Williamsburg. Given the need to locate Frye in Virginia's capital, the film still might have concentrated on his discussions with other burgesses instead of the theatrics of Patrick Henry. Unable to explore the issues in any depth, the film is unable to explain Frye's motivations.

In addition to being superficial, *The Story of a Patriot* is dated, its ideological message as outmoded as Todd-AO sound and Vista-Vision. The film really tells us more about the cold war era, about the fear of Communism, the desire to portray our history as free from deep-seated social cleavage, about consensus history, and about the messianic zeal of American foreign policy, than it does about the coming of the Revolution. "Dedicated to the principles of liberty wherever and whenever they may be under challenge," *The Patriot* appeals to our fears as well as our patriotism by suggesting that we, like John Frye, might have to make monumental decisions between freedom and subjugation. To be free, the film sermonizes at its close, one has to learn to choose and to make the right choice.[24] Small wonder that the Pentagon bought so many prints of the film!

As originally conceived, *The Story of a Patriot* was much more analytical, much less nationalistic. When it first decided to make a

[24] Colonial Williamsburg, *The Story of a Patriot*, introduction.

film for the visitor center, the foundation commissioned James Agee to write a treatment. Novelist, social critic, experienced scriptwriter, student of American film, chronicler of the plight of the sharecropper, Agee brought to the assignment an appreciation for the potential of the film medium and a strong desire to say something original about the background of the Revolution.[25]

Although it is fragmentary, Agee's treatment speaks eloquently to the issues that divided the American colonies and continue to disturb Americans today. Above all he wanted to avoid pageantry and to be wholly fictional. To dwell on the behavior of Patrick Henry or Thomas Jefferson would only detract from the central focus of the film—a vitriolic tavern debate between loyalists and emerging revolutionaries. All the action was to take place in one day and spring from one event, the news of a violent assault on a royal stamp collector. The leading character of the film was to be a frontiersman who would sit in studied silence as the debate raged and move finally to speak his piece in favor of resistance to royal decrees. Agee emphasized that the tavern debate was to be intense yet not one-sided, that it had to present the royalist position as convincingly as the argument for revolution.

Agee also wanted to emphasize the importance of slavery in colonial society. In part he was trying to paint a realistic portrait of Virginia life. Yet he also wanted to remind modern audiences of the supreme irony of the Revolution: that only white men were created equal. To this end, Agee suggested inclusion of scenes depicting life in the slave cabins (he speculated that they would have to be built), the wet-nursing of white children by black women, the possibility of miscegenation, and the use of black males for slave breeding.

James Agee died before completing his treatment, but even had he lived he would not have been able to sell these ideas to Hollywood or to Colonial Williamsburg. His views were far too radical for either. His emphasis on deep-seated conflicts ran counter to the prevailing belief in a fundamental ideological consensus, just as his suggestions of black hostility and the African origins of black slaves threatened the 1950s integrationist assumptions that "Ne-

[25] The commentary is based on a copy of James Agee's treatment loaned to me by Edward P. Alexander. Since the treatment is incomplete and was assembled from Agee's literary remains, I have agreed not to quote directly.

groes are after all only white men with black skins, nothing more, nothing less."[26] Because of its patriotism, pageantry, and hero worship, *The Story of a Patriot* is sheer entertainment, nothing more, nothing less.

And the public is always ready to be entertained. Witness the spate of bicentennial celebrations and the commercial success of the 1972 BBC production *America: A Personal History*. Produced, written, and narrated by Alistair Cooke, the thirteen-part series chronicles the development of American society from Columbus to Vietnam, with stops in between at Independence Hall, Monticello, the Mormon Tabernacle, the Augusta National Golf Course, and Basin Street. Perhaps, recognizing that most previous historical films lacked interpretive thrust, Cooke decided to offer his own account of the American experience. No doubt he was buoyed by the acclaim accorded *Civilization*, an earlier BBC production. But where Kenneth Clark was a recognized art historian who confined the series to this field, Cooke had no scholarly credentials and did not feel bound to limit his approach in any way. As a consequence he produced a polished series of guided tours, held together by misguided interpretations based on scholarship nearly thirty years out of date.

The first four segments of *America* cover the colonial period from first colonization through the establishment of the Constitution.[27] In each episode the pattern is the same. The film begins with beautiful color footage of some geographical marvel or historical landmark (it never rains in *America* either!) and then cuts to Cooke's opening monologue, which is similar to his introductions to BBC's "Masterpiece Theatre," both in superficiality and pomposity. During the course of each episode, Cooke tours such historic locations as Colonial Williamsburg; Salem Village; New Castle, Delaware; and Washington, D.C., pausing every so often to comment or expand on his opening remarks. Clearly this is no ordinary documentary; in fact the major shortcoming of the entire series is a lack of definite focus, a penchant for the broad sweep

[26] Kenneth Stampp, *The Peculiar Institution* (New York: Knopf, 1956), pp. vii–viii.

[27] The first four segments are entitled "The New Land," "Home from Home," "Making a Revolution," and "Inventing a Nation."

instead of the key event, and above all a frustrating eccentricity in some way related to Cooke's British ancestry.

There was potential in the series, for Cooke was not afraid to speak his mind or to offer succinct explanations for even the largest of historical events. He had total control over the production of the series. He wrote the scripts himself and supervised both photography and editing. As the title of the series implies, this is a personal history of a sort rarely found in educational or even Hollywood films. It is a pity that Cooke has such limited historical training, for he might have asked more meaningful questions of his material.[28]

His lack of sensitivity is most clearly evident in his failure to use artifacts as historical documents. He visits a seventeenth-century house on the Mississippi River, comments that it is typically French, but never says why.[29] He roams the halls of Shirley Plantation in Virginia, points to portraits of the Carter family, describes their position as one of the First Families of Virginia, and then, in the midst of all this aristocratic splendor, he discourses on Virginia as the birthplace of democracy.[30] A visit to John Winthrop's house produces even more unrealistic statements. Cooke might have remarked on the theological implications of Puritan furnishings but instead he delivers a blunt diatribe against "religious dictatorship." Inevitably Cooke must enter a Puritan meeting house, mount the pulpit and sermonize, not on the role of the ministry or on the organization of the seventeenth-century congregation, nor on Puritan theology, but on a comparison between Puritans and the modern Communists. Seventeenth-century builders of the Bay Colony were addicted, it seems, to "the thoughts of Winthrop."[31]

In essence then, Cooke uses historical sites and restored buildings as attractive backdrops for his sermonettes. Rarely does he comment on the meaning of cultural artifacts in the way that Kenneth Clark analyzed the significance of European art. With a

[28] For two reviews assessing the historical accuracy of *America*, see *History Teacher*, 6, 3 (May, 1973), 413; 7, 1 (Nov., 1973), 99.
[29] *America* segment, "The New Land."
[30] *America* segment, "Home from Home."
[31] *Ibid.*

continent at his command, a highly professional film crew at his disposal, and a script of his own choosing, Cooke had everything —everything that is save the one essential element—the depth of historical knowledge required to interpret the American past with sensitivity.

What lessons can universities, museums, and historical agencies draw from the foregoing survey? First, they must realize that the public will accept and probably enjoy a well-made media production with a clear interpretive thrust. Education and entertainment are not mutually exclusive. Clio may be a muse and amuse at the same time. Second, it is vitally important that historians and/or museum professionals control the filmmaking process. They alone have the knowledge and experience necessary to make sound, interpretive statements about the past.

The pressures against retaining such control are considerable. Filmmaking is expensive. Museums and universities must usually obtain outside funding for such ventures. Funding agencies frequently insist on support from some established filmmaking organization, such as David Wolper Productions or a local educational television station. To gain money the grantee must ally with the technical specialists who usually insist on making major decisions regarding treatment and script. Several years ago, the Winterthur Museum discovered the perils of placing itself at the disposal of a television crew. The plan, which did not originate at Winterthur, seemed innocuous enough. Harry Reasoner and a CBS crew from WCAU-TV in Philadelphia would come to the museum, interview the staff, take a guided tour of the collections, and produce a one-hour special for local broadcast. Harry seemed reasonable and WCAU seemed respectful of Winterthur's stature. Yet the curatorial staff had no hand in planning the tour, formulating the questions, or editing the final results. As a consequence *Candlelight on the Brandywine* is a curious film.[32] It reached a sizable audience and showed them several beautiful museum interiors, yet it did not demonstrate how a study of the decorative arts could lead to greater understanding of American culture. Indeed while the film featured several shots of the custodial and gardening staff, it never even mentioned the research library or the Winterthur

[32] WCAU-TV, Philadelphia, *Candlelight on the Brandywine*, 1970, color, produced by CBS.

fellowship program which produced two of Reasoner's tour guides. And the guides themselves, despite valiant efforts and an admirable display of tact, never managed to educate their distinguished visitor, who insisted on making such remarks as "now there is an ugly chair."

Certainly this is not the film Winterthur would choose to make about itself, nor would most museums want their television debuts sponsored, as *Candlelight on the Brandywine* was, by the John Wanamaker department stores, which used the occasion to feature its Williamsburg shop and an entire line of historical reproductions. The answer, of course, is for Winterthur to make its own films, as several museums and universities have done. Winterthur's one venture in this respect—a thirteen-minute color film on the Corbit-Sharp House in Odessa, Delaware—might have been more effective, and less expensive, had the museum's curatorial or educational staff assumed responsibility for writing the script.[33]

Some of the more accurate and interpretive historical films have come from university film departments such as the Audio-Visual Center at Indiana University. This organization has produced a number of good films, the most recent being a half-hour documentary on New Harmony, Indiana.[34] This program proves that film can deal sensitively with topics for which there is little or no photographic documentation, without relying on the unrealistic medium of dramatic re-creation. *New Harmony* uses drawings, portraits, nineteenth-century newspapers, architectural plans, and film of historic sites to describe the founding and progress of this important nineteenth-century utopian community. The film is too much chronicle and too little analysis, but still it points in the right direction.

Finally, one must ask: Is film too expensive and too commercial a medium for historical expression? Perhaps less costly approaches should be tried first. Why must a visitor information center show a film? Why not a slide-tape program? The advantages of slide-tape are several. It is much less expensive, much easier for the untrained to master, and much more conducive to experimentation.

[33] Winterthur Museum, *The Corbit-Sharp House*, 1965, color, produced by Willard Van Dyke.

[34] Audio-Visual Center, Indiana University, *New Harmony: Example and Beacon*, 1972, color.

If film is the preferred medium, there is much to be gained by working out our ideas in the cheaper medium first. Then, when satisfactory results are achieved, move on to film, confident that we have said what we want to say and that the public will find our ideas both entertaining and enlightening—even though they don't come from the lips of Jack Lord or Alistair Cooke.

Through the Glass Case:
The Curator and the Object
Arlene M. Palmer

"The most learned and polite people the world ever knew delighted in antiquities." By quoting Tacitus (who was describing the Greeks), Abiel Holmes sought to encourage and inspire the members of the American Antiquarian Society, celebrating their second anniversary in 1814.[1] Although its focus was the preservation of the written word, the society was one of the first institutional repositories for miscellaneous bits and pieces of America's past. The Worcester group appointed a cabinetkeeper to receive, register, describe, arrange, and delight in these antiquities, which, by 1819, included the "Fangs of the large, and Rattles of the dwarf . . . rattlesnake," and a "piece of the Tent of Gen. Washington, used by him at Cambridge, in 1775." Though natural and man-made specimens have long since parted ways in most modern cabinets, our collections are hardly less varied. As Holmes predicted, we now "behold with rapture" many of the articles that the early antiquarians looked at "with coldness" but preserved nonetheless.[2] Cabinetkeepers have become curators; while the basic goals of preservation and order have remained the same, the scope and

[1] Abiel Holmes, "An Address Delivered before the American Antiquarian Society," Oct. 24, 1814 (Boston: Isaiah Thomas, Jr., Nov., 1814), p. 3, bound in *Publications of the American Antiquarian Society, Proceedings, etc.*, vol. 1 (1812–53).

[2] Abiel Holmes, "Address to the Members of the American Antiquarian Society; Together with the Laws and Regulations of the Institution, and a List

methods of curatorial activity have greatly expanded. In their museum positions, curators essentially act as middlepersons between objects and those who would use them; they not only seek and save the past but interpret it as well. Through their recommendations for acquisitions, curators determine which fragments of our heritage will be preserved for the future. By their critical and continual examination of collection objects, curators develop skills of connoisseurship that enable them to "read" and to evaluate artifacts. After the exhaustive investigation of pertinent verbal and nonverbal sources, curators supply identifying information about objects that must precede their interpretation as social documents and artistic expressions. Museum installations designed to convey the cultural significance of objects to the public are largely the work of the curatorial staff.

These various museum-oriented responsibilities endow curators with a singular sensitivity to objects: they are our "thing," but not our everything. Artifacts are, by definition, the products of human workmanship. They can raise and answer many questions about the *people* of the past and consequently stimulate their curatorial inquisitors to look beyond their own galleries to the broader implications of material culture.

While collectors of early American decorative art objects have viewed them as pleasing alternatives to machine-made contemporary furnishings and valued them for their aesthetic or technical merits, institutions have been more interested in their associative properties, in their evocation of earlier domestic life, or in their sanctified connection with a great person (witness the AAS's piece of the true tent). American decorative arts first entered the "serious" world of art somewhat timidly in the 1909 Hudson-Fulton Celebration at the Metropolitan Museum of Art. The experiment was intended "to show by means of noteworthy examples the development of artistic expression in the more important handicrafts."[3] It was judged a success, and the "arts of living" have

of Donations . . ." (Worcester, Mass.: William Manning, March, 1819), p. 30, bound in *Publications of the American Antiquarian Society, Proceedings, etc.*, vol. 1 (1812–53); Holmes, "An Address," p. 21.

[3] Henry Watson Kent and Florence N. Levy, *Catalogue of an Exhibition of American Paintings, Furniture, Silver, and Other Objects of Art MDCXXV–MDCCCXXV*, vol. 2, *The Hudson-Fulton Celebration 1909: The Metropolitan Museum of Art Exhibition* (New York, 1909), p. ix.

enjoyed a place in many of our art museums ever since. Yet, the purpose of an American decorative arts collection can and does vary widely from museum to museum. Each institution has its own plans and policies, and it is the curator's job to evaluate holdings in light of these goals and to propose additions or subtractions accordingly.

Many museums in this field, including Winterthur, began as private collections, with the taste, life style, and whims of the collector inextricably bound to the things he or she accumulated. The Winterthur staff's purpose in expanding Henry Francis du Pont's formidable assemblage is to extend the presentation of decorative art objects made or used in America before 1840 to reflect and to reveal new information about early American society in general and about the history of materials and their artistic manipulation by man. We seek to acquire things of significant merit that will have potential interest to the public and to scholars of the future.

Two examples of recent Winterthur purchases will demonstrate the curatorial role in acquisition. A Venetian-style seventeenth-century drinking glass might at first seem to be an inappropriate addition to the display of artifacts in a seventeenth-century Massachusetts room at Winterthur. Although the drawings that London glass seller John Greene sent to his Venetian supplier between 1667 and 1673 document glasses of this form to the Murano factories, it is presently impossible to separate such common Venetian products from their imitations made elsewhere in Europe. Whether Venetian or *façon de Venise*, however, these fragile luxuries were used in England and were sent to the colonies as well. We know this from sherds excavated at Jamestown and from the fact that the term *Venice glasses* occurs in household inventories and other records from Massachusetts to Virginia.

The vessel also figures in Winterthur's presentation of the history of glass, because it is of the kind that rankled the London Glass Sellers Company as a constant reminder of England's dependence on foreign manufactures. George Ravenscroft's experimentation and perfection of the sturdier lead oxide glass in 1676 introduced the great age of English glassmaking, a revolution that is best and only understood in light of the objects themselves.

Another object, it was felt, would improve Winterthur's collec-

tion is a porcelain barber's basin, or shaving bowl, made in Japan around 1700. Although there seems to be no archaeological proof of such wares in America, several similar basins are owned in the old Dutch families of New York State. It is reasonable to assume that Japanese porcelains were used by the early New Yorkers, because Dutch traders had established trade with Japan in the early seventeenth century and had exported quantities of Japanese porcelain, including barber basins. The "china basons" listed in early New York inventories may well be of this kind.[4] In terms of the history of ceramics, the basin exemplifies the nature of Japanese porcelain and also typifies the "Imari-type" decoration which was copied and modified by both Chinese and European potters for over one hundred years.

In the selection of objects for a museum collection, a curator weighs not only factual data but also the more elusive attribute of quality: Does the object under consideration demand to be experienced aesthetically? Will it delight? Because of their penchant for the unusual rather than the commonplace, the best rather than the average, museum collections have been disputed as legitimate indexes of past cultures. The nature of museum holdings, however, may be as much a fact of survival as choice: ordinary goods were recognized as such and treated, or mistreated, accordingly, while articles of special quality or sentiment were cherished.

It should be noted, as an aside, that broken objects were not summarily sent to the trash heap to become the meat of archaeology. The booming business of china menders attests to that, as do inventory references such as John Petty's "Mended Chaney Bole," and the repaired objects themselves.[5] Even if damaged beyond use, an article may only have been discarded after the owner died, possibly years after damaging. Indeed, glasswares might never touch ground since glass could be profitably recycled: most glassmakers were eager to purchase broken glass to add to the raw ingredients of their batch.

For an accurate picture of American life, we need both the

[4] Roger Gerry and Joseph T. Butler, "Japanese Export Porcelain for the American Market," *Antiques*, 95, 4 (April, 1969), 544–546.

[5] Philadelphia County, Pa., Probate Court, Records (1973), microfilm 1030, no. 285, Joseph Downs Manuscript and Microfilm Collection, Winterthur Museum Libraries.

wooden cup and the Venetian goblet, the kitchen refuse and the silverware that passed down in the family. In the final analysis, however, it may be more enlightening to know that a particular family on the fringes of the wilderness could afford English plate of the latest fashion than to confirm that they used coarse redware of local manufacture in their kitchen. Certainly a parallel situation exists in the case of written records, where the vast majority of citizens left no letters or diaries for the historians convenience. It is, moreover, the extraordinary document that leads to the greatest insight.

The criticism leveled against museums is legitimate when articles of a typical merit are presented as absolute evidence of the way most early Americans lived. Several years ago, Thomas W. Leavitt and E. McClung Fleming argued that museums, if they are to be responsible educational instruments, should clearly state the purposes of their installations. Fleming urged exhibits to be read as "curatorial publications" subject to the same critical analysis that is accorded written publications. Because of the physical realities of museums, and museum budgets, curators can rarely do what they would like, but the idea is a valid one. Thus, curators should be judged on their ability to identify and evaluate an object and to convey its meaning to the museum public.[6]

Before there was a modern curatorial profession, guidelines for identifying early American decorative arts were provided by pioneer collectors and dealers, such as Luke Vincent Lockwood, Irving Lyons, Mary Harrod Northend, and Wallace Nutting. Without the groundwork they laid, there would be no discipline today; indeed, there would probably be very little American material culture for us to worry about. If they thought all furniture was made by Thomas Dennis or Duncan Phyfe, all glass by Henry Stiegel or the Boston and Sandwich Glass Company, it was, at least, a beginning. That the factual picture today is considerably less tidy is largely the fault of the museum curator lurking behind the glass case.

To provide reliable information about the objects in their care is

[6] Thomas W. Leavitt, "Towards a Standard of Excellence: The Nature and Purpose of Exhibit Reviews," *Technology and Culture*, 9, 1 (Jan., 1968), 70–75; E. McClung Fleming, "The Period Room as a Curatorial Publication," *Museum News*, 50, 10 (June, 1972), 39–43.

perhaps the curator's most awesome charge. Yet the identification, or "external criticism," of artifacts is not the facile task some would have us believe. It demands of the curator a variety of research skills and an approach that is both rational and imaginative. In his model for artifact study, Fleming defines the five properties of an object that must be considered: material, construction, design, function, and history.[7] By classifying these properties the curator in a way attempts to restore to the museum object the pedigree from which it was severed and to lend it an archaeological stratum it never had.

Those who believe that factual information, once wrung from an object, can replace the thing itself are probably those who rely on published transcriptions of original written documents. Yet who, when comparing copy to original, has never found errors or omissions that can alter meaning? The characteristics of objects, like the handwriting of early manuscripts, can be hard to read, even after considerable practice. Thus the curatorial process of identification, as well as authentication, requires direct and continual perception of the physical traits of objects.

The nature of materials—composition, purity, texture, color—plays a primary role in the attribution process. For example, a porcelain dish was banished to a dark, closed cabinet beneath a display area at Winterthur because it was believed to be a nineteenth-century piece. Because of the evidence of the materials, however, we now feel it must be of the K'ang-hsi period (1662–1722). Of a pure white substance, it is extremely thin and translucent, in the manner of early eighteenth-century Chinese "eggshell" porcelain. Most important, its decoration is unquestionably painted in the transparent *famille verte* enamels that were superseded by the opaque *famille rose* colors by the end of the reign of Yung-cheng (1722–35).

In their relentless pursuit of the innermost secrets of objects, curators are learning to feel at home in the laboratory. A precise knowledge of the chemical composition of the materials of objects is proving to be of value in assigning dates and places of origin. The staff of Winterthur's analytical laboratory has analyzed about

[7] E. McClung Fleming, "Artifact Study: A Proposed Model," in Ian M. G. Quimby (ed.), *Winterthur Portfolio* 9 (Charlottesville: University Press of Virginia, 1974), 153–173.

twenty-five hundred pieces of silver by means of a nondestructive X-ray fluorescent spectrometer. Their conclusions are that English silversmiths, required to pass assay tests, regularly fashioned vessels and flatware from silver of 92.5 percent or greater purity. Their American counterparts, on the other hand, had no enforced standards and so maintained a lower silver content, generally around 90 percent.[8]

Because of the paucity of documented specimens, the attribution of early American glasswares to individual factories has been a dangerous pastime. Spectrographic analysis, however, may provide some guidelines based on the assumption that glassmakers would have drawn from specific sources for raw materials. Because sand differs from area to area with respect to its impurities and because glassmaking recipes were varied, patterns of impurities might reflect and distinguish factory traditions. In spite of the obvious ringer in the hypothesis—that non-American cullet or waste glass was regularly added to the pots to improve the batch—the results of tests have so far been encouraging.

Several key pieces owned by the descendants of glass manufacturer Caspar Wistar and fragments from the Wistarburgh site were found to have fairly similar chemical compositions. As other objects were discovered, which on stylistic, technical, or historical grounds related to Wistar production (such as the "electerising" tube of the kind Benjamin Franklin had made at Wistarburgh for use in his electrical experiments), the traditional ideas about a *characteristic* composition were reinforced. By the same token, every piece of signed and well-attributed glass made at John Frederick Amelung's glassworks in Frederick County, Maryland, has been analyzed, and a fairly consistent composition has emerged that is different from that of Wistar's New Jersey wares.[9] Both formulas, moreover, are distinct from those of known German and other nonlead glasses that have been analyzed to date.

[8] Victor F. Hanson, "Quantitative Elemental Analysis of Art Objects by Energy-Dispersive X-Ray Fluorescence Spectroscopy," *Applied Spectroscopy*, 27, 5 (Sept.–Oct., 1973), 302–333.

[9] Arlene M. Palmer, "Glass Production in Eighteenth-Century America: The Wistarburgh Enterprise," in Ian M. G. Quimby (ed.), *Winterthur Portfolio* 11 (Charlottesville: University Press of Virginia, 1976), pp. 75–101; Dwight P. Lanmon and Arlene M. Palmer, "John Frederick Amelung and the

The course, the ability of the X-ray spectrometer to aid curators in questions of glass attribution will be fully understood only after scores of known non-American wares are analyzed and after more primary evidence from glasshouse sites can be evaluated. At the present time, the technique is limited to glasses of nonlead formulas. Testing has concentrated on eighteenth-century wares and may prove of little value for the purer glass made in the nineteenth century. Written evidence, moreover, shows that the glassmakers went far afield for their materials and probably shared sources with other manufacturers. Before the War of 1812, for example, New England glasshouses purchased sand from the Demerara River in British Guiana: they later turned to a New Jersey river bed. In the 1840s they bought sand from Canada, as did many glassworks of the Ohio Valley.[10]

A new approach to the study of blown-molded glasswares, pioneered by Dwight P. Lanmon of the Corning Museum of Glass, entails the close examination of the physical evidence of workmanship. Metal molds, either part-size or full-size, were used by glassmakers to create decorative surface patterns on thousands of pieces of glass. Just as molten glass picks up the details of the intended design, so it also retains any unintentional variations in the pattern as it exists in the mold: scratches cutting through a pattern, an unusually small diamond in an otherwise regular row of large diamonds, and so on. These mistakes are not imparted to just one product of the mold but to every one. Sharing the same *pattern* is no longer considered sufficient evidence for attributing all such pieces of glass to the same maker. Should the pieces carry the same mold defects, they may be attributed to the same mold, but not necessarily to the same factory. We know that glasshouses purchased molds from each other, and that a glassmaker might

New Bremen Glassmanufactory," *Journal of Glass Studies*, 18 (1976), 9–136; Robert H. Brill and Victor F. Hanson, "Chemical Analyses of Amelung Glass, *Journal of Glass Studies*, 18 (1976), 216–237.

[10] Deming Jarves, *Reminiscences of Glass-Making*, 2d ed. (New York: Hurd & Houghton, 1865), p. 11; letter from Jarvis and Vallé, Jan. 31, 1846, American Fur Company Papers nos. 15, 369, "Calendar of the American Fur Company's Papers, pt. 2, 1841–49," *Annual Report of the American Historical Association for the year 1944*, vol. 3 (Washington, D.C.: Government Printing Office, 1945), p. 1476.

carry his molds and other tools with him as he moved from one glasshouse to another in the course of his career.

This study is still in progress but some of the findings suggest the usefulness of the approach. While most of the part-size molded glasswares found in American collections are assumed to be of American origin (and some undoubtedly are), many must be of British manufacture. An inexpensive alternative to cut glass, such wares were suitable for the "meaner" English households, so, of course, they figured in the export trade. But molded wares have been virtually ignored by the students and collectors of English glass, with the result that what molded glasswares did not come to America in the eighteenth and nineteenth centuries, arrived in the twentieth, notably in the 1920–40 period when glass collecting was at its peak. Separating the chaff from the wheat has, therefore, become a major headache for curators of American glass. At least one piece, an unusual diamond-patterned caster in the Winterthur collection, must revoke its Yankee claim because it has a mold-mate which has never left England.

More positive conclusions may be in the offing when the study of diamond-daisy liquor flasks is completed. This design, consisting of five large diamonds, each containing a twelve-petaled flower above a band of thirty flutes, has no known parallel in either English or Continental production (Fig. 1). Many examples were found in the Middle Atlantic states and have been attributed to the glassworks of Henry William Stiegel in Lancaster County, Pennsylvania. Unfortunately, there are no firmly documented Stiegel products of any type that will permit a definite attribution. It is significant, however, that a number of the diamond-daisy flasks appear to have been patterned in the same mold. If one should be found, above or below ground, that can be documented to Stiegel, or any other glassmaker, and if it also bears the same defects, then, perhaps, we can attribute the entire group with some credibility and thereby solve one of the major puzzles in the study of early glass.

Decorative art objects, however decorative, were made to be used, although function and the exact manner of use are not always obvious. Contemporary illustrations can illuminate the role of objects; some, for example, reveal the manner of holding drink-

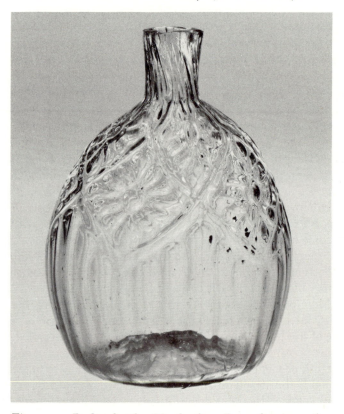

Figure 1. Pocket bottle, Maryland or Pennsylvania, 1765–1800. Glass; H. 4¾₆″. (Winterthur 59.3088.)

ing vessels, a manner quite foreign to modern habit although we employ the same form. Words and pictures are tools in the search for this kind of data, if only to prove that our ancestors were as resourceful and as unpredictable as ourselves in "making do" with whatever was at hand. Thus five-board chests doubled as beds, and at least one bedpan was used as a chafing dish. In the 1740s a man used a single basin "to eat his soup out of and to shave in, and, in the water where a little before he had washed his face and hands, he washed likewise his cabbages. This, too, served him for a punch bowl." Dr. Alexander Hamilton's rather horrified tone in relating

these activities of his tavernmate suggest that such economy was out of the ordinary, at least in his social class.[11] But was it a fact of life in other echelons?

Some objects had very specific functions, but many of the common names for them, coined during the early years of collecting, assign a function that is inaccurate or, at best, misleading. Large glass tumblers, for example, are always called "flip glasses," yet that name does not appear in early household inventories, newspaper advertisements, or merchants' records. Newspaper advertisements and inventories supply a quantity of object names that are very specific with regard to function: lemonade cups, punch glasses, punch tumblers, cream cheese dishes, artichoke cups, marmalade pots, cordial cups and saucers, stew cups. It is a dangerous business to start matching objects with words unless there is a documented prototype. Sack probably was stored in tin-glazed earthenware bottles labeled "Sack." A certain type of small glass bottle (Fig. 1) has been called a perfume bottle, but there is little doubt that it contained a different, more alcoholic "comfort of life."

Style, as exemplified in form and decoration, offers important clues to an object's date and place of origin. To elicit this information curators must recognize general artistic movements as well as their national and regional manifestations and be aware of the pitfalls. Some artifacts can be precisely dated by their forms because they enjoyed only a limited period of fashion. A Chinese export porcelain wall cistern in the Winterthur collection is a faithful copy of Continental faience forms that were popular from about 1700 to 1725. The transparent enamels of the Chinese version, applied in a typical K'ang-hsi design, support the dating suggested by the form. A mug and bourdalou, also of Chinese export porcelain, bear the arms of Sir William Dalling of Surrey. The service almost certainly was ordered during his sojourn as commander-in-chief of Madras from May 30, 1785, to the end of 1786, the same period when other services with this Fitzhugh-type

[11] Carl Bridenbaugh (ed.), *Gentleman's Progress: The Itinerarium of Dr. Alexander Hamilton 1744* (Chapel Hill: University of North Carolina for Institute of Early American History, 1948), p. 130.

border, such as George Washington's Order of the Cincinnati set, were made.[12] Based on its shape the bourdalou would date the service to the 1760s, some twenty years earlier, because no bourdalous of that style are known in armorial services after that time. Examination of this particular specimen, one of three in the Winterthur collection, reveals that the borders are painted over the glaze, not under the glaze, as one would expect, and as is found on the mugs and other pieces. The arms, however, are like those on the other pieces of the set in every respect. Given these points one can only surmise that while most of the service was potted and the borders painted at Ching-te Chen, the unfashionable bourdalous were taken from old stock in Canton. There, the chamber pieces had their borders added, and, along with the rest of the set, were painted with the Dalling arms.

Certain forms that were popular in one country did not always achieve popularity in another, while other forms were readily adopted. An export porcelain dessert compote (Fig. 2), modeled after a Meissen prototype, was probably supplied to the Chinese by a European to be made as cheap Meissen. Yet Winterthur's example bears the insignia of the Order of Cincinnati and the initials S S; it was owned by Samuel Shaw, first American supercargo at Canton. A curator aware of the Shaw compote would be rash to assume that an undocumented example was intended for the European market.

Sometimes it is impossible to put forth any attribution on the basis of form. Certain shapes persist over hundreds of years and disregard national boundaries simply because they represent the most satisfactory solution to a universal problem.

The embellishment of form may betray an object's source, but decoration, like form, can be deceptive. A tureen bearing the unmistakable stamp of the French rococo, and dishes with Kakiemon-inspired designs demonstrate the problems of reading the inscrutable Oriental. Separated by sixty-five years and some six thousand miles, they emphasize the twin troubles of style transmission and transmutation. A cup recently added to Winterthur's study collection epitomizes the ultimate confusion: a "Chinese chinoiserie"

[12] David Sanctuary Howard, *Chinese Armorial Porcelain* (London: Faber & Faber, 1974), p. 683.

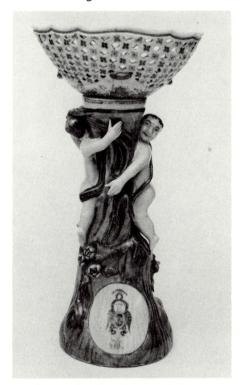

Figure 2. Fruit basket on stand, China, 1785–
90. Made for Samuel Shaw. Porcelain; H.
14⅞″. (Winterthur 59.2934.)

cup modeled after a Meissen example inspired by the Chinese
(Fig. 3).

Decoration can be unquestionably chauvinistic. It is doubtful
that anyone but an American would have wished to drink his tea
or coffee out of eagle-decorated cups, yet we know that the Portu-
guese were content with porcelain emblazoned with an adaptation
of the arms of New York State. Finally, as with form, there are
traditional folk designs which transcend the boundaries of time
and place.

Much curatorial effort is directed toward documentation be-
cause artifacts which, through direct or indirect evidence, can be

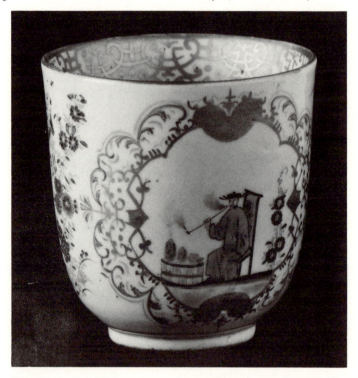

Figure 3. Cup, China, ca. 1730. A Chinese chinoiserie in the Meissen style. Porcelain; H. 3$\frac{1}{16}$". (Winterthur 75.131.)

linked to people, places, and periods, form the foundation for the whole process of attribution. They serve as a control group from which knowledge about other artifacts can be extrapolated. From the view of the cultural historian, the more complete an artifact's identification, the more useful it will be for the interpretation of the society that made and enjoyed it. For the archaeologist who must identify his sherds, such a data bank is very helpful.

What may appear to be an object's forthright statement of its origins, such things as dates and makers' marks, must always be handled with curatorial gloves. Aside from the higher market value and the resulting incentive to fakery, documented objects can represent to the modern eye something far different from what the maker or user intended. Very often the date on an object is not the

date of its manufacture. Commemorative wares made in all materials are the most obvious examples. Then there is the case of Winterthur's six silver tankards made by Paul Revere and bearing the date of Mary Bartlett's death and bequest to the Brookfield Church, 1768; yet the church records, as well as Revere's accounts in the Massachusetts Historical Society, show that the tankards were made in 1772. Another example is silverware which descendants of the original owners made their own upon inheritance by adding their own initials and the date of acquisition.

It is well known that Chinese potters of the Ch'ing dynasty marked their porcelains with the reign marks of earlier eras. Presumably done as an innocent sign of respect for the past and pride in the present, the practice has long worried students of Chinese art. The intention of certain English potters of the late eighteenth century was quite a different matter when they "borrowed" the name of Wedgwood for the bottoms of their pots. Hoping to capitalize on Josiah Wedgwood's fame and to divert some of his fortune, these entrepreneurs escaped litigation only by not making exact copies of the prestigious mark. If any factory was hopelessly aped in its time it was Meissen. The famous crossed-swords mark appeared in slight variation not only on other German-made wares, but also on English, French, and even Chinese products.

The curator must look beyond the object to other sources, especially such object-related documents as the household inventory, the cargo list, and the factory ledger. But words on paper can be as misleading as words on objects. "India China" does not mean porcelain made in India; it refers to the products of China that were shipped to Europe by way of India and the East India companies. Indeed, the term *china* was applied to fine ceramics of many kinds, not just to porcelain. Documentary records can be of inestimable help. Cut and engraved tumblers with sulphide busts inserted in their bases have always been attributed to Benjamin Bakewell's glassworks in Pittsburgh, but Hezekiah Niles's description of the novelties in 1825 lends credence to the attribution: "A novel, curious and elegant specimen of American industry and talent, from the glass making establishment of Messrs. Bakewell, Page and Bakewell, of Pittsburg. It consists of cutglass tumblers, in the bottom of each of which by a very ingenious process, is

imbedded an excellent likeness of some distinguished American citizen, as Adams, Jackson, Lafayette, &c."[13]

Although traditions of ownership must be used with great care, they should not be dismissed entirely. A small blue-tinted glass taperstick was represented as a Wistarburgh product. Clearly its original owner, Caspar Wistar's great-granddaughter, believed it was, since she had collected it and recorded it as such in the 1840s or '50s, but it just did not resemble anything that could have been made in eighteenth-century America. In the Winterthur collection, there is a closely related, full-size stick that had been found by George and Helen McKearin in New Jersey and was considered by them to be of possible eighteenth-century Jersey origin. The plot thickened when another small blue stick, virtually identical to the first, was found in the possession of another Wistar descendant. It lacked documentation, but another blue piece was found with the same history. On its bottom is the circa 1840 label of Richard Wistar Davids which reads, "[Blown] at C[aspar] [Wistar]s glassh[ous]e ab[ou]t [17]30."

Manufacturers' design books and advertisements are of immeasurable value to the study of objects. A German glassmaker's catalog (Fig. 4), used by an early American merchant, identifies hundreds of glass forms that were exported from the Continent to America. Most importantly, the catalog virtually eliminates the possibility that most of these wares were blown by Amelung workers as has so often been claimed. Thanks to James Morley's advertisement in the Bodleian Library, a small brown salt-glazed stoneware cup can be neatly tied to the Nottingham pottery and dated to the 1690–1710 period.

Contemporary illustrations, like all types of evidence, must be used with caution. Many of the objects found in paintings and prints were simply artists' props, and when American painters copied from English mezzotints the only thing that was true to life was the face of the sitter—and in some cases artistic liberties were taken even there. A distorted idea of American glassmaking could result if a curator took the well-known portrait of Emma van Name too seriously, tantalizing though it is to hope that a glass-

[13] *Niles' Weekly Register*, vol. 28, March 19, 1825, p. 34.

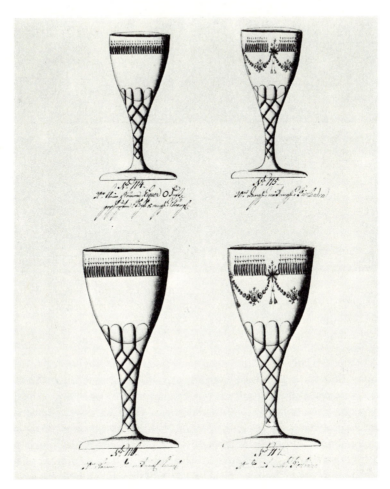

Figure 4. "Small Roemer liquers." Ink and wash on paper. From Gardiner's Island Glass Catalogues, 1800–1830, vol. 1, nos. 114–117. (Winterthur Museum Libraries, 71 × 206.1.)

house of the 1790s could have produced the large goblet shown in the painting.

Archaeology is, perhaps, the truest aid to curators in the identification of glass and ceramics, because in a field where few objects

Figure 5. "Exact Reproduction of Antique Glassware." From Pair-
point Corporation catalog, New Bedford, Mass., ca. 1920–25. (Corn-
ing Museum of Glass.)

were signed, the excavation of a factory site can provide the only
proof that a certain ware was or was not manufactured there.
Recent excavations of potteries in England have resulted in many
more precise attributions. Few American potteries or glasshouses
have yet been professionally dug, but there is an ever-growing
awareness of the importance of such undertakings. Archaeologists
not only unearth documented objects, they may also present the
best picture of technological achievements by their discoveries of
furnaces and kilns, a picture which, in turn, influences attribution.

Underlying every aspect of the identification process is the ques-
tion of authenticity. Curatorial judgments are both rational and
instinctive and are based on a broad knowledge of objects. Cura-
tors need to be familiar with the history of collecting in order to
discern market interest that might have spawned deliberate forger-
ies. They must know the honest reproductions that can appear in
other guises, such as the "Stiegel-type" engraved glasses made by
the Pairpoint Corporation in the 1920s (Fig. 5). The skills of

connoisseurship acquired and improved by the constant handling, viewing, and studying of objects enable a curator to distinguish early form from late, period color from modern, genuine wear from artificial. Several glasses in the Winterthur collection became suspect on these counts; the additional evidence of their molds set them apart from genuine articles of the same pattern, as well as from documented reproductions of those designs.[14]

While nothing will ever replace the experienced eye and hand, science now offers some aids to authentication. In copper alloy metals, for example, the absence of certain trace elements implies a purification technology only developed in modern times. Spectrographic analysis can unmask the would-be Paul Revere by distinguishing modern silver alloys from early ones. Other scientific tests conducted on the suspect group of blown three-mold glasswares, cited above, supported curatorial suspicions of foul play.[15] But verdicts need not always be negative; curators exalt as often as they condemn, and previously banished artifacts may return to the gallery fold. Authentication is rarely cut and dried since no two curators can bring the same experience and expertise to an object. Assessing an object's aesthetic merits is more than a subjective exercise. It demands of the curator/connoisseur, in the words of Charles F. Montgomery, "a good visual memory stored with an infinite number of images of ordinary, fine, and superior objects mentally pigeonholed as to desirability."[16]

In these curatorial responsibilities of authentication and evaluation there can be no substitute for the artifact itself. Things, not their descriptions or photographs, must be continually reviewed in light of new information and improved techniques of object examination.

In the 1920s a decanter, such as that shown in Figure 6, would have been classified as a product made between 1830 and 1850 by the Boston and Sandwich Glass Company. Today a curator can

[14] Molded glasses of this type have been classified by pattern in George S. and Helen McKearin, *American Glass* (New York: Crown, 1941), pls. 88, 92. The patterns in question are GII–18, GIII–5, GIII–6.

[15] Dwight P. Lanmon, Robert H. Brill, and George J. Reilly, "Some Blown-'Three-Mold' Suspicions Confirmed," *Journal of Glass Studies*, 15 (1973), 143–173.

[16] Charles F. Montgomery, "Some Remarks on the Science and Principles of Connoisseurship," reprint from *Walpole Society Note Book* (1961), p. 8.

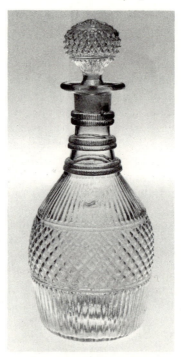

Figure 6. Decanter, United
States, 1820–50. Glass; H.
10⅜″. (Winterthur 59.3206.)

only make such an attribution after gathering and weighing all the
evidence very carefully. The decanter was blown in a full-size three-
part mold, a technique practiced by ancient craftsmen. Its form,
however, places it around A.D. 1800. The diamond pattern of the
decanter was copied by forgers in this century, but the quality of
the material and the presence of proper wear marks indicate that
the piece is genuine.

Assuming that the decanter was made early in the nineteenth
century, where could it have been made? Sandwich was by no
means the only glasshouse in New England to manufacture molded
glass of this sort, and factories in the Ohio River valley as well as
in the mid-Atlantic region produced this type of ware. European
glasshouses also turned to decorative molded glass as a cheaper

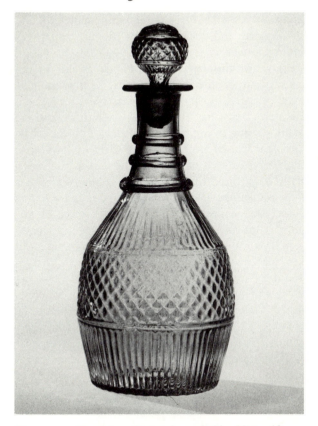

Figure 7. Decanter, Portugal, probably Vista Alegre, 1824–32. Glass; H. 9¾″ (Corning Museum of Glass.)

alternative to cut glass. In fact, the Corning Museum of Glass recently acquired in Portugal a nearly identical decanter (Fig. 7). A pattern book published in 1829 by the glassworks in Vista Alegre illustrates a decanter of this style which suggests that the object found in Portugal had indeed been made there.[17] Unfortunately for glass historians, the Portuguese decanter, like its American counterpart, has a lead-glass composition, and there is no known method of distinguishing one lead-glass formula from an-

[17] Vasco Valente, *O Vidro em Portugal* (Porto: Portucalense Editora, 1950), p. 83.

other. And so, the visitor leaves the museum, clutching his molded lead glass decanter and wondering why the glass curator can't tell him anything about it.

The purpose of this curatorial chronicle is not to discourage historians of whatever breed from turning to museum collections. Rather, the intent is to suggest that material culture can only be profitably used after it has been properly identified and evaluated. Curators are striving to improve knowledge of objects; it is a learning process that can be frustrating but never dull. While curators may not get as close to a moment of the past as the archaeologist occasionally does, the thrill of the chase is almost always as exhilarating. A curator, like Mark Twain, can be reduced to "gibbering ecstasy" over the marks on the bottom of a piece of rare crockery.[18] But it is not the marks themselves that excite; it is what they mean as well as the satisfaction of dropping another piece of the puzzle into place.

Curatorial responsibilities have been likened to those of a priest "for the souls of his parish." While the tome of a new historian may not be everyone's idea of heaven, it is, nonetheless, up to the curator to see that the artifacts have a fighting chance of passing through those pearly gates. Artifacts will only be recognized and exploited as sources of historical data on three conditions: (1) if they are as fully annotated as possible, (2) if the process of identification can be explained, and (3) if they have something to say.

The many kinds of cultural evidence that artifacts can supply have been amply set forth by E. McClung Fleming, but a few points can be stressed here from the curatorial view. First, artifacts are only as interesting as the persons who made and enjoyed, sold and collected them. Craftsmen, especially glassworkers and potters, rarely left diaries or letters; their only statements are the objects they fashioned. These objects can speak of craft traditions and training; they can trace the Americanization of European ways. They attest to the skill and pride of workmanship or the complete lack of it. While the famous Royal Worcester Porcelain Company's "Potter" vase reveals the artisans' idealized self-vision, the flask (Fig. 8) with the portrait of its manufacturer, Thomas W.

[18] Mark Twain, *A Tramp Abroad* (1880), pp. 179–180, as quoted in Bevis Hillier, *Pottery and Porcelain, 1700–1914, The Social History of the Decorative Arts*, ed. Hugh Honour et al. (New York: Meredith, 1968), p. 279.

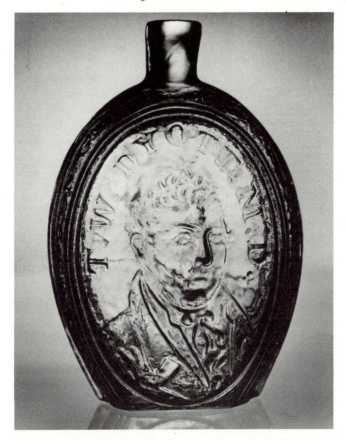

Figure 8. Pocket bottle, Kensington Glassworks, Philadelphia, 1826–28. Glass; H. 8″. (Winterthur 73.407.2; gift of Mrs. Harry W. Lunger.)

Dyott, suggests pride of another kind (the reverse features Benjamin Franklin) or just plain good business sense. Further insight into the impenetrable countenances of our forefathers is gained from such artifacts as the Sill family tankard, the owner of which felt no compunctions about borrowing the heraldic bearings of Lady Jane Still. The role of artifacts as relics is both varied and valid.

Second, objects are only as meaningful as the questions put to

them. Curators, in their work of identification and interpretation, are asking a variety of questions and are trying to show others how to ask questions of their own. At first glance, a group of historical flasks may appear uninteresting. But look again. To the historian of technology they reveal the adaptation of manufacturing techniques for mass production; in one advertisement alone, Dyott, in 1825, offered over 250,000 pictorial flasks, as well as 35,000 gross medicine bottles and vials. Flasks document the decline of the glassblower as creative craftsman and the rise of the moldmaker. To the art historian American flasks offer an unparalleled source of pictorial art and design for the masses. To the social historian they speak of the popular heroes and slogans of the flask-toting public. No one concerned with the temperance movements of the nineteenth century can overlook the invigorating possibilities of such flasks as source materials. For whom was "corn for the world" (corn liquor) a daily, perhaps hourly, toast? Who did not buy flasks? At 87 cents a dozen, the cost of a Masonic flask, who could not afford them? What did they hold? What was the attitude of society toward drinking? One advertiser noted that though his liquors "were selected for the *sick and wounded*" he added, "the healthy need not fear any ill effects from their *proper use*."[19]

Third, not all things will be of interest to all historians, no more than are all written records. In a recent study of colonial family life a new historian dismissed material objects with no ownership histories and claimed that they possessed "no significance beyond pure antiquarianism."[20] No significance for him, perhaps, in that particular study, but had his focus been the economic life of the colony, the crafts, manufactures, and commerce of the inhabitants, such artifacts might well have proved invaluable sources. Objects have been taken to task for not relating to the broad, theory-of-civilization-type ideas which historians say they like to discuss. Such theories we trust must be based on some fact, and objects, like probate records can be the building blocks. More than that, they can be the stimulants. The imaginative study of objects can start a chain reaction leading to broader, often uncharted, areas of

[19] Advertisement of Frederick Bull, *Connecticut Courant* (Hartford), June 28, 1823.

[20] John Demos, *A Little Commonwealth: Family Life in Plymouth Colony* (New York: Oxford University Press, 1970), p. 21.

the past. Thus, a piece of glass leads to a consideration of the specific factory, which in turn demands consideration of eighteenth-century American glassmaking in general, which leads to the role of manufactures in the colonial period, the change of that role in the post-revolutionary period, and so on—that is just one of many chains that can be made. "Problem" artifacts, like the decanter, are especially valuable because of the many challenges they pose. When considering the larger historical picture the object catalyst soon fades into the background only to be recalled to service by another examiner with a different set of questions.

If curators are to be seekers of knowledge rather than mere cabinetkeepers, they must endeavor to close the information gaps that exist between object and public viewer and object and scholar. This is no easy task. As suggested, the process of uncovering the truths about artifacts is anything but static, with the result that up-to-date information is more often in a curator's head than on a catalog card. Until they are sure of their own attributions curators are generally reluctant to multiply error and so are content to live with the old ones: for now, the label on the decanter in Figure 6 might just as well read "Sandwich, 1830–50." A depressing fact of life is that there are many who still believe, and who will continue to believe, that Stiegel and Sandwich did it all.

In the end, curators may be most influential to the future of the study of material culture not so much because of their knowledge of things but because of their capacity and initiative to process all types of information.[21] A sensitivity to objects and the pursuit of the questions they raise put curators in a unique position to make artifacts meaningful to both the museum public and the scholarly world. That they have not exploited their opportunities is the result of several factors. Curators are paid to run museums; there is little time for research. Museum management has not always considered curatorial research a top priority, particularly when it extends beyond the immediate needs of the museum. Finally, curators have tended to spend what time they have in publishing descriptive rather than interpretive studies, in a crusading effort to maintain a level of scholarship in a field that is crawling with "experts" on antique and not-so-antique everything, from buttonhooks to glass

[21] Craig Gilborn, "Words and Machines—the Denial of Experience," *Museum News*, 47, 1 (Sept., 1968), 26.

insulators. Curators are the logical ones to assert the role of material culture. If object research becomes an end unto itself curators will be expending energy on what even in 1814 was recognized as a pastime which "to a superficial observer may appear idle, and to a rigid moralist, useless."[22]

[22] Holmes, "An Address," p. 13.

Index